The Compleat Lover

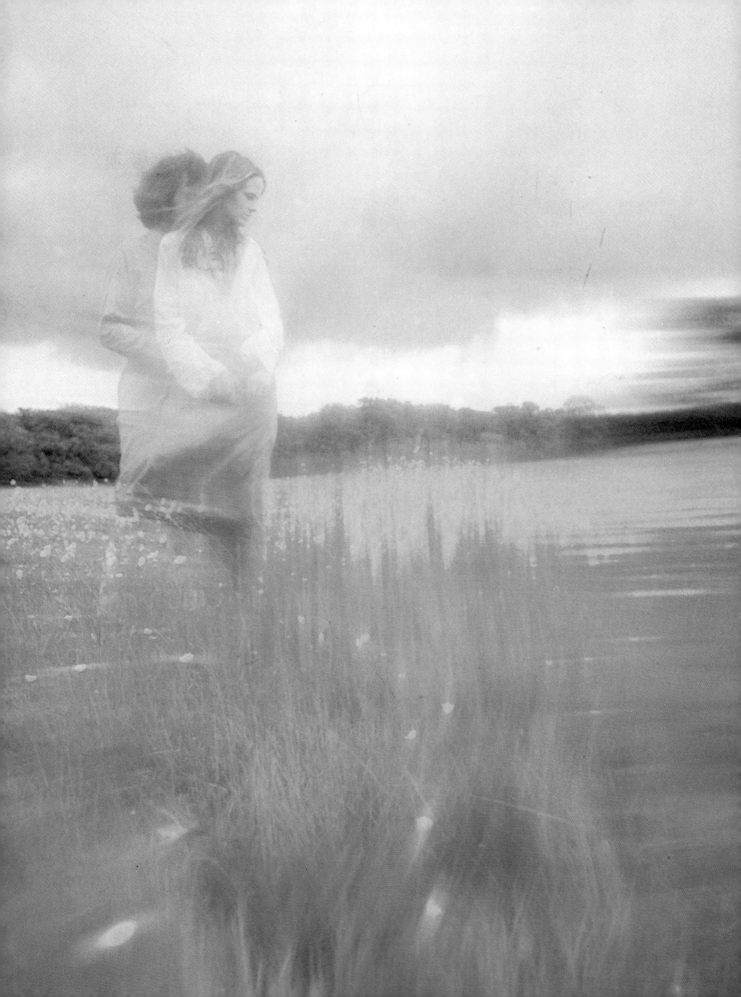

The Compleat Lover

Derek and Julia Parker

Mitchell Beazley Limited
London

First published 1972 by
Mitchell Beazley Ltd.,
Artists House, Manette Street,
London W.1. © Mitchell Beazley Ltd. 1972.

ISBN 0 85533 008 2

Printed in Holland

Contents

The Story of Love Pages 17-36
In which we follow the
turbulent history of love from the
ancient Greeks to the present day.
Together with certain amorous anecdotes: of
Daphnis and Chloe, of Sir William Roper and his
private view of a choice of brides, and of the
preparation of a meticulous map of Love's
terrain. And arguing that after the
adventures of Aphrodite and the
cunning of Cupid, we may once
more persuade the gates of
Eden to creak open.

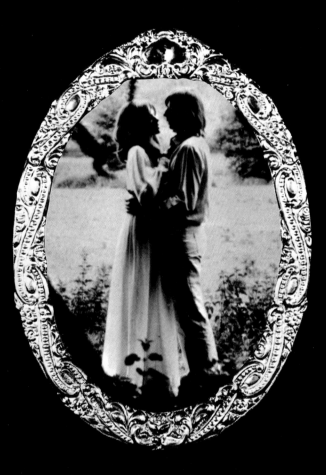

Falling in Love Pages 37-56
In which the reader is invited
to consider, or perhaps remember,
first love—the sudden surprising
realization that of a hundred thousand
people, it is *one* who matters. With a glance
at the lovers provided by astrology, the computer
or the newspaper column, and at the interesting
customs of other ages; and tales of first
meetings from the pages of history and fiction.
In fact, showing how and in
how many places, unexpectedly
or foresightedly, love may
be born.

Courting Pages 57-96

In which the reader is invited
to view the world of the chase,
where men and women, suitably
dressed and perfumed, pursue each other
through ballroom or wood, past maypole or
skyscraper. We recall the old traditional dreams
of love, look over the shoulder of a lover as he pens a
Valentine or a love letter, or in a Victorian garden
catches the scented message of a bunch of
carefully-chosen flowers. Keepsakes and
customs, food and drink, and the very
breath of love, invite us to the
courtship and its
culmination.

Falling in Love: An Anthology Pages 97-112

In which, in pieces of poetry and prose,
from Shakespeare's sonnets to Tolstoy's *Anna
Karenina*, all the many contradictory
faces of love are captured and
reflected.

Making Love Pages 113-160
In which, in photographs, in
paintings and in words we explore
the physical world of love and the
infinite capacity of the human body for
expressing love and tenderness. We show too
the newness which the experience of love can bring
with it—the rebirth of our appreciation of sight,
sound and touch, in which poetry and life
meet; a rebirth which gives us a new
vocabulary, the language of love,
with which we can explore a
whole and unsuspected
new world.

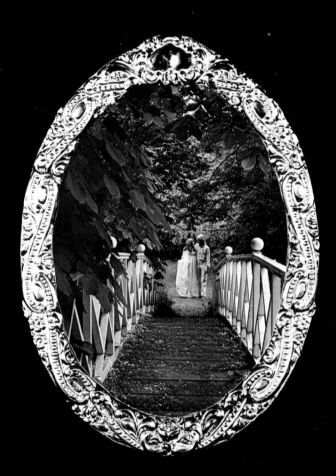

Making Love: An Anthology Pages 161-176
In which all the intensity and tenderness of physical
love is expressed in poetry and pieces
of prose.

Great Love Stories Pages 177-192
In which, from the annals of
the history of love, we pluck seven
stories to illustrate the varied course
of true love: from the tragedy of Romeo
and Juliet and Tristan and Iseult to the
rebirth of life which love brought to the Brownings;
and from the mythical magic of Beauty and the Beast
to the fact-become-fiction of Marguerite
Gautier, the Lady of the Camelias; and
ending with the greatest public love
story of this century—of the young
king who gave up his throne
for the woman he loved.

A Lifetime of Loving **Pages 193-208**
In which love is followed
through man's (and woman's)
seven Ages: from the innocent
explorations of infancy and the friendships
of childhood, to the confusions of adolescence
and the delights of maturity. But showing, too, the
growing together which love brings: the identity of
one with another, and the gradual development
of a love which is so complete that partners
become one personality; and
illustrated by a series of paintings
to mirror each age
ideally.

The Amorous Muse: An Anthology **Pages 209-220**
In which the Muses relax, climbing
drainpipes to darkened windows, lifting a petticoat
to glimpse a charming leg, or welcoming
willing maidens into their arms
and beds.

Games **Pages 221-251**

Index and Acknowledgments **Pages 252-256**

Introduction

The prospect of writing any kind of book about
'love' (perhaps the most indeterminate and
indefinable word in the English language!) is a
daunting one. Indeed, to attempt in the 1970s
a book on love is to court criticism and even abuse
of a varied kind. Never in human history have the
nature of love and the practice of love-making
been so controversially and violently debated as
they are now.

One of our main reasons for writing *The
Compleat Lover* is that we believe that in the midst
of all this confusion the individual capacity to
love is still the most intimate, the most powerful,
the most gentle gift bestowed upon all of us at birth.
We believe too that love is the only means whereby
we can each establish and explore our identity and
self-fulfilment as individuals in relation to others.
Through love, we can, in part, transcend the basic
state of loneliness in which we are all born.
Perhaps immodestly, we wanted, therefore, to set
out our feelings about love for anyone who cared to
read them; and like most writers we wanted at
the same time to clarify our feelings on the subject –
to remember, expand and develop some of the
emotions we felt during two years of courtship
and fifteen years of marriage, and to share them with
other people.

It might be argued that love is too difficult a
subject to be tackled by any but the greatest poets,
that they are the only ones who can write about love
without stooping to triteness or excessive sentimen-
tality. Other lesser mortals, writing of love from the
humble 'molehill of personal experience', can so
easily run the risk of making bores or fools of
themselves. So we have in fact taken out a sort of
insurance against this point by reprinting some of

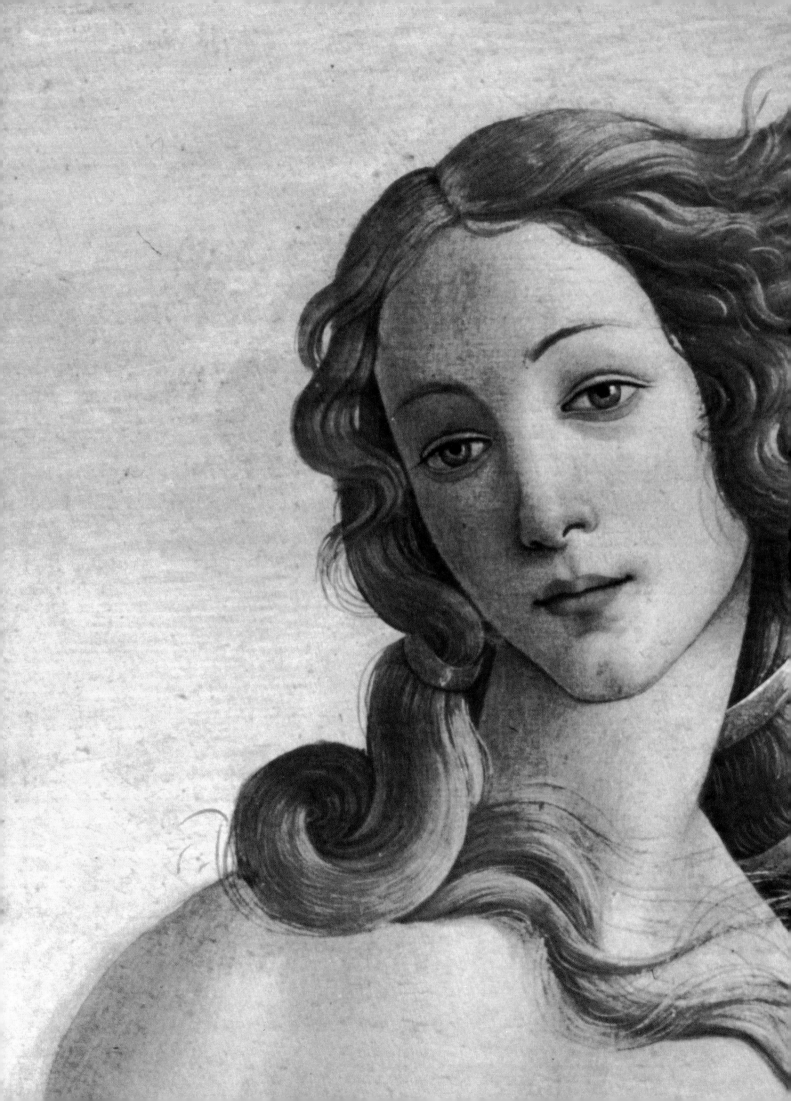

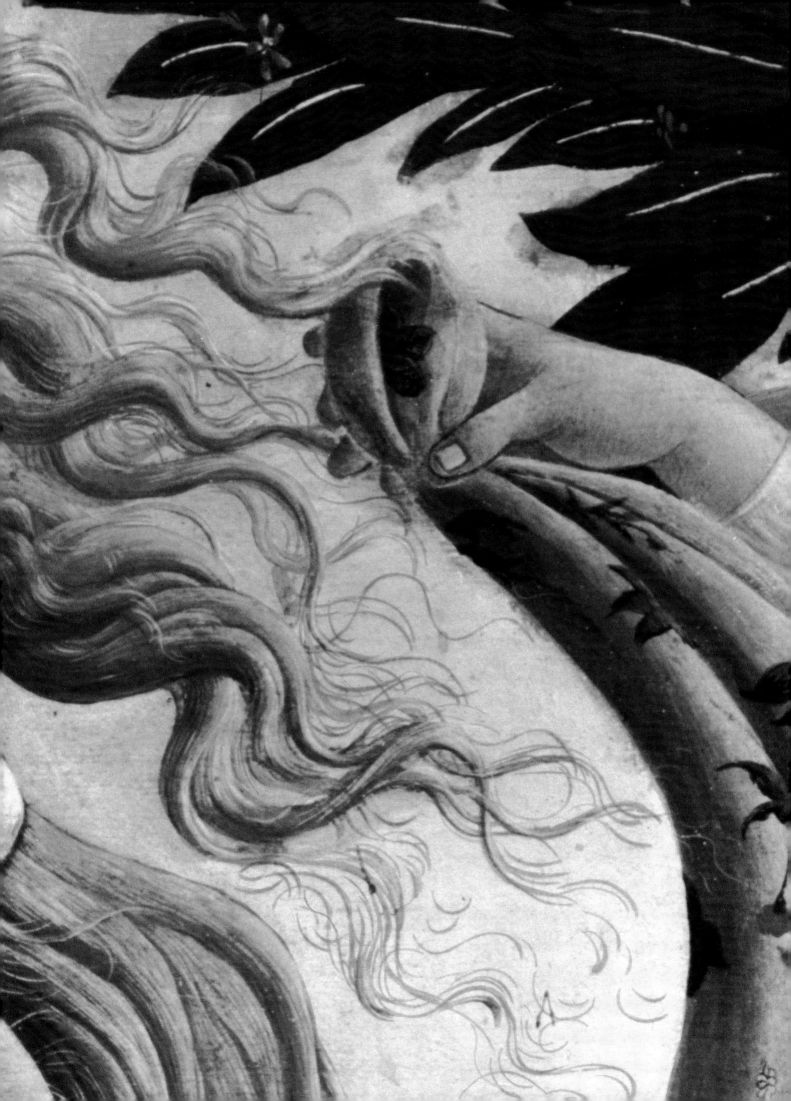

the finest love poems ever written, and by reproducing paintings and drawings in which some of the world's greatest artists have set out with tenderness, compassion or gusto their feelings on the subject of love. While the poems and paintings we have chosen form a personal anthology of our own favourite pieces, they are certainly more than 'just' literature or art; they come as near as any human utterances can come to expressing 'the life force', the extraordinary, delightful and infinitely complex phenomenon of love.

In the end, however, once one stops writing about history and starts talking about 'love' in the abstract, one has to rely very much on one's own experience: on the view from the 'molehill'. So, in addition to presenting others' opinions and attitudes, we have underlined throughout the book the qualities *we* think are essential (not just helpful, but *essential*) to a happy partnership: lack of selfishness, and selfconsciousness; lack of shyness and inhibition, understanding, kindness, a sense of humour and fun. Even in the games section at the end of the book, which is obviously mainly for amusement, a reader may perhaps recognize his own faults or his partner's virtues, or some aspect of a love affair which he has so far missed.

If we are asked what made us think *we* were qualified to talk about love, the only answer is that our experience of love and life together has been extraordinarily happy. This kind of statement can only sound smug, if not dull – it is only unhappiness, like bad news, that hits the headlines. We shall no doubt be accused of being romantics, of showing an idealized picture of love. Well, this is a happy, an 'upbeat' book; we all know that love can tear a being apart, as well as hold two beings together.

But if we have to speak of our own experience, we can only repeat with what may seem boring self-satisfaction that we *are* extremely happy, and attempt to say why.

If we face facts, we have undoubtedly been extremely lucky: in the first place, lucky that we happened to meet – something that no-one can really 'arrange'. But apart from that, we are inclined to think that one of the main ingredients in our partnership has been a shared sense of fun. So many people seem to take love, and life, over-seriously. We hope our own insistence on the *fun* of love comes across throughout the book, and particularly in some of the illustrations and livelier poems. Like pomposity in human beings, no problem within a partnership can survive being laughed at: it simply deflates and vanishes.

We have tried to reflect most of the faces of love in *The Compleat Lover*, and in that we are of course lucky to be writing in the 1970s. Some of the pictures here, and some of the poems too, would doubtless have shocked our Victorian grandparents. Yet how safe and unshocking they seem today, compared with the 'full frontal' approach to love that is now so prevalent in books and periodicals, on stage and screen. In the past two hundred years, the pendulum of taste has swung violently from one extreme to another – from almost total repression to almost total licence. There are obviously some dangers in each position: it seems to us that there is a civilized middle course, and we have tried neither to suppress anything we felt needed saying, nor to say anything with unnecessary or shocking crudity. We know *The Compleat Lover* is manifestly incomplete in the sense that we boast no ambition to include an encyclopedic catalogue of all types of

overleaf: 'In a somer seson whan soft was the sonne . . .'

loving and love-making. But we never intended our book to be a charter for budding Don Juans!

True, we incorporate a gentle guide to the discipline and understanding of the body: but what this book tries to do is *much* more than any love-making manual! There are plenty of sentimental anthologies and plenty of sex manuals on the bookshelves already: we wanted *The Compleat Lover* to be something different, growing out of the experiences of lovers over two thousand years, but yet completely of our own time.

We hope that everyone, whether they are about to scribble a first heart-and-arrow on the wall of a schoolyard, or are planning a golden wedding celebration, will find something in this book with which they can identify: a picture, or a poem, or a passage of prose, which will underline the fun, the romance, the excitement, and perhaps even the heartache, of their own experience.

And whether it sounds smug or not, the best we can hope for every reader is that they find, or have found, someone with whom their life will be as happy and as much fun as ours is with each other.

Derek and Julia Parker

Foxton, Cambridgeshire,
England. 1972

The Story of Love

*The turbulent history of love
from the ancient Greeks
to the present day*

The Forbidden Fruit

Adam and *Eve* by Albrecht Dürer. For Western civilization the history of love conventionally begins with Adam and Eve in the Garden. Without shame, without guilt, they were at one with everything in the created world.

Then they ate of the forbidden Tree – the Tree of the knowledge of Good and Evil – and became aware of themselves as free agents, and the brightness fell away. Self-awareness brought doubt, shame, division of purpose. Paradise, oneness with life, was lost, as we lose it with the end of childhood; only by becoming as children again could we ever regain our primeval innocence. This is how most modern thinkers would interpret the myth of Adam and Eve today. But for the early Christian Church the apple of the Tree of Knowledge was the apple of Carnal Love. Tasting the apple of sensuality Adam and Eve lost for ever, according to the teachings of the Church, the capacity for true, lasting love.

For most of us however, most of the time, the words Adam and Eve conjure up neither version of the great biblical story – they are merely Adam and Eve, the first lovers of all.

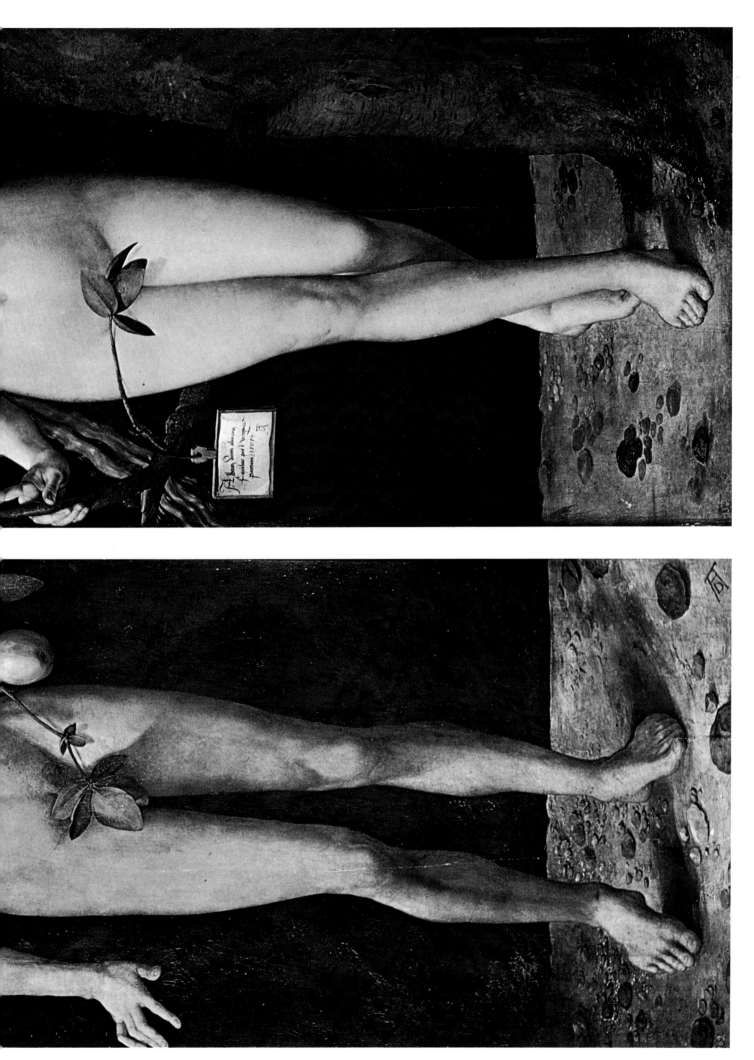

Love in Antiquity

Love is such an elemental feeling. It may arrive without warning as though carried by the wind, taking root without heed of the conventions that men and women usually prefer to live by. Love has been likened so many times to a tornado, a summer storm, a whirlpool or some other event of irresistible power that in the language of romance men and women have come to seem frail victims in its path, unable to withstand its engulfing presence.

Perhaps we enjoy the idea of being overthrown, the threat to what we fondly call our innocence. Even the most assertive of people are prone to relish seeing themselves in the role of the innocent, flung this way and that in a trance-like agony of pleasure and uncertainty. It is all, of course, part of a game, if at times a deadly serious one. Lovers without their blissful deceptions would scarcely qualify as lovers at all.

For the Ancient Greeks, love was very much a game. And their pantheon of lusty gods faithfully mirrored the outlook of the society that created them. If Zeus, the God of Heaven, could spend so much of his time arranging the mechanics of his affairs with beautiful mortals – ravishing Danaë in a shower of gold, or carrying off Europa in the shape of a white bull – then why should mortals be denied similar pleasures? The young Greek looking for such love found it in the arms of a succession of courtesans. Aphrodite, the goddess of physical love, was worshipped throughout Greece as the mistress of all things, vegetable, animal and human. Meanwhile, according to legend, her son Eros, the god of romance, had been romping about heaven and earth since the beginning of the earth itself. His wings took him swiftly from lover to lover; arrows flicked from his ready bow to wound the most unlikely of mortals with the sting of love. 'He whom thou touchest straightway runs mad', wrote Sophocles (c. 496–406 BC); and Eros was even ready to edge his mother, Aphrodite herself, into the most ill-considered of entanglements.

But if, in Greece, love was the most enjoyable of parlour games, it was not a game to be played with a possible future wife. Marriage was, in fact, a kind of business transaction in which the interests of the woman's parents and those of her prospective husband were of paramount importance. As one of Xenophon's characters remarks to his new wife:

> We could easily have found someone else to share my bed. I'm sure you recognize that. But after thinking it over, I in my interests and your parents in yours, and reviewing all the possible candidates for our household management and the care of our children, I selected you and your parents myself.

Indeed the role of women, aside from those courtesans who were at the top of their profession, was wholly lacking in promise. Deprived of any worthwhile education or of independence of action, women were reduced to the drudgery of organizing their husband's domestic comforts.

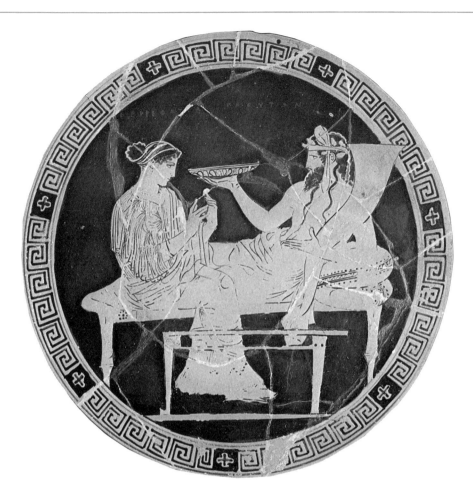

Because their wives made such indifferent companions, men turned to each other for love relationships. Much of the romance, the fervour of love which men could not express otherwise was poured out to boys, and is enshrined in poetry, in carvings, and in historical texts.

In due course, as the centre of Western society moved to Rome, women became more accepted in society. But it was a slow and gradual process before man's respect for women had risen to a point where love as we would understand it today could take its place in marriage.

Was there, then, no classical golden age of love, no ideal vision through which the love of man for woman was celebrated? A great many ideals, it is probably true to say, were realized in myth alone, and not in reality. And yet there are so many delightful fairy-tales in the literature of antiquity, so many romances and happy endings that it does seem as though, beneath the hard everyday veneer of arranged marriages and kept women, the Ancients had a sense at least of the joys which their unequal society denied them.

Perhaps this short extract from the story of *Daphnis and Chloë* may serve to represent the purest essence of romantic love as it was conceived in the age of the Greeks. 'Love, sweet Chloë, is a god, a young youth, and very fair, and winged to fly. And therefore he delights in youth, follows beauty, and gives our phantasy her wings. His power's so vast; that of Jove is not so great. He governs in the elements, rules in the stars, and domineers even o'er the gods that are his peers . . . There is no medicine for love, neither meat, nor drink, nor any charm, but only kissing and embracing, and lying naked together.'

A Greek dish showing Persephone banqueting with Hades, the god of the Underworld. Persephone was the daughter of Demeter, the goddess of fruit, crops and vegetation. While picking flowers with her friends one day, she found herself alone in a field of blue flowers. Tugging hard at one particularly beautiful one, she pulled up its root, and a yawning gap opened in the earth. Hades saw Persephone as he drove past in his chariot, and, falling in love with her, carried her off to live with him. The distracted Demeter searched the earth in vain for her daughter. Finally, at the intercession of the other gods, Persephone was allowed to return to her mother provided she had eaten nothing while imprisoned in the land of the dead. But she had eaten six pomegranate seeds, so she was allowed to return to earth for only six months in the year.

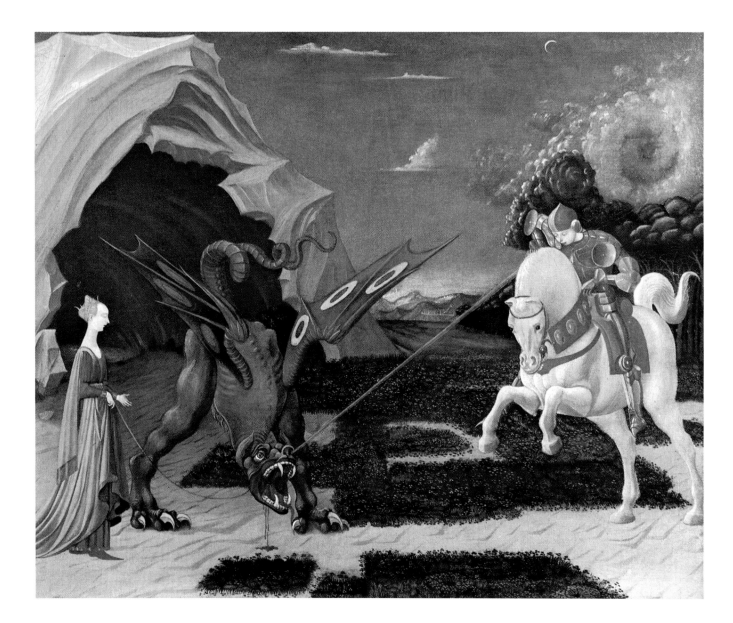

above: A chivalrous knight comes to the rescue of a damsel in distress in *St George and the Dragon* by Paolo Uccello.

opposite: 'Outside the courts, love was decidedly more natural . . . the woods and fields throbbed with the cries of large-eyed country girls and the triumphant laughter of their young men.' (Detail from *Fête de la Libération* by Bauchant.)

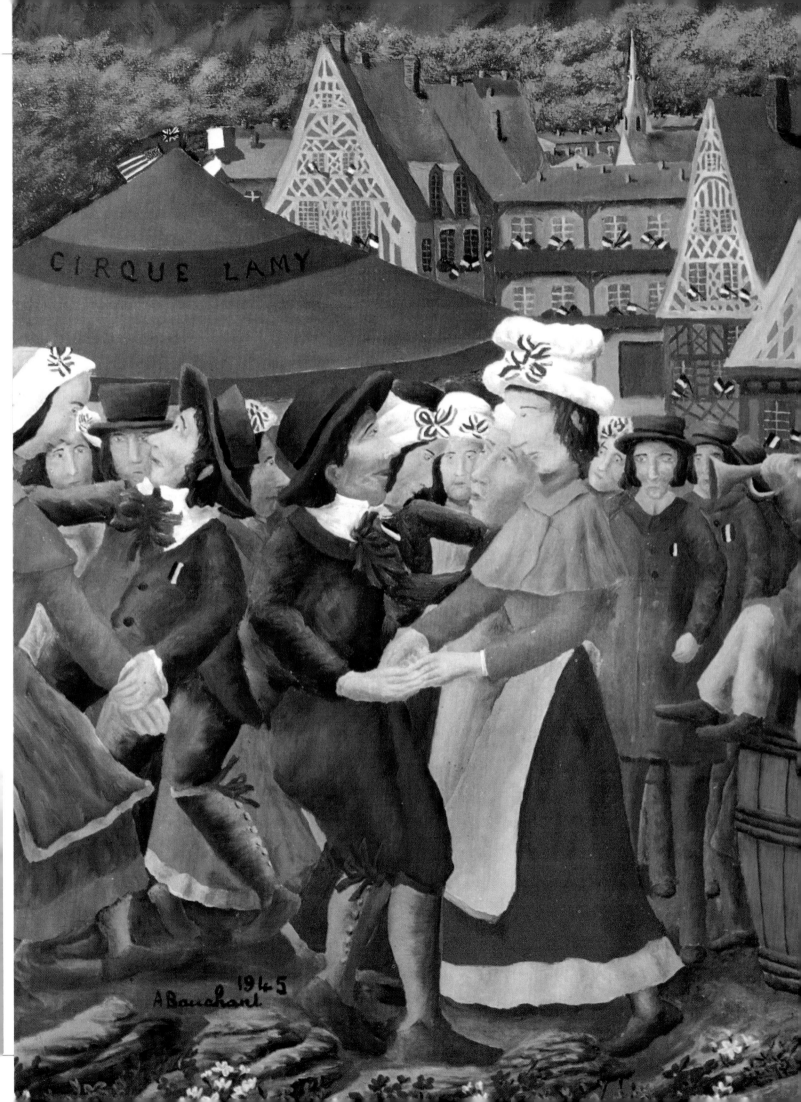

Love in the East

The Spirit of Eden, if it dwelt anywhere, did so in the Far East. In ancient China life was simple and full of gaiety. Chinese poems, for instance, tell of girls and boys encouraged to meet, to dance on the banks of the river and freely to pledge their love. In India, the *Kama Sutra* of Vatsyayana encouraged young men to conduct their courtships with tenderness and grace, gathering flowers with their girls, writing them glowing love-letters, and finally making a *gandharva* marriage in which both partners had a full say in their commitment to each other.

But later things began to change. Confucius (the St Paul of the East) made known his feelings on the subject of woman, whose duty, as he saw it, consisted simply in 'obedience'. In childhood she obeyed her father; in marriage, her husband; in widowhood, her son. Then she died, as unobtrusively as possible. A little further west, in India, the Hindu laws of Manu pointed out that 'a woman whose mind, speech and body are kept in subjection, acquires high renown in the world, and in the next, the same abode with her husband'.

In many schools of Buddhism as in Christianity, woman as a sexual creature was connected intimately with the sense of sin, and any sensuality in her was to be properly rebuked. And the idea of sensuality as a means of demonstrating the love of woman for man, or of man for woman, in or out of marriage, simply did not exist.

Just as, in Greece, men had courtesans to resort to, so in the East there were respected classes of prostitutes: the temple prostitutes of India, and in Japan the Geisha, who lived in luxury and were accomplished not only in sensuality, but in singing and dancing and conversation.

A principal difficulty in discussing 'love' in the East is that since antiquity, the tables have nearly always been turned: the functional aspect of sex, procreation, was of paramount importance. Love, if one was fortunate, followed a marriage; it was certainly not considered before the ceremony. A Japanese legend tells how a god and goddess, after centuries of innocent celibacy, suddenly discovered how to make love – and then gave birth to the whole world: man, woman, fish, fowl, sea, plain and mountain. By comparison with that performance, which resulted from the discovery of *sex*, what did love matter? What mattered more was the fusion of the principles of *yin* and *yang*, the male and the female: with what emotions that fusion was accompanied, seemed immaterial. This principle naturally led to the Confucian idea that, if the purpose of sex was to produce children, and if it had no place of any real importance in life other than this, then one could theoretically decline to have anything to do with it unless for the purpose of procreation. Making love thus became not only inessential, but was declared positively dangerous, leading to a loss of health and a weakening of intellect.

Hinduism, on the other hand, embraced a wide-ranging variety of beliefs and practices. Some branches of the religion took the line that it should be possible to achieve a life in which asceticism and sensuality were perfectly balanced: men vowed to continence lived in temples

alive with the carvings of erotic artists; boys were expected to remain completely celibate until at least after they had finished their studies; sex was permitted inside marriage. Manu was not quite as strict on the subject of sex as Confucius: 'Let not a man, from a selfish appetite, be strongly addicted to any sensual gratification. . . In caressing women there is no turpitude; for to such enjoyments men are naturally prone; but a virtuous abstinence from them produces signal compensation.'

Other branches of Hinduism, especially those influenced by Tantric thought, attached special importance to woman and to sex. Physical love was regarded as an art and a ritual, a joyful religious act in which the human act of creation mirrored the divine creation. Woman was seen as the receptive creature embodying the divine principle of 'insight-wisdom'; man embodied the creative, dynamic principle, and the sexual union of the two represented the ultimate unity, celebrated in erotic temple carvings all over India.

Yet, for the most part, love as we would recognize it has been absent from the East for the past two thousand years. This may be partly as a result of the lowly status of women, but it is perhaps mainly because of the importance attached to the procreation of male children. This was too important a matter to be left to lovers, their eyes muddied by romance. It was seen to be safer for elder relatives, helped by astrologers and advisers, to arrange a marriage, and for the bride and groom not to meet until the ceremony – a practice which still prevails today: Indian newspapers carry regular advertisements, inserted by parents, for possible partners for their sons or daughters.

There was, and still is, however, a saving grace; the chance of love *after* marriage. Thus, in the months after marriage, a husband might court his wife as ardently as a boy experiencing his first love. Savitri Devi Nanda described how 'the wedded ones court each other slowly, by pleasing, and by giving and taking happiness. Each seems only to look upon the lovely things in the other, forgetting or not seeing the unlovely things. Thus in time they mould each other to the one common way, which is their way of life. Once given, the love of a Hindu girl can never be taken back.'

This still seems a strange idea to Westerners, but one that they might profitably listen to. How many marriages, after all, tend to grow stale when a young couple's relationship moves from the violence and lushness of spring to the stillness of summer, faltering as familiarity dulls the senses? It will take a few centuries for East and West to be reconciled on this theme. But we notice – from our experience of Eastern films and literature, and from what we see around us in the West – that as the world grows smaller, the face of love is beginning to wear the same expression all over the world; and it is an expression on the whole of tenderness. The pendulum, having swung violently between two extremes of sensuality and celibacy for three thousand years, is perhaps slowing down to a regular middle beat.

overleaf, left: A detail from *La Perspective* by the eighteenth-century French painter Jean Antoine Watteau, showing a group of decorous lovers playing music among the trees.

right: Love played according to the rules, within the safety and conventions of the middle-class family. (*Le Déjeuner dans un Jardin à Villeneuve-sur-Yonne* by Edouard Vuillard.)

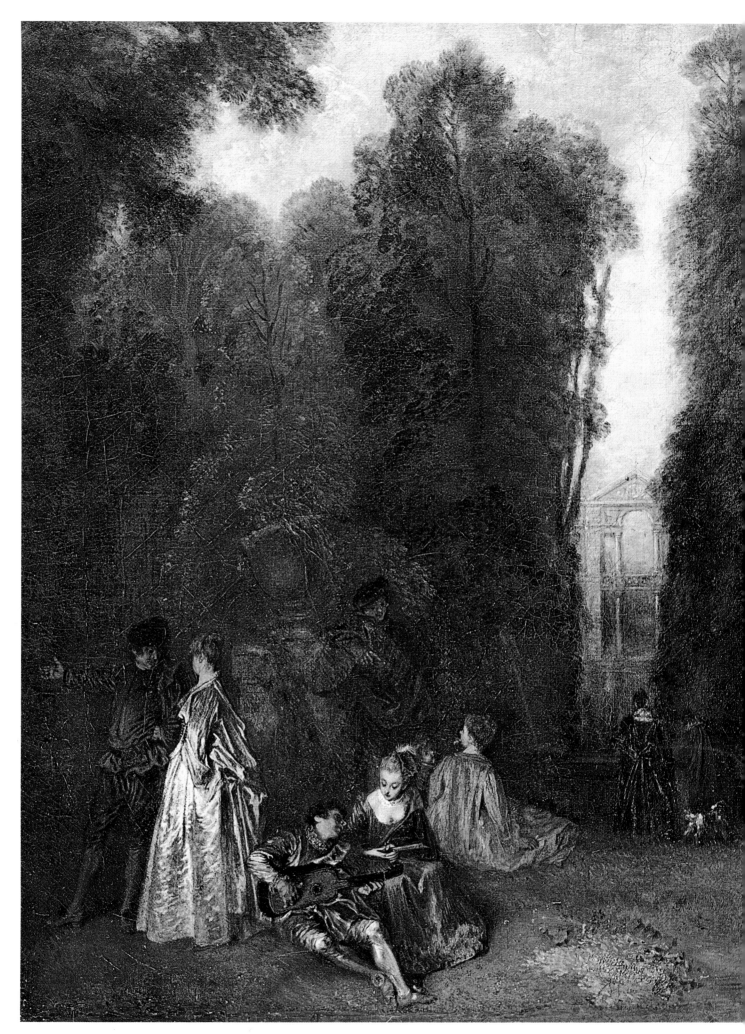

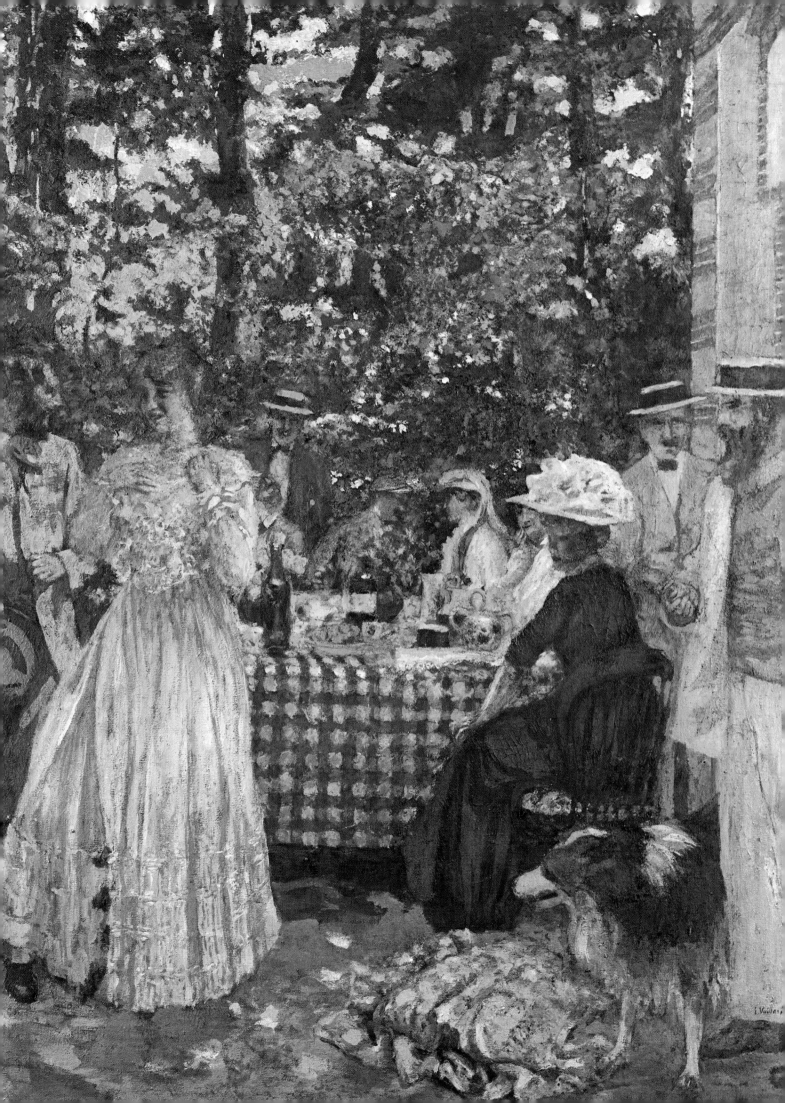

Onward to Eden?

From the repressiveness of the Puritan era in the West, the pendulum swung with great gusto in a very different direction. With the founding of Versailles in 1661, Europe witnessed the birth of 'polite society', an innovation which greatly strengthened the position of women, as well as prescribing new standards of behaviour for the people at large.

Some of the results of the cult of refinement were not without their comic side – in Paris, in the late seventeenth century, in London in the eighteenth, the aristocracy even walked in a stylized balletic fashion. And there were other excesses of preciosity such as a map drawn up in total seriousness by Mme de Scudéry (1607–1701) and published in her novel *Clélie*. The map is called the *Carte du Tendre* (Map of Tenderness) and it charts the progress of a slender river from a town labelled New Love past another called Tenderness; the river then debouches into the Sea of Danger, strewn with jagged rocks. On either side of the river stand small hillocks named after emotions and stages of love: there is Billet doux, Billet galant, Generosity, Respect, Probity, Obedience, etc etc. To one side of the map yawns the Lake of Indifference, on the other stands a boiling Sea of Enmity.

Despite such excesses of preciosity, civilization was undoubtedly set on a fresh course. Gentility was revered in men, and a new morality was formulated in which philosophers and poets came most to respect the *honnête homme*, the decent man, moderate and tolerant in his views. After the excesses of arduous wars and the Inquisition this was a major step forward. It was also in many ways a concept ideally suited to the rising middle classes. However, this was not altogether good for love. What every woman of spirit most enjoyed was not an *honnête homme* but some-one much more exciting, a dark-eyed rebel in the Casanova mould who would sweep aside the conventions and avidly transport her to wherever in her imagination she most wanted to be – to Rome, the Far East, a couch behind locked doors, or even a nearby forest. And so, behind the ideal flourished a rather different practice.

These were the first ages of the 'beautiful people', and of the beautiful hostess to whose salon and masked balls the entire capital feverishly sought to be invited. Once there, desirable partners were to be met, looks exchanged and secret notes pressed into gloved hands. The nature of the chase was irrevocably changed. It had become an urbanized and highly polished procedure, and it gave women an altogether firmer say in who should have his way with them – and who should be cast aside to declaim his agony on some lonely shore.

There were, of course, strict conventions to be observed: all forms of relationship were condoned providing they remained invisible from public view. Breaking the rules might involve the trespasser in severe penalties – a duel, imprisonment, a ponderous and costly lawsuit. But successful lovers would seldom begrudge their loved one a three-hour wait in a darkened coach beneath the trees – if their passion were then to be fulfilled. Giacomo Casanova (1725–98) flourished in a secret under-

world of his own making, lying hidden for hours in cupboards and behind curtains, and, on one occasion, waiting in vain all night on a rat-ridden back staircase. Refusing to admit failure, he returned the following night, waited several more hours – and was granted his triumph! The idea, incidentally, that women did not enjoy sex was not much in evidence before the nineteenth century. It was then widely put about in order to maintain appearances among the bourgeoisie, and to discourage young girls from trying too much too quickly and so bringing possible disgrace on their families. Up till then, however, it can safely be said that sex was the agreeable lubricant of every civilized society.

The nineteenth century saw a widespread tightening up of morals; the church spoke out strongly against the sins of the flesh. Suddenly ashamed of themselves, the men and women of the nineteenth century began to see indecency everywhere. Statues were draped, even the legs of tables and piano stools had to be covered. Any physical contact that there might be in marriage was widely regarded as an unpleasant duty for the woman and as an insensitive need for the man, to be controlled as far as possible.

But the hypocrisy was transparent. Victorian women, baring their upper breasts, whitening their skins, drawing in their waists, did everything in their power to make themselves as seductive to their menfolk as

'Today there is an ever-increasing recognition of woman's right to live, work and love as an equal.' Mistress of her own destiny, the elegant owner of the glamorous open car and the pedigree dog is free to decide whether or not she needs the man. (*Photograph by John Hedgecoe.*)

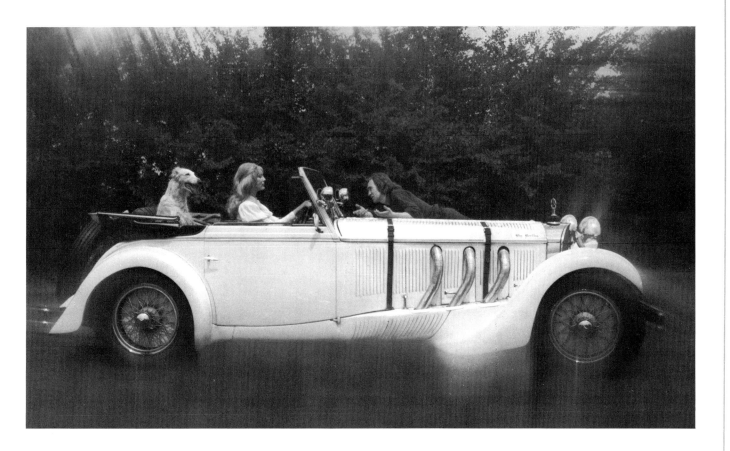

possible. The men, paying lip-service to the conventions, kept mistresses, haunted the stage doors of the music halls. And families were larger than any before or since . . .

And so we come to the infinitely more relaxed attitudes of the present day; the veil of hypocrisy has been cast aside; physical love is recognized as an integral and fulfilling part of a relationship. And, perhaps more importantly still, there is an ever-increasing recognition of woman's right to live, work and love as an equal. If the gates of the Garden of Eden have remained shut for so long that the lock seems to have rusted, then in a sense man only has himself to blame for his persistent denial of these rights. For there can be no real partnership where there is no equality. Courtly life set the pattern in former times but was almost exclusively a game for the rich. Women of the upper classes habitually enjoyed power of which lowlier women could only dream.

Quite suddenly, since the end of the nineteenth century, man has begun to recognize this. A woman no longer has to accept that her place is 'in the home' – unless that is how she wants it. A woman no longer has to wait for the man to make the first move, in any situation. Slowly (and revolutions take time if their results are to be enduring) she is moving away from a position of complete submission to a position in which she will be truly free. When she has settled into that position, the gates of Eden may even creak open. And this time we can all enjoy the apple, the serpent will have vanished, the sunshine will be real.

Falling in Love

*The sudden surprising realization
that of a hundred thousand
people, it is* one
who matters

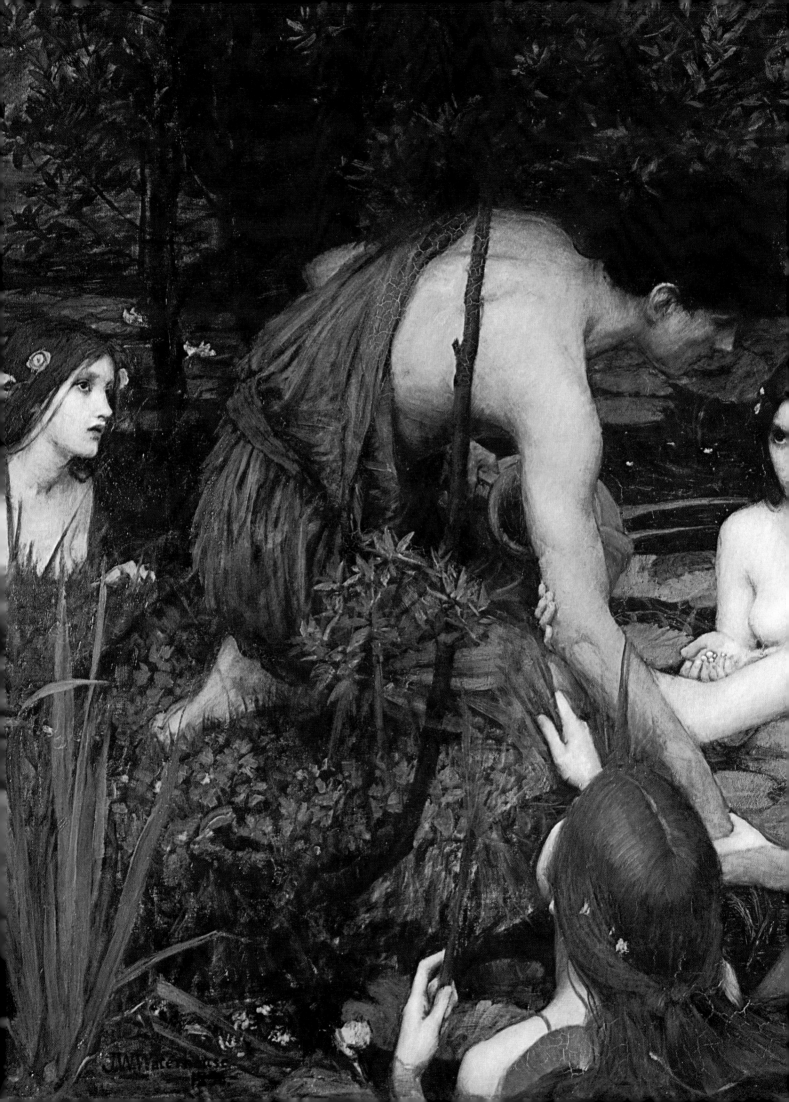

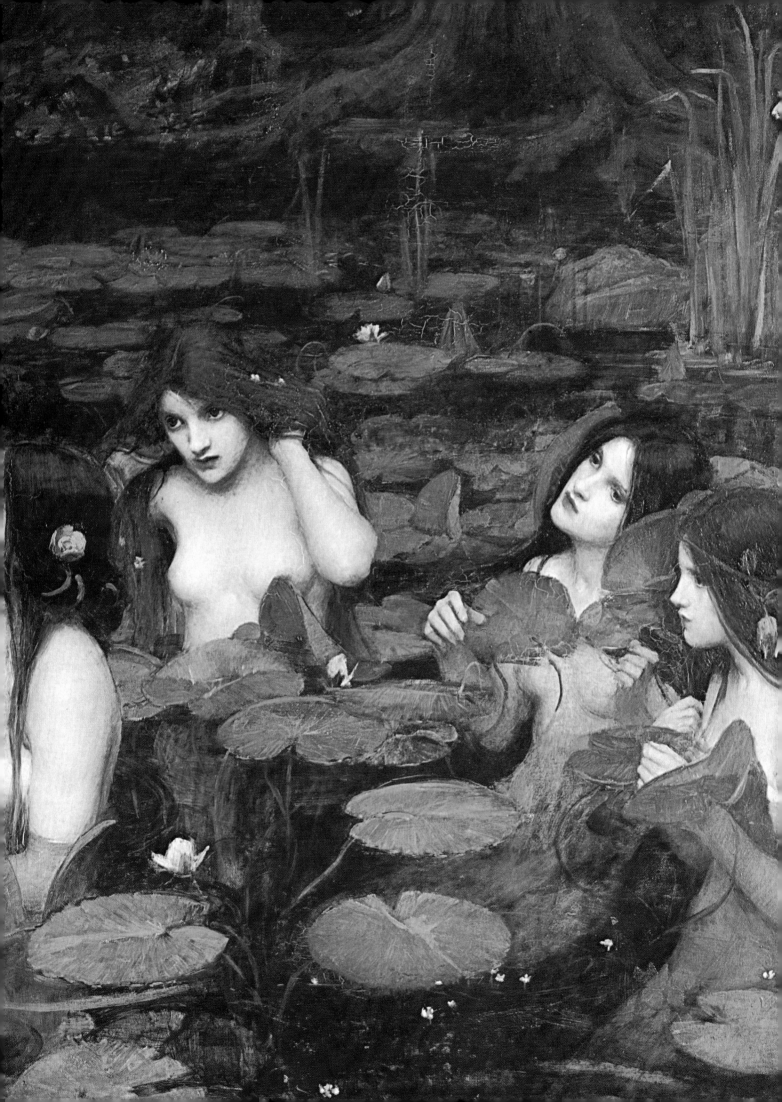

Young Love

Many people say that 'first love' is different from any other. But it is not. A boy of sixteen can be in love with all the passionate purity of a Dante, with a girl to whom he has never spoken. At the same time, he can be discovering the first pleasures of physical love with quite another girl. Or, reaching out automatically for any girl to take out, he can be surprised to find a new sensation stirring within him – a feeling which seems to have nothing to do with kissing and touching, but a longing simply to be in the same room as her, to exist in her presence.

No-one who remembers their teenage years will easily forget the idealized image of their first 'true love'. Young love is the dream of eternal love, of a love softly wandering through sunny fields of growing corn; the dream of hands and eyes that will hold us in them until a final kiss; the dream of a shared affection that gradually strengthens with the years; the dream of a lifetime fulfilled, of deeds achieved, memories treasured, lives created, and shared. Young love is all these things; but love, young, is rare.

Even in wiser years love rarely proclaims itself. Often we imagine ourselves immersed in a love so strong that its end is impossible to see. And just as often such love fades like a morning mist. So how in our youth can we possibly know the heights and depths of love? Yet Romeo died for his Juliet, and she for him. The tenderness of a young boy for his girl and her care for him can be remarkable, and hold lessons for adults. But the stirrings of the body are often very confusing. Many girls are physically mature at thirteen years, young men are often most sexually potent before they are twenty. Yet some adults still tend to discourage emotional relationships between teenagers; even at co-educational schools the fourteen-year-old boy and girl are expected to be unaware of each other except as class-mates. This has two results: the shyness in admitting love, which parents may have remarked is silly at their age; and a secret discovery of the facts of sex, a discovery which is often tinged with guilt and even shame.

As time goes on, and we know more about the working of men's minds and bodies, it is evident that the basic procreative instinct is combined with a mass of other factors – natural intelligence, particularly, or the home conditions and social situation of the partners. The conventions of the group in which the individuals find themselves more often than not strongly condition their attitude to love, especially to a declaration of it. Many misunderstandings, and much sorrow, have arisen because one or other partner is too shy, too worried, or sometimes too selfish to commit himself. Warm friendships have foundered when a boy says, 'I love you' and a girl makes no reply, or a girl's devotion goes unrecognized and unreciprocated in however small a way. To open oneself in a gesture of friendship or love and to be received in apparent coldness, through fear or diffidence on the part of the other person, can induce a sense of foolishness and impotence which it will take a long time to dispel.

The physical signals the body gives out when a boy sees an attractive girl, or *vice versa*, are no doubt in part the signals it was trained to make when man was still an ape, and the urge to procreate was above all vital to the survival of the species. As man becomes more sophisticated and complicated, the basic procreative instinct becomes mingled with a mass of other factors, and inevitably confusion results, both among young people awakening to physical love and in the minds of adults, the 'older generation'. One of the main reasons for this confusion is that scarcely any civilized country has yet worked out a proper system of sex education – much to our shame. Whereas Margaret Mead, in her famous book *Sex and Temperament in Three Primitive Societies* outlines methods of sex education among people we might misguidedly call 'savages', which are natural and right.

Ideally children should learn about sex as early as possible, and at home. But a recent survey in England revealed that a quarter of all boys and a third of all girls felt they should have been taught more about sex by their parents; most boys and girls felt they should have learned more about it at school; and almost all of them agreed that adults seemed to think they should be able to find out about sex for themselves – while discouraging them from the means of doing so. By the time one is capable of making love, one obviously ought to know the facts of life. There is no evidence at all that sex education leads to promiscuity: indeed there is evidence to suggest that ignorance or a scant knowledge of the workings of sex leads to greater sexual activity as girls and boys follow their own strong instincts, their desire to experiment, without having learned of the social consequences.

It is foolish to suppose that love and sex can be completely divorced; recognition of one implies the presence of the other, and if love is sometimes absent from sex, the opposite is practically never true. The relationship between them is so mysterious that adults, let alone adolescents, can scarcely comprehend it. It would certainly appear, however, that the child who grows up afraid of sex, or shy of expressing the spiritual side of love, is unlikely to be happy in his adult relationships. But love is so entirely personal an affair that it is presumptuous to lay down rules. Even as adults we can say little that is definitive about love. It affects some people one way, others completely differently. Some may search desperately and rarely find it; others may find that they seem to 'fall in love' constantly. And each experience can be as truly love as the other.

'Young love' may well be a traumatic experience, whenever it comes. But if we seem to make heavy weather of an experience poets praise as idyllic and crystalline, it is because it is too important to lie about. Young love deserves our respect, our concern, our sympathy, and the best chance we can give our children of finding true love – lasting, permanent and satisfying love – is by transferring to them our own sense of pleasure and delight in it.

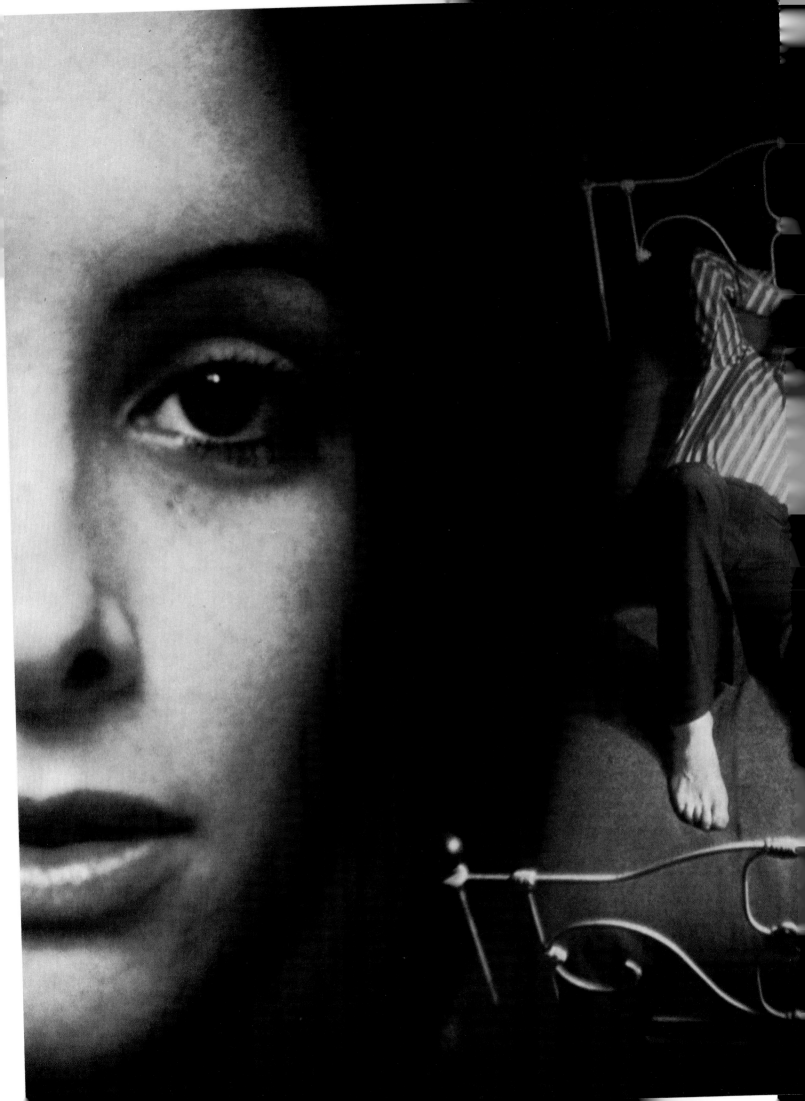

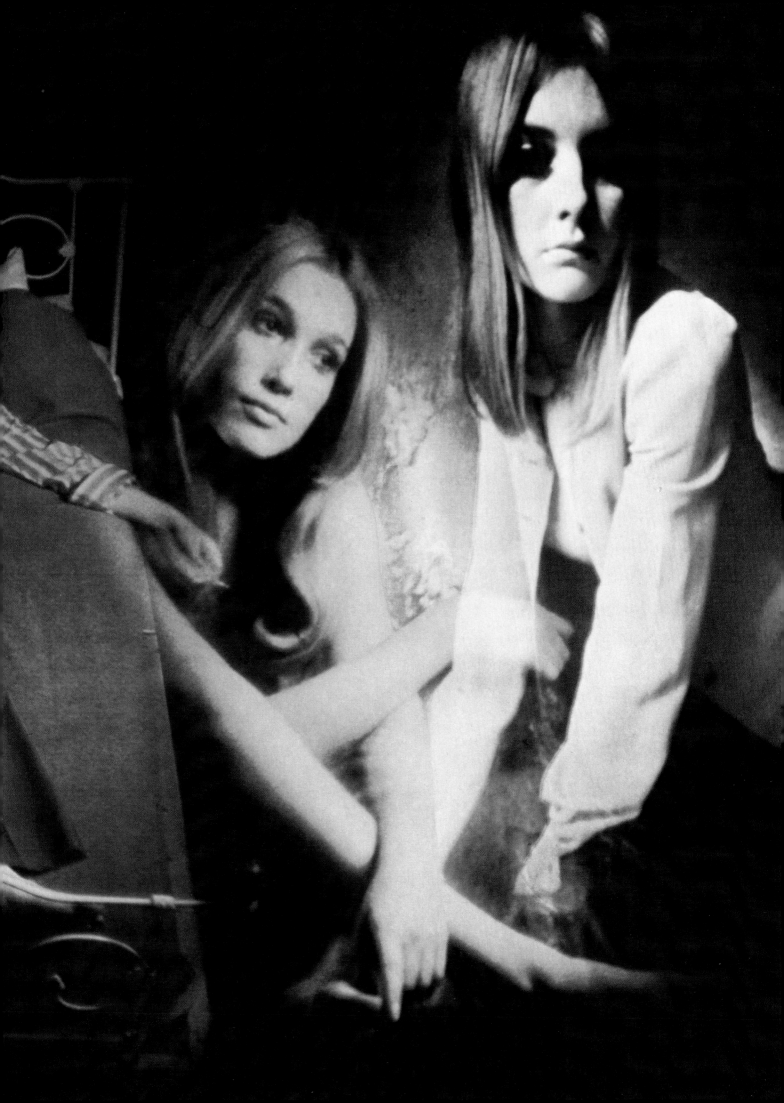

The Search for Love

The ways of conducting the search for love are as innumerable as the forms of love itself.

The lazy way (or perhaps the way of mild desperation) is through an agent: and the newspapers and magazines have always been a help. Today, most periodicals, hippy or stately, glossy or pulp, carry advertisements phrased in more or less polite terms, announcing that a Miss A seeks Mr B, for any one or more of several motives; as in the advertisement which appeared in an English provincial newspaper in 1972: 'Lady with long grass wishes to meet gentleman with power mower; view also friendship'.

An advertisement, a marriage bureau, an astrologer (much used in India, where a notice might say: 'Alliance sought by rich young businessman worth six figures, with beautiful vegetarian Brahmin girls; reply with horoscope'), or a computer dating system, all provide opportunities for the vital first meeting – hopefully with someone compatible. Sometimes, indeed, *too* compatible. Fed with details of hair colour, height, religion, personal tastes, a dating system in London went into full swing, and after much cogitation came up with a date for one man. Having waited at the meeting place for two hours, he telephoned the agency, to discover that he had been paired with himself. Another man found himself at a meeting with a six-foot, slim, intelligent blonde – of his own sex. A beautiful friendship resulted, but was not precisely what either had in mind.

Where one may meet a prospective lover depends on a number of factors – not least, the social climate. Parents who worry about their children dating at pop festivals or meeting on some protest march, might bear in mind that in another age they could well have met for the first time in bed. In the Middle Ages in France, for instance, it was a custom in many villages that on a certain evening in each week the single girls left their bedroom doors or windows open, and any eligible young man might come in, 'to lie all night talking and playing' – though any extensive love-making was frowned upon. Bedrooms in those days were not lit, so the face you found on your pillow in the morning might be a nice surprise, or otherwise.

The custom was not strange to England, even as late as the 1840s, when the Rev. William Jones, Vicar of Nevin, in Wales, complained that he could not keep servants unless he agreed to them entertaining their particular friends in their beds.

But most people in the villages and small towns of Europe met their lovers out-of-doors:

> Among the acres of the rye
> The pretty countryfolk do lie

and 'many a squire's daughter has clambered over hedge and stile to give a rampant jump into the arms of a jolly young haymaker or ploughman', wrote one historian in the 1880s.

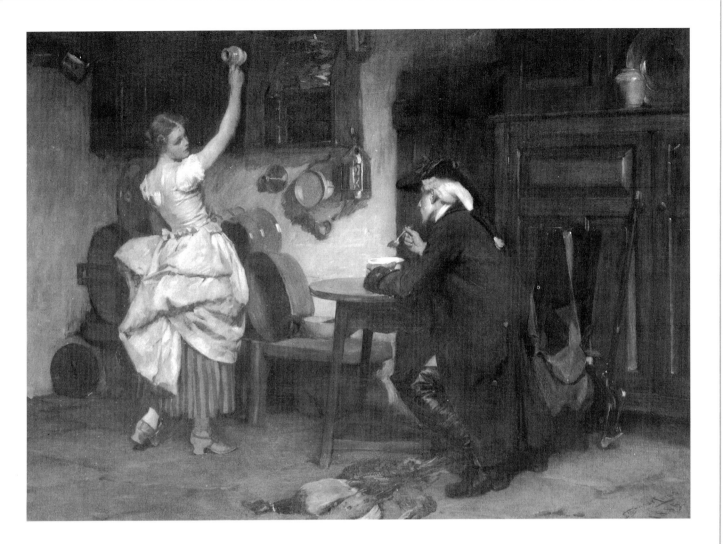

Flirtation by John Seymour Lucas.

In town, when houses had few private rooms, or were full of prying servants, the mazes, arbours and bowers of large private (or public) gardens provided secluded corners for assignations. In Restoration days, Greenwich, Vauxhall and Ranelagh Parks were extremely fashionable and popular: it was at Ranelagh that the elderly Lord Carteret was introduced to his young bride, and was seen 'all fondness, stopping every five steps to kiss her'.

The theatre, and even the church, was considered a very proper place in which to keep one's eye open for 'the beautiful fair'; Ben Jonson pointed out in one of his plays that if one wanted to meet beautiful young women, one should go where they were likely to be – 'to courts, to tiltings, public shows and feasts, church, and sometimes plays. In these places a man shall find out whom to love, whom to play with, whom to touch once, whom to hold ever'.

And it is still true that only a tiny minority of people need the excuse provided by the computer or the advertisement: chance is enough for most of us; when we see a girl or a man who is particularly attractive, in a train, or a park, or a street, or at a party, it is usually possible to arrange an exchange of a few words – to place the tip of one's toe in the water, so to speak, and take the temperature. Often the water is merely tepid, sometimes icy cold. But occasionally it scalds, and life will never be the same again.

overleaf: 'Among the acres of the rye . . .' First meetings as we may imagine them are seldom as romantic as this. (*Photograph by John Hedgecoe.*)

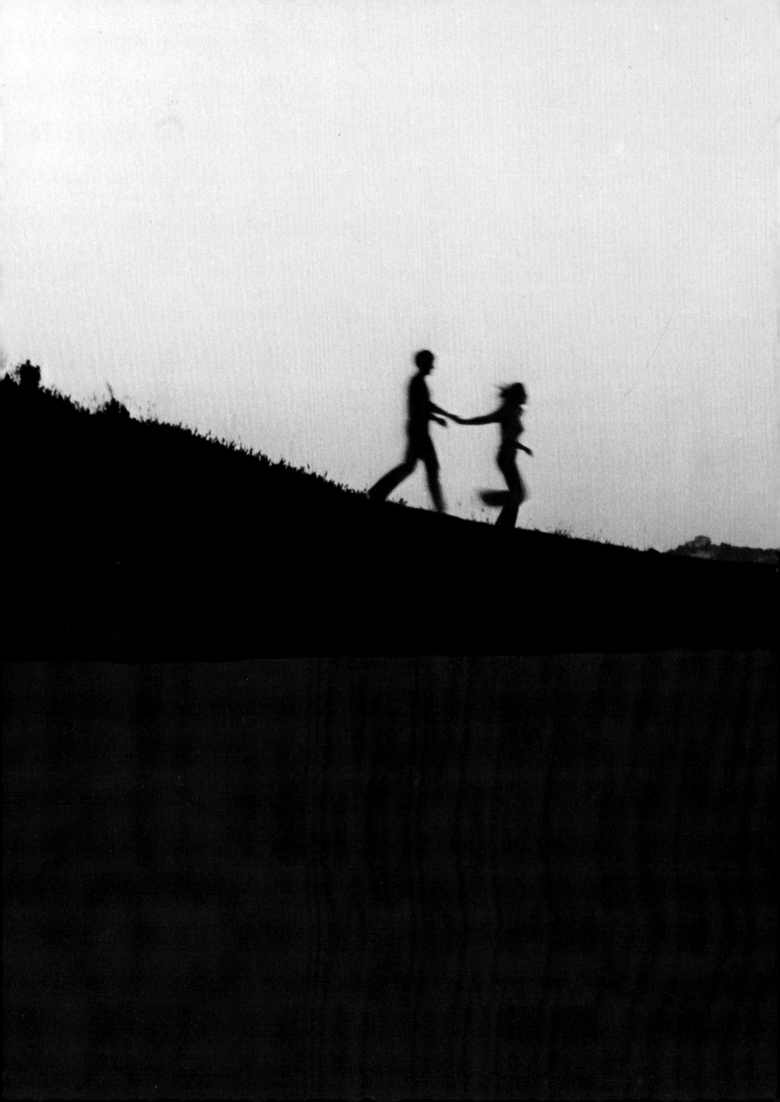

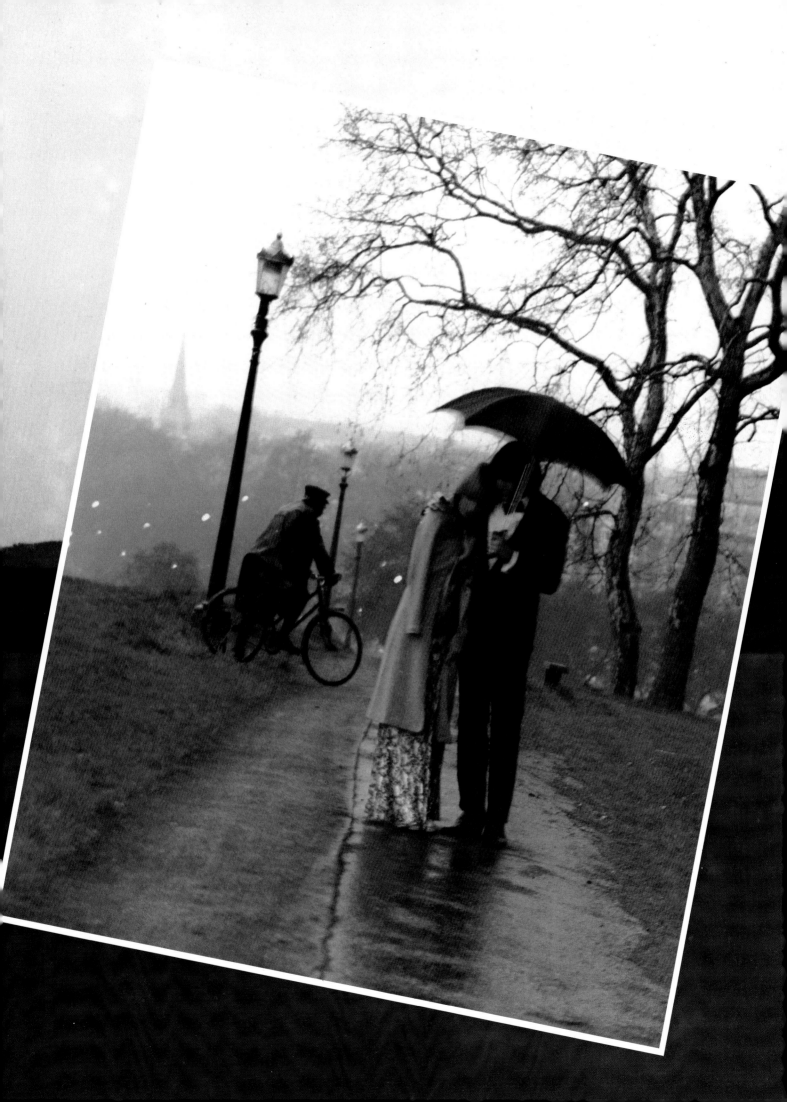

The First Meeting

How many thousands of ways there are for a fateful first meeting to occur! By chance or plot, by formal introduction or by being thrown together, there is scarcely a circumstance or situation which could not provide the setting for a meeting to which two lovers look back with nostalgia, amazement, amusement, or simple affection. Many times, too, we don't even know it has happened until days or weeks after the event. Sometimes the first glance can tell all, and seal a union as firmly as any ceremony ever performed.

One royal meeting was as happy as anyone could wish: introduced to Prince Albert as a possible suitor, Queen Victoria was in little doubt. She found him 'so charming, and so excessively handsome, and such beautiful blue eyes and exquisite nose, and such a pretty mouth with delicate moustachios . . . a beautiful figure, broad in the shoulders and a fine waist'.

But her predecessor, the Prince Regent, had not been so fortunate: although he loved Maria Fitzherbert from the moment he saw her on the arm of a friend outside the opera house, the facts remained that she was a Roman Catholic, and he was the heir to the throne and to the leadership of the Church of England. Their marriage was never officially recognized, but he loved her until he died. And while Nelson and Emma Hamilton were attracted to each other at their first meeting, she was after all both the wife of a distinguished British Ambassador and a lady of no extraordinary virtue – on neither ground a proper match for a hero (who himself was married). They let nothing stand in their way, however, and their affair was one of the most famous in history.

Sometimes a first meeting passes without incident, the occasion going by without a hint of a love match remotely approaching the heads or hearts of either person concerned: as when Tolstoy, dining at Pokrovskoye-Streshnevo with his old friend Lyubov Behrs, was served at table by her eleven-year-old daughter Sonya, little thinking that six years later that little girl would become his wife.

And while love may grow from nothing, or announce itself with a violent clash of cymbals, some lovers, meeting for the first time, react very coolly indeed. When John Keats met Fanny Brawne, for instance, he found her beautiful 'but silly, fashionable and strange . . . ignorant, monstrous in her behaviour, flying out in all directions, calling people such names that I was forced lately to make use of the term Minx'. Yet within weeks, he was writing her some of the most impassioned love letters in the English language.

And in one of the most celebrated first meetings in fiction, in Jane Austen's *Pride and Prejudice*, Mr Darcy appeared to the heroine Elizabeth Bennet 'the proudest, most disagreeable man in the world'; while he found her 'tolerable, but not handsome enough to tempt *me*'. Jane Austen knew human nature: very often the first reaction is one of distaste – sometimes for the very qualities which later seem admirable; sometimes for traits of personality which have to be tactfully curbed!

Of course, a meeting can take place before lovers are introduced, or introduce themselves: an intuitive awareness of each other is the most effective of all introductions – the exchange of glances across a room which is not just a device of the romantic novelists, nor just wishful thinking, but can be an intense instant of contact which can compel an immediate reaction or stun us into delighted amazement.

If that glance is the very opposite of magnetic – a purely dismissive one such as Mr Darcy gave Elizabeth at the ball – it may be months or even years before the awareness of love grows, through a slow attraction: 'I cannot fix the hour, or the spot, or the look, or the words which laid the foundation', Mr Darcy was to say later, when Elizabeth asked him when he came to love her: 'I was in the middle before I knew that I had begun'. But the first meeting will always be remembered, for this one thing is certainly true of lovers' first meetings – that neither of them will ever forget it.

And as for the occasions: they too can scarcely be catalogued, they are so varied. They can be completely accidental: Byron, whose capacity for loving was generous to the point of indiscrimination, met his last and greatest love, the beautiful young Countess Guiccioli, at a party to which they had both gone with the utmost reluctance, and only out of politeness to their hostess.

Then of course there are the calculators, the handkerchief and glove droppers, the men and women who engineered first meetings with great care: like Isabella Harvey, who was leaning from her window in Kensington one afternoon in the early 1660s, and saw the Earl of Sussex passing in brilliant procession below, his handsome young son Sir Humphrey among the company. She dropped her glove at the feet of Sir Humphrey's horse; the knight speared it with his lance and lifted it high to her window; soon afterwards they were married.

And sometimes true love begins under unpromisingly businesslike circumstances. A newspaper of 1754 printed an advertisement from a suitor which somehow has a genuine tone:

'If the beauteous Fair One who was in the front boxes at the play *Romeo and Juliet* last Wednesday night dressed in a pink satin gown with a work'd handkerchief on, and a black feather in her hair with bugles; also a black ribbon round her neck with a solitaire; has a soul capable of returning a most sincere and ardent love to one who thinks he had the honour of being taken notice of by her as he sat in the side box; let her with all the frankness of a Juliet appoint in the paper or any other where, how and when she will give her Romeo a meeting.'

The modern equivalent would be a meeting arranged by computer; love might result, or a disappointment – but without a meeting, there can be nothing, and the first meeting can be the doorway to a lifetime of happiness.

overleaf: 'The first meeting can be the doorway to a lifetime of happiness.' (*Photograph by John Hedgecoe.*)

The first kiss. (*Photograph by John Hedgecoe.*)

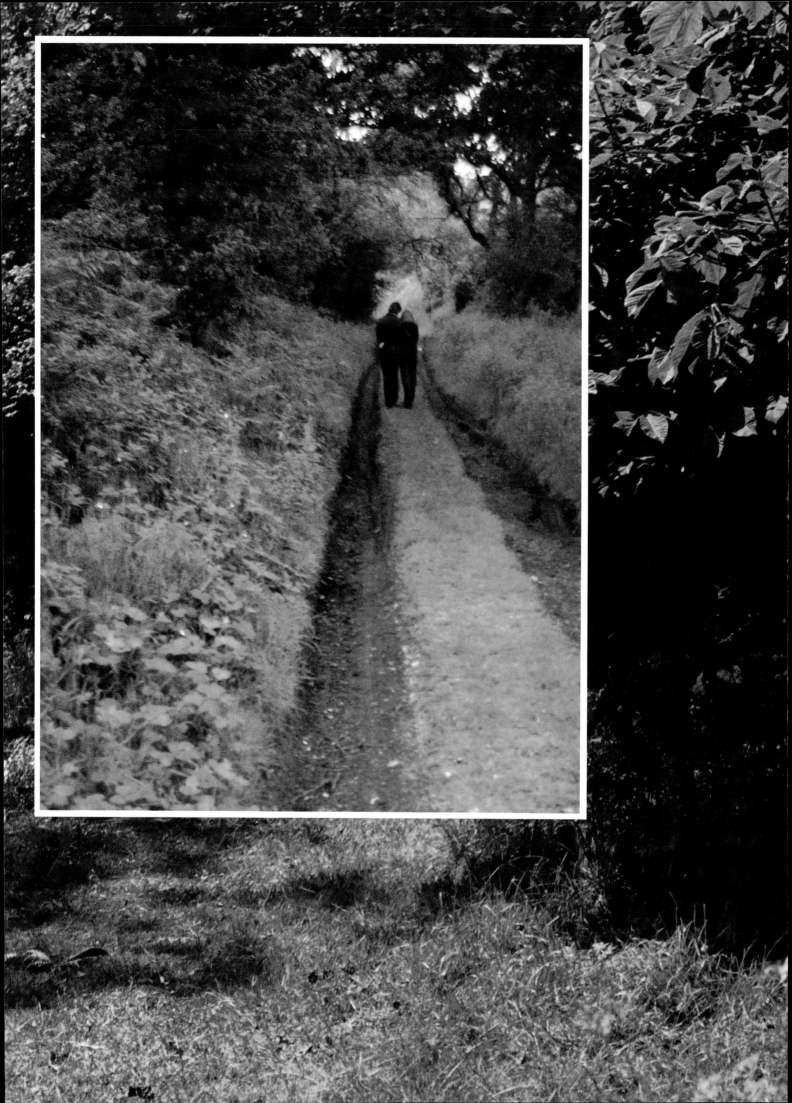

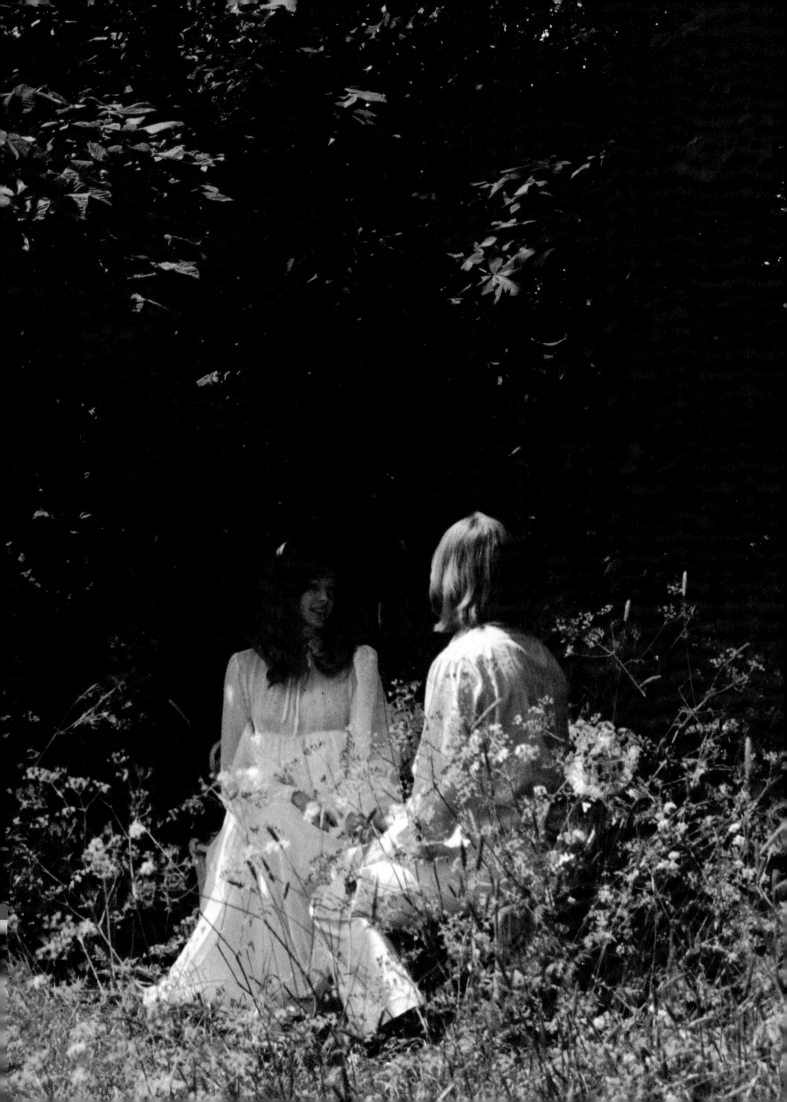

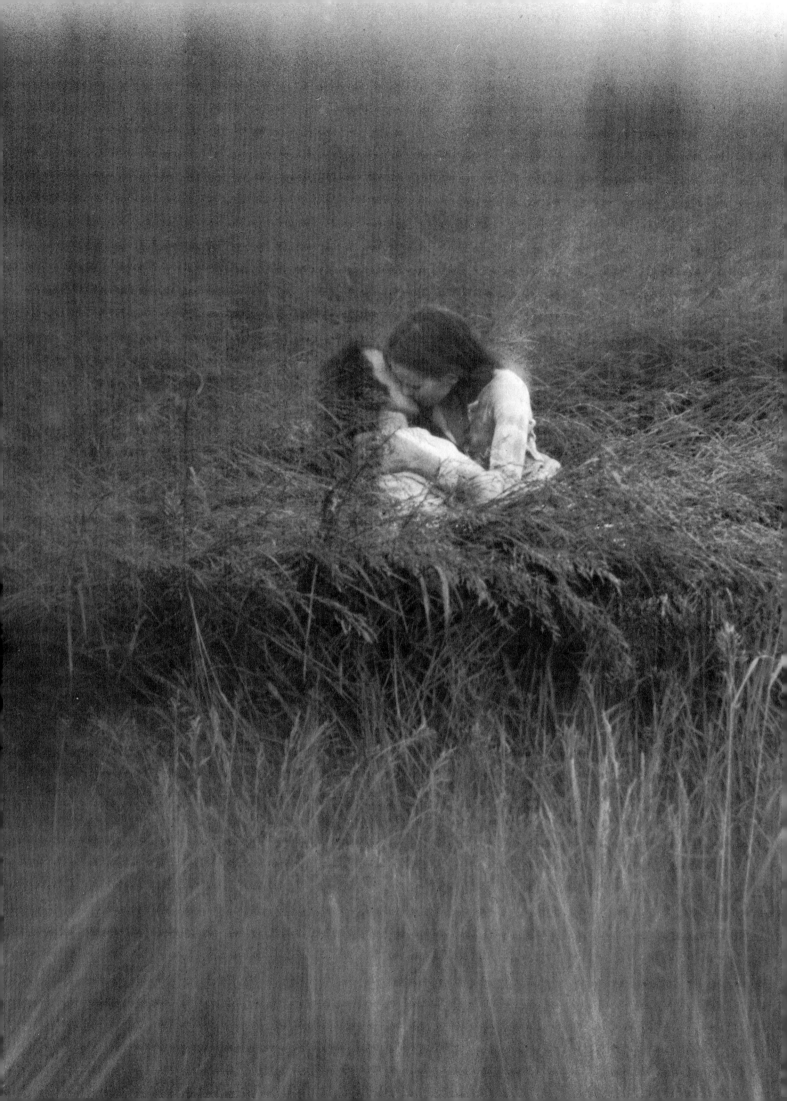

Courting

*The traditions and techniques
of the world of the chase*

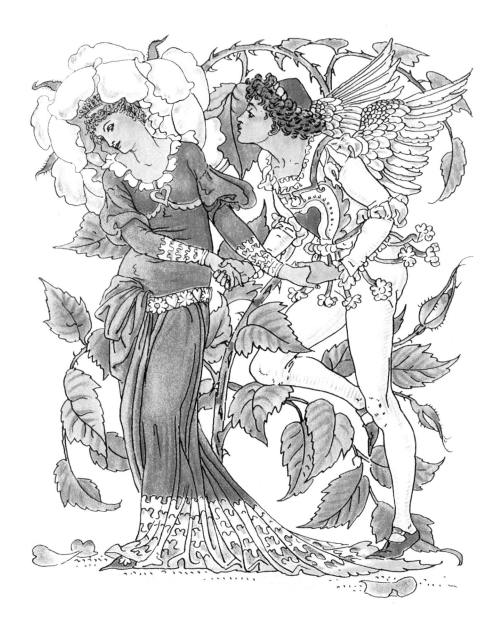

The Sprightly World of the Chase

In the annals of love two forces – man's desire to conquer the woman to whom he feels himself drawn, and the woman's enjoyment of her status as his ideal of beauty and love – have provoked a whole enchanted World of the Chase. As for the intrigues we indulge in, well, men have laid traps for women ever since Adam was a gardener – even though it was Eve who proffered the first, climactic apple.

For those of us who lack Casanova's overbearing sense of purpose, or Don Juan's wit, authors have always been ready with advice. Ovid, the witty Latin poet (43BC–*c.* AD17), wrote a delightfully lighthearted guide to the chase, the *Ars Amatoria*. Although in his private poems Ovid agonized over his own love, in the *Ars Amatoria* he directed other lovers to be more calculating. Gifts, food, drink, perfumes, dress . . . all of these, Ovid wrote, could carry the power to provoke love – and not necessarily frivolous or temporary love, but, equally, the kind that endured for ever.

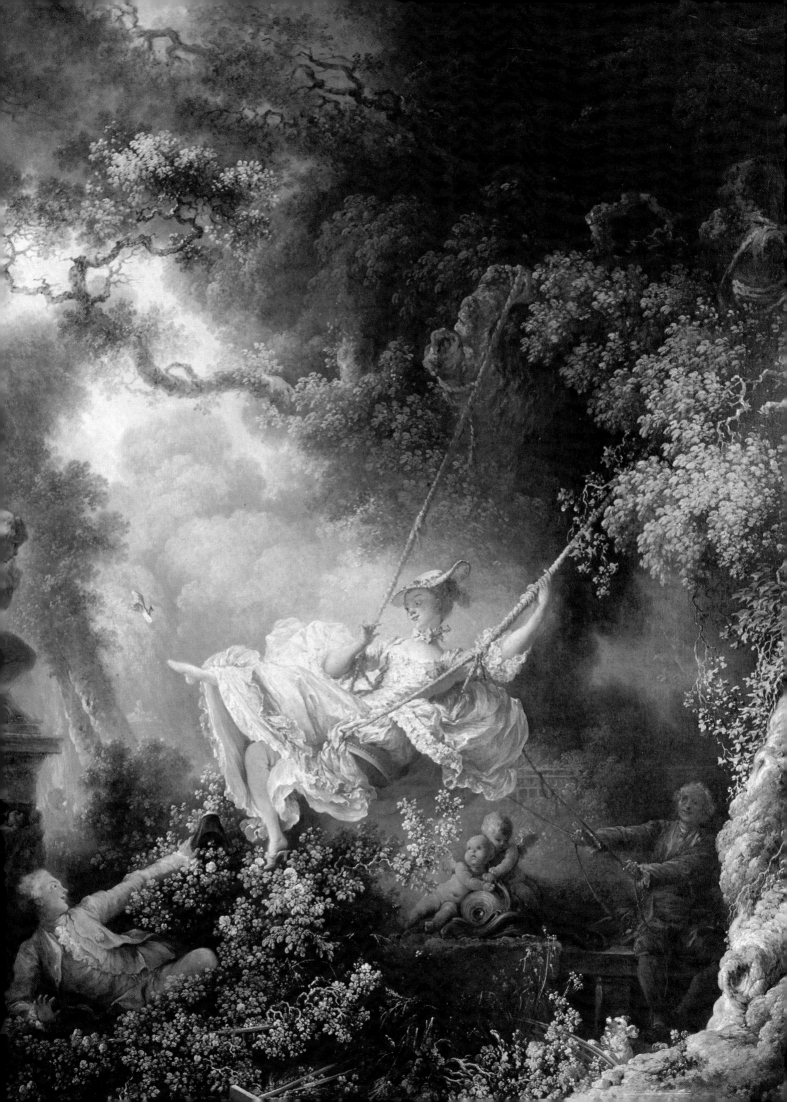

Artichokes and Lizard's Leg: Foods to Inflame your Desire

Some blandishments are more subtle than others. There is, for instance, the matter of inflammatory foods. Almost every kind of food has from time to time been thought to stimulate an erotic desire in man or woman, from cocoa to the powdered horn of the mythical unicorn. But there is, and always has been, a great difference between the aphrodisiac which simply prepares the way for love, and the preparation which specifically provokes lust.

The idea of the aphrodisiac dates back to the time when the important thing about life, love and marriage was the production of children; and in very ancient times it was often considered that fertility was not a matter for man alone but an affair in which the supernatural assistance of the gods could, without disgrace, be sought. Anxious for children, man relied on aphrodisiacs not only to provoke his initial desire, but also to spur himself to great erotic heights, in the belief that the greater his lust, the better the chances of conception. The true seducer naturally was quick to turn the whole idea to his own advantage, but even so there were those who felt that an infallible aphrodisiac somewhat destroyed the fun of the game. To them, it was rather like beginning a chess tournament with one contestant being at once deprived of her Queen, both Bishops, and all recollection of the rules! But, in more moderate, less racy circles such aids were not altogether spurned. Then, as now, a good dinner and good wine were seen as a totally pleasant and enjoyable preamble to making love.

A closer look at the history of 'serious' aphrodisiacs – food or drinks specially prepared to increase potency, or to promote irresistible desire – reveals that the more unpleasant the mixture, the more efficient it was supposed to be. The most unspeakable drinks were solemnly prescribed, carefully prepared, and more or less enthusiastically consumed – drinks beside which the witches' brew in *Macbeth* ('Eye of newt, and toe of

frog, Wool of bat, and tongue of dog, Adder's fork, and blindworm's sting, Lizard's leg and howlet's wing') seems a pleasant evening postum. These drinks were often taken from cups cast in the form of human parts, and there was for some centuries a belief that any food remotely erotic in outline must be an efficacious aphrodisiac.

There has always been danger in 'real' aphrodisiacs: the notorious 'Spanish Fly' (the insect Cantharides, dried and powdered) for instance, which works by acutely inflaming the gastro-intestinal system; and while its results delighted the Marquis de Sade by driving the guests at a certain ball to the utmost reaches of debauchery, it can cause serious damage. And in Africa there is yohimbine, a substance derived from the bark of the central African yohimbé tree which has been used for centuries to increase sexual powers. Yet modern scientific research has shown that it can cripple and that stimulative effects are in fact obtained only with toxic doses.

The more innocent aphrodisiacs such as the sweet potato, enjoyable for their own sake, were very rarely truly aphrodisiac: or if so, like alcohol (as Shakespeare pointed out) they 'provoke the desire, but take away the performance'. Almost every vegetable or herb at some time or another has been held to have aphrodisiac properties, especially if it was unfamiliar. The Elizabethan garden was a hot-bed of potential lust (one wonders how ladies could bring themselves to walk in them!) The famous *Herbal* of Nicholas Culpeper (1616–54) readily suggested herbs to assist the limping lover, and the powers of onions and all kinds of bulbs, chestnuts, eringo and asparagus were universally recognized; carrots, too, were held to be 'a great furtherer of Venus her pleasure, and of love's delights'. And by the nineteenth century advertisers by the score were ready to announce that the definitive aphrodisiac had at last been found: in the 1880s, a 'Balsamic Corroborant, or Restorer of Nature' was declared to have 'received flattering encomium from a certain Royal and several Noble personages'.

More simply, though, is not the mere presence of woman (or man) enough to excite us? Even the air we breathe can assume fresh and intoxicating powers. Take, for example, the experience of an eighteenth-century gentleman, a certain Captain Philip Thicknesse, who, 'in general, though I have lived in various climates, and suffered severely both in body and mind, yet having always partaken of the breath of young women, wherever they lay in my way, I feel none of the infirmities which so often strike the eyes and ears in this great city of sickness by men many years younger than myself.' Not that he was the first; other men than Captain Thicknesse have found it extraordinarily enlivening to partake of the breath of beautiful young women lying in their way! But by his gentle and imaginative approach, his willingness to draw strength from the passing breeze, to be thrilled by the mere proximity of a desirable woman, it is clear that Captain Thicknesse had all the makings of a Compleat Lover!

overleaf: '. . . a good dinner and good wine were seen as a totally pleasant and enjoyable preamble to making love.' (*Photograph by John Hedgecoe.*)

Cockney lovers in a *tête-à-tête* by Robert Seymour, the nineteenth-century English caricaturist.

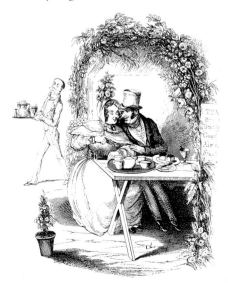

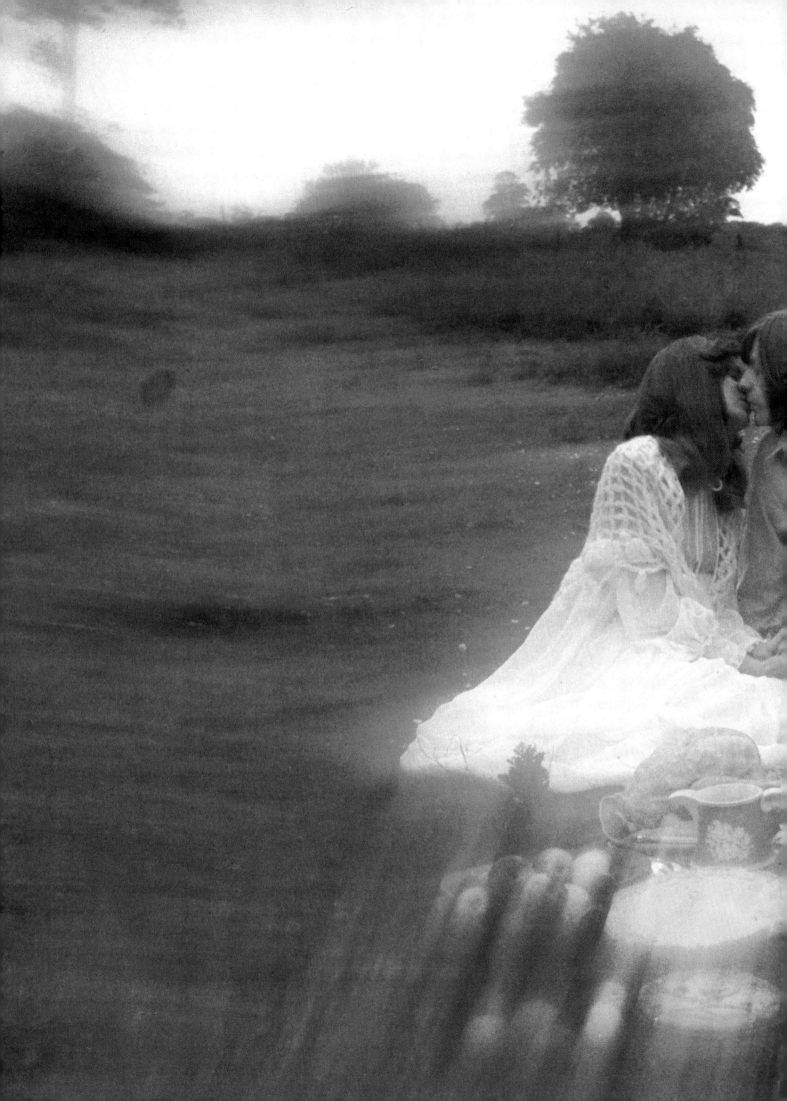

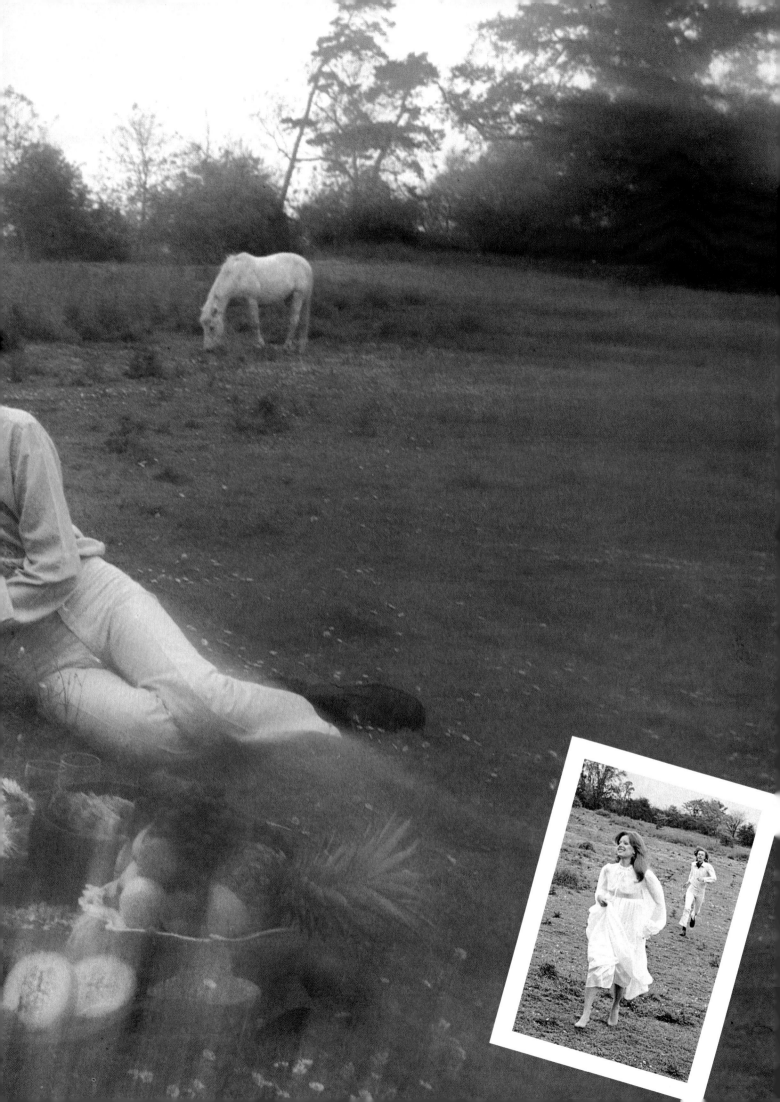

Clothes to Kindle a Wantonness

Men have always taken pride in decking out their mistresses, looking on them as companions not only to covet, but to decorate as well; the most popular courtesans in Europe have always tended to appear in public, on fashionable occasions, looking rather like Christmas trees. Joseph Addison wrote, in 1711 in *The Tatler*, 'I consider woman as a beautiful romantic animal, that may be adorned with furs and feathers, pearls and diamonds, ores and silks. The lynx shall cast its skin at her feet to make her a tippet; the peacock, parrot and swan shall pay contribution to her muff; the sea shall be searched for shells, and the rocks for gems; and every part of nature furnish out its share towards the embellishment of a creature that is the most consummate work of it'.

Addison was being no more than gallant by the standards of his age; and although his ideal of a beautiful woman, or a beautifully dressed one, may seem far removed from the casual fashions of the present day, there is something undeniably modern in his assessment of woman as a '*romantic* animal'.

The 'romantic' image is, of course, very much cultivated by the advertising media of today, and we are all to some extent influenced by the advertisers' message in our search for an image for ourselves. From the time we can read, or even earlier, we are deluged by a rival flood of films and printed matter, the outpourings of the image-making industry, all of which hints broadly that sexual and romantic love are of very great importance. And so they are. However, commercial interests are apt to drive their message hard. In posterland, all the girls are incredibly beautiful, incredibly passionate; dressed in flowing silk, their newly-washed hair streaming golden in the wind, they travel by fast car or steady jet to sunny sparkling beaches, where incredibly handsome, incredibly healthy, incredibly rich young men lie waiting for them.

With most young people the message is quickly taken, and they begin to formulate an appearance that is at once fashionable within their age-group and distinctive to them as individuals and – most important of all – alluring to the opposite gender. But how can clothes and hairstyles and all the rest of the pre-packaged so-called 'romantic' paraphernalia be emotionally arousing? Men and women are born naked, and it would be ironic if it were true that the main reason for wearing clothes was as a kind of ceremonious preamble to removing them for amorous purposes. Perhaps, nevertheless, it is so.

The English costume historian James Laver set out some years ago his theory of 'the shifting erogenous zone'. By this he sought to show that the design of women's clothes varied simply in order to satisfy men's eyes. At any particular time, women emphasized one area of the body – constricting the waist to display slenderness, placing bustles to draw the eye to the buttocks, deepening the neck of a dress to display the breasts, and so on. Then, when men began to show signs of boredom, they shifted the emphasis to another part of the body. Men's eyes invariably followed.

It does in fact seem that clothes can have aphrodisiac qualities, controlled by the wearer, who decides just which area to reveal and how much of it. It is the selection that matters, and society in the end lays down the rules. With, possibly, a glance back at the erotic, bare-breasted Egyptian women of three thousand years ago, designers in the last decade tried to bring in the topless dress, but failed. Perhaps it was too explicit a move. The Victorian woman, on the other hand, showed considerable areas of breast – though her ankle was taboo. Now, after the miniskirt era, the eye is moving again, perhaps once more to the breasts.

The man is in a more equivocal position; it is doubtful whether women are on the whole particularly susceptible to what men are wearing, or even to their wearing nothing at all; women's magazines which have tried to introduce the concept of male nudes managed only to raise a storm of yawns from their indifferent readers. No, it seems that if a woman finds a man's clothes attractive, it will be for the sake of the clothes themselves as much as for the man inside them; while the man who enjoys what a woman is wearing, is very probably thinking of what is beneath them:

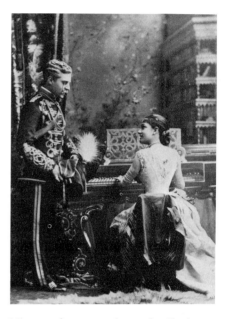

Nineteenth-century 'posterland': the handsome, attentive soldier in full regalia; the accomplished girl, fashionably bustled, at her piano.

> *Young men's love then lies*
> *Not truly in their hearts, but in their eyes.*

WILLIAM SHAKESPEARE, Romeo and Juliet

Of course, in our own time man has been handicapped: we are now (it is to be hoped) at the tail-end of the only period in history during which man has been reduced to being, fashion-wise, a cipher. Sometime after the middle of the nineteenth century, Euro-American man began to sober up in terms of dress to the extent that by the middle of the twentieth century any attempt to show individuality in dress was suspect. Sociologists have seriously suggested that women preferred their men in sober suits during the first half of this century, because, at a time of unemployment and general uncertainty, this indicated a faithful and sober husband and a good worker.

Over the past fifteen years – and it is no coincidence that affluence has reached new peaks in this period – the peacock principle has returned to male dress. Men suddenly began to 'display' once more, as the male animal has always done; and Mr. Laver's erogenous zone theory could now be seen to apply to men's fashions – at one stage tight trousers emphasizing the buttocks and thighs, at another the tee-shirt drawing attention to a muscular torso, or the cut of a coat exaggerated to show off the width of the shoulders.

But, however that may be, we are inclined to think that man (as distinct from woman) has little to gain in the courts of love, either by dressing or undressing! The recent focus on men's fashion may simply depend on boredom with the old, dull clothes that men were forced to wear for so long. Only in time, perhaps, will all be revealed.

overleaf: 'The cosmetic arts are as old as time . . .' (*Photograph by John Hedgecoe.*)

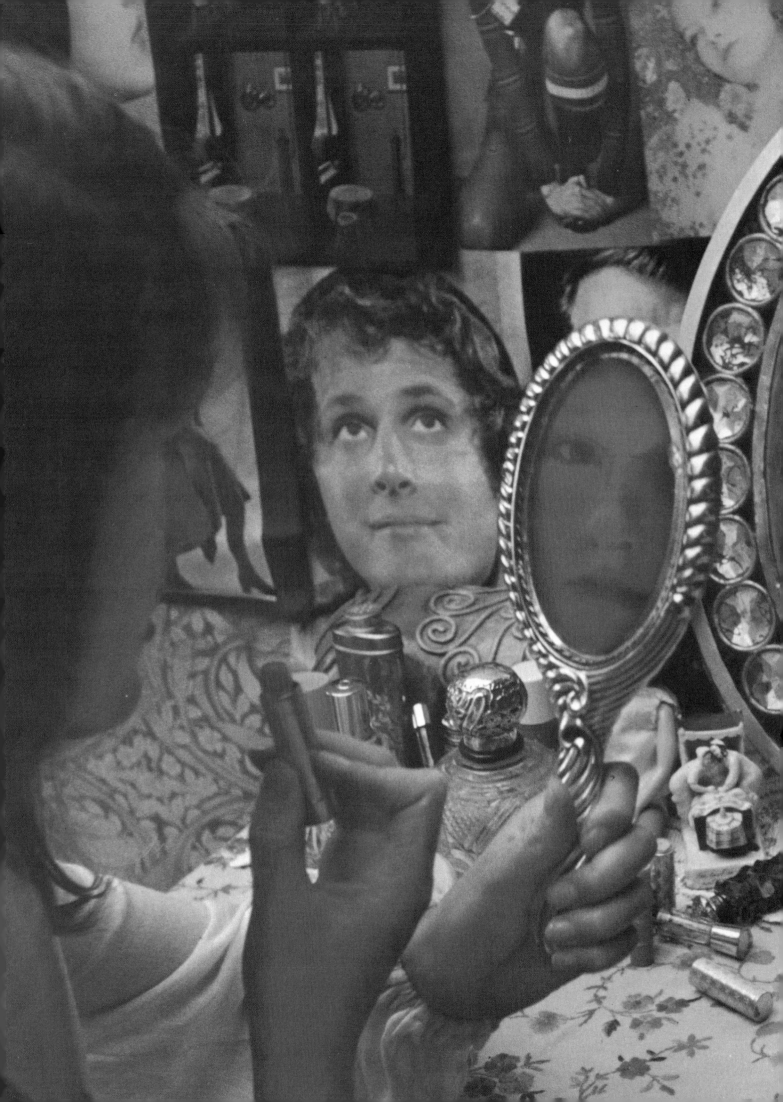

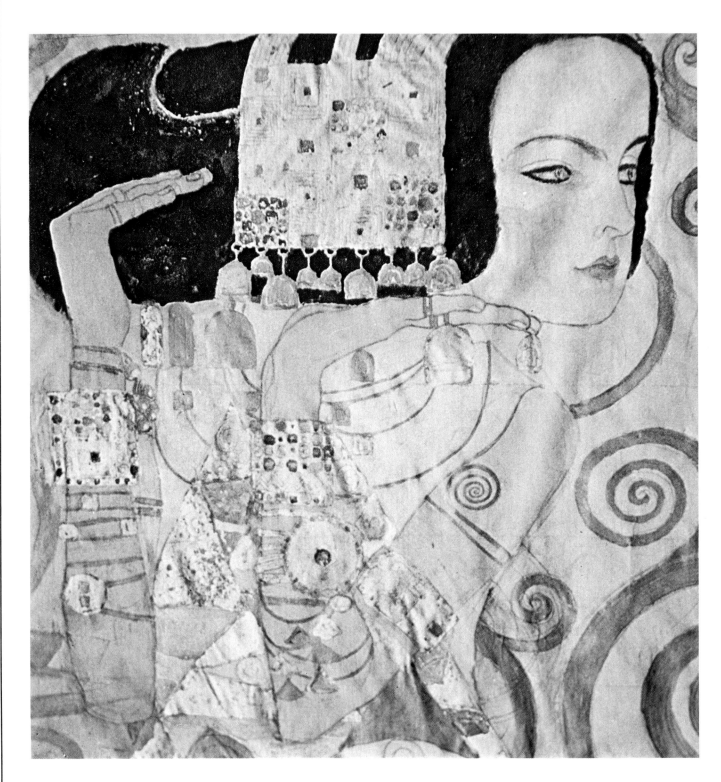

above: Silks and satins, elaborate
jewellery, carefully dressed hair and a
peach-bloom complexion in this
design for a mosaic wall by Gustav
Klimt.

right: The peacock principle in
Elizabethan male dress. (*Youth Leaning
against a Tree among Roses* by the
miniaturist Nicholas Hilliard.)

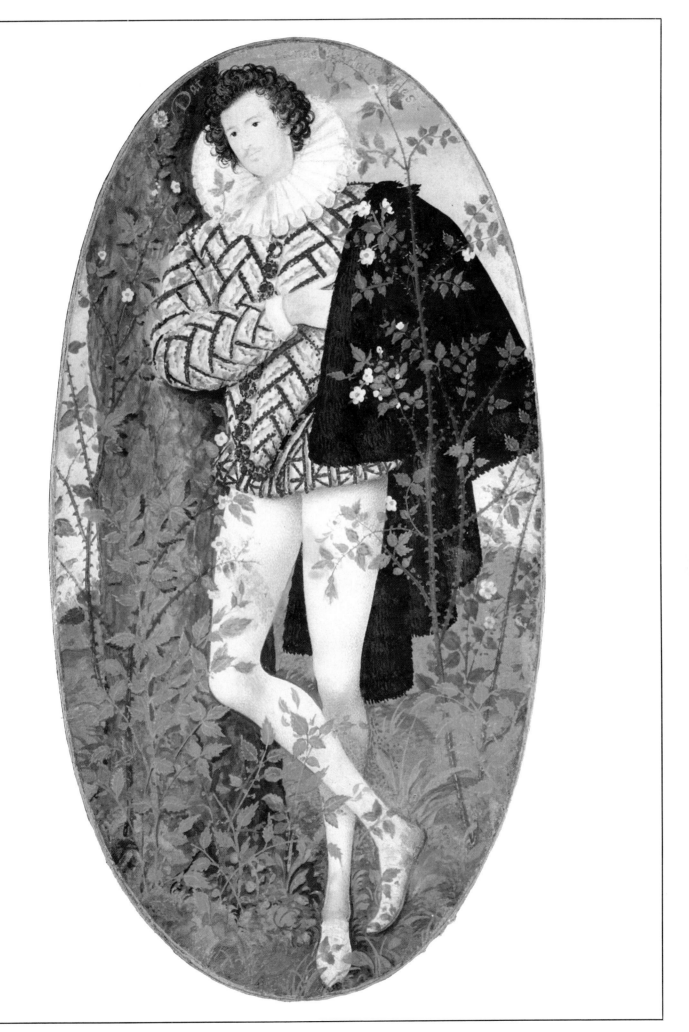

The Joys and Heartaches of Dreamland

In the nineteenth century the interpretation of dreams became a highly fashionable pastime. Already, before the advent of Freud and Jung, it was beginning to be suspected that dreams were connected with man's most secret thoughts and wishes, and a number of 'dream books' were published in which dreams were interpreted and also used to indicate future events. Naturally enough, such works were in greatest demand when they offered guidance in matters of the heart. Below is a selection of entries, all of which relate to courtship, taken from the *Dictionary of the Interpretation of Dreams* of 1818, said to have been culled 'from the learned writings of Artemidorus and Others'. The moral tone is stern and unmistakably of its day. Is it all too fantastic to be credible? Perhaps. But there were many who believed its findings at the time. Dreams, after all, occupy a strange corner of our existence; and it is just possible that beneath the sweeping prophecies of Artemidorus and his friends, there lurks an element compounded of truth and common experience. The reader must decide.

Adultery For persons to dream they have committed it, shows that they shall meet great contentions and debates; but to dream they have resisted the temptation to it shows victory over their enemies, and that they shall escape great dangers.

Boots To dream that one is well booted, or hath good boots on, signifies honour and profit by marriage.

Cards To dream one plays at cards or dice signifies deceit and craft in love: your loved one should be less trustful of you! He that playeth at cards in a dream, shall be a great gamester as well with Joan as with my lady.

Coalpits To dream of being at the bottom of a coalpit signifies matching with a widow: for he that marries her must be a continual drudge, and yet shall never sound the depth of her policies.

Confections To dream that one makes confections and sweetmeats signifies great ease in courtship.

Deer To dream of hunting deer signifies a hard and lengthy courtship, but victory in the end (should you capture the prey).

Dragons To dream you see a dragon is a sign that you will marry some great lord or mistress, or a law-maker; it signifies also riches and treasure.

Earthworms To dream of earthworms signifies a secret enemy to the marriage, or a secret lover, who is the mere worm of the earth.

Figs To dream of figs in season is a good dream and signifies joy in love, and pleasure. But out of season, the contrary.

Grapes To dream of eating grapes at any time signifies the celebration of love's rites. To tread grapes signifies the overthrow of a reluctant love; to gather white grapes signifies the gain of a much-sought love.

Harpies To dream one sees harpies, which are infernal creatures, half women and half serpents, or else furies, such as the poets feign them to be, signifies tribulation and pains occasioned by envious men or women, and such as seek our ruin, shame or other misfortune by seduction.

Ladder The ladder is a sign of travelling, to or from a loved one; to ascend a ladder signifies success in love; to descend one betokeneth failure.

Leeks To dream of leeks signifies a discovery of secret domestic matters.

Lentils To dream of lentils signifies corruption, either of the dreamer or the beloved.

Logs To dream that one is cleaving logs is a sign that a stranger shall come to the house, with a danger to virtue.

Marry To dream that you marry signifies often a desire that you shall not be married.

Meat To dream you see the meat you have already eaten signifies that you desire the end of a love match.

Monster To see a monster or monstrous fish in the sea is not good, and signifies your love may wish you harm; but out of the sea every fish and monster is good, because then they can hurt no more, or save themselves. And therefore besides that our dream signifies that though one we love may wish us harm, they have no power.

Nettles To dream of nettles, and that you sting yourself, shows that you will venture hard for the love you desire. And if young folks dream thus, it shows they are in love, and are willing to take a loved one though they be stung thereby.

Nightingale To dream of this pretty warbler is the forerunner of a good-tempered lover. For a married woman to dream of a nightingale shows she will have children who will be great lovers. It signifieth also principally weddings and music, and promiseth a housewifely wife.

Organs To dream that you hear the sound of organs signifies joy.

Oysters To dream of opening and eating oysters shows great hunger in love, which the party dreaming shall suddenly sustain; or else that he shall take great pains in courtship, as they do that open oysters.

Pigeons To dream you see pigeons is a good sign; to wit that you will have content and joys at home. To dream you see a white pigeon flying signifies good success in love, providing your motives are for the good of your beloved. Wild pigeons signify dissolute women, and tame pigeons denote honest women and matrons.

Plough To dream of a plough is good in love, and affairs, but it requireth some time to bring them to perfection.

Rice To dream of eating rice denotes extreme fecundity.

Saddle To dream you are riding a horse without a saddle signifies outrageousness in love, lack of real concern, a disposition to deceive.

School To dream you begin to go to school again and you cannot say your lessons right, shows that you are a novice in love, and must take pains to learn its niceties.

Velvet To dream you trade with a stranger in velvet signifies joy from your lover, who shall bring you richness, and not only in gold.

Wrestling He that dreams that . . . he wrestles with a woman . . . is too forward in love. A woman who dreams she wrestles with her husband, will certainly bring him shame.

'Dances are a great and perennial spur to flirtation.' (*Artist unknown.*)

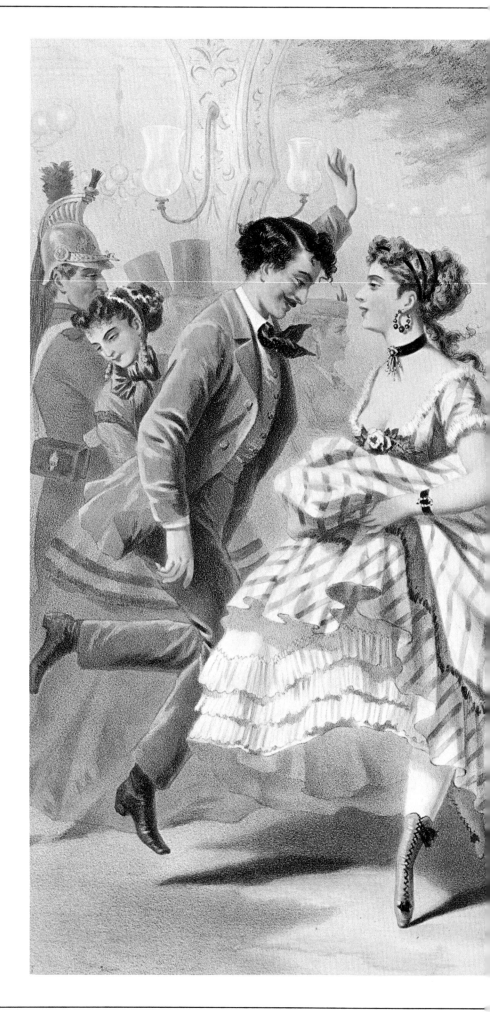

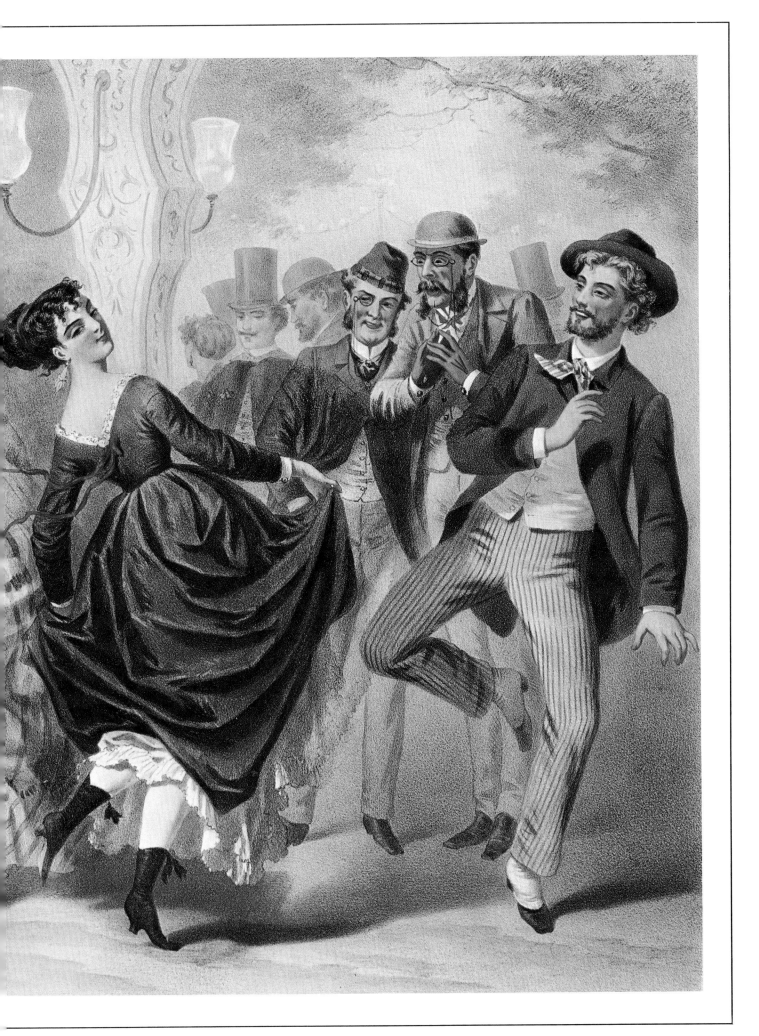

Ballrooms and Maypoles: the Unbridled Ecstasies of the Dance

'The delightful unison of their unerring feet, the movement, the music, her cool breath saluting his cheek – it was not a waltz, it was an Ecstasy!'

Dances are a great and perennial spur to flirtation – from the splendid balls at which polite behaviour was at least presumed to be the rule, to the kind of rude assembly that the puritan Philip Stubbes (*fl.* 1583–91) had in mind when he wrote of dances as 'an introduction to whoredom, a preparation to wantonness, a provocation to uncleanness, and an introite to all kinds of lewdness . . . I have heard many impudently say that they have chosen their wives and wives their husbands by dancing, which plainly proveth the wickedness of it. Every leap or skip in dance is a leap towards hell'.

More sympathetic was the novelist Charles Reade, who in 1863 painted a telling portrait of two lovers breathless in a first encounter: 'To most young people love comes after a great deal of waltzing. But the pair brought the awakened tenderness and trembling sensibilities of two burning hearts to this their first intoxicating whirl. To them, therefore, everything was a thrill – the first meeting and timid pressure of their hands, the first delicate enfolding of her supple waist by his strong arm but trembling hand, the delightful unison of their unerring feet, the movement, the music, her cool breath saluting his cheek. . . It was not a waltz, it was an Ecstasy'.

In country districts dancing embodied a blend of religious and magical belief as well as a great deal of boisterous physical activity. May dances were and still are held throughout Europe, from Sweden to the South of France, their function being inextricably allied to the ceremonies of increase customarily held at that time of year to promote the crops and fertility in general. In the seventeenth century the poet Robert Herrick noted that boys and girls rose early 'to observe the rite of May? But to the ever-watchful Stubbes, there was more to it than that. According to him, on the eve of May Day young people 'run gadding over night to the woods, groves, hills and mountains, where they spend all the night in plesant pastimes'. As to the Maypole dances, Stubbes 'heard it credibly reported (and that viva voce) by men of great gravitie and reputation, that of fortie, threescore, or a hundred maides going to the wood to deck the maypole, there have scaresly the third part of them returned home againe undefiled'.

And Stubbes, with his eye gluttonously fixed to the keyhole of his society, was not one to spurn such titillating statistics. But, for all that, the message of the maypole remained clear enough; ornamented with nosegays, garlands, red ribbons, flags, handkerchiefs or gilt egg-shells, depending on the country of origin, it announced that warm summer days had arrived again:

> Come lasses and lads, get leave of your dads,
> And away to the Maypole hie,
> For every he has got him a she,
> And the fiddler's standing by.

ANON. *c. 1670*

All Cupid's Heraldry: the Irrepressible Rise of the Valentine

The occasion in the year when the heart of every Compleat Lover beats a little faster is 14 February, St Valentine's Day. The Saint himself is a very shadowy, perhaps totally mythical, figure; his day seems to have been associated with love through the ancient notion that it was on that day that birds began to mate. Robert Herrick, the English lyric poet, wrote rather mournfully,

> *Oft have I heard both youths and virgins say*
> *Birds chuse their mates, and couple too, this day;*
> *But by their flight I never can divine*
> *When I shall couple with my Valentine.*

Certainly from Elizabethan times the term had been well-known; Margery Brews married 'her well-belovyd Valentyn John Paston, Squyer', in 1477; and in 1535, in a will, a man wrote: 'I gyf and bequeth to my Valentyn Agnes Illyon ten shillings'. Often a Valentine received much more: Samuel Pepys recorded that the Duke of York in 1667 gave Lady Arabella Stewart a Valentine gift of a ring worth £800; and two hundred years later an embarrassed lady in Norwich, England had to cope with the unexpected arrival of a grand piano!

More modestly, the Valentine card became the recognized mark of anonymous affection. The tradition started in the early part of the eighteenth century, when manufacturers began issuing sets of verses which the largely illiterate public could mount on cards of its own devising. The fashion really caught on in the nineteenth century: in 1850, Lord Macaulay commemorated the events of St Valentine's Day:

> *On earth the postman toils along*
> *Bent double by huge bales of song,*
> *Where, rich with many a gorgeous dye,*
> *Blazes all Cupid's heraldry –*
> *Myrtles and roses, doves and sparrows,*
> *Love-knots and altars, lamps and arrows –*
> *What nymph without wild hopes and fears*
> *The double rap this morning hears!*
> *Unnumbered lasses, young and fair,*
> *From Bethnal Green to Belgrave Square,*
> *With cheeks high flush'd, and hearts loud beating*
> *Await the tender annual greeting.*
> *The loveliest lass of all is mine!*
> *Good morrow to my Valentine!*

The fashion limped a little during the 1880s, but now seems as popular as ever. Each year token hearts are given and exchanged. Solitary hearts pound in expectation, ache and are broken, flutter wildly and are saved; 'my true love hath my heart and I have his'.

overleaf: Nineteenth-century Valentine cards. (*Photograph by John Hedgecoe.*)

My Uncle Toby and the Widow Wadman by Charles Robert Leslie.

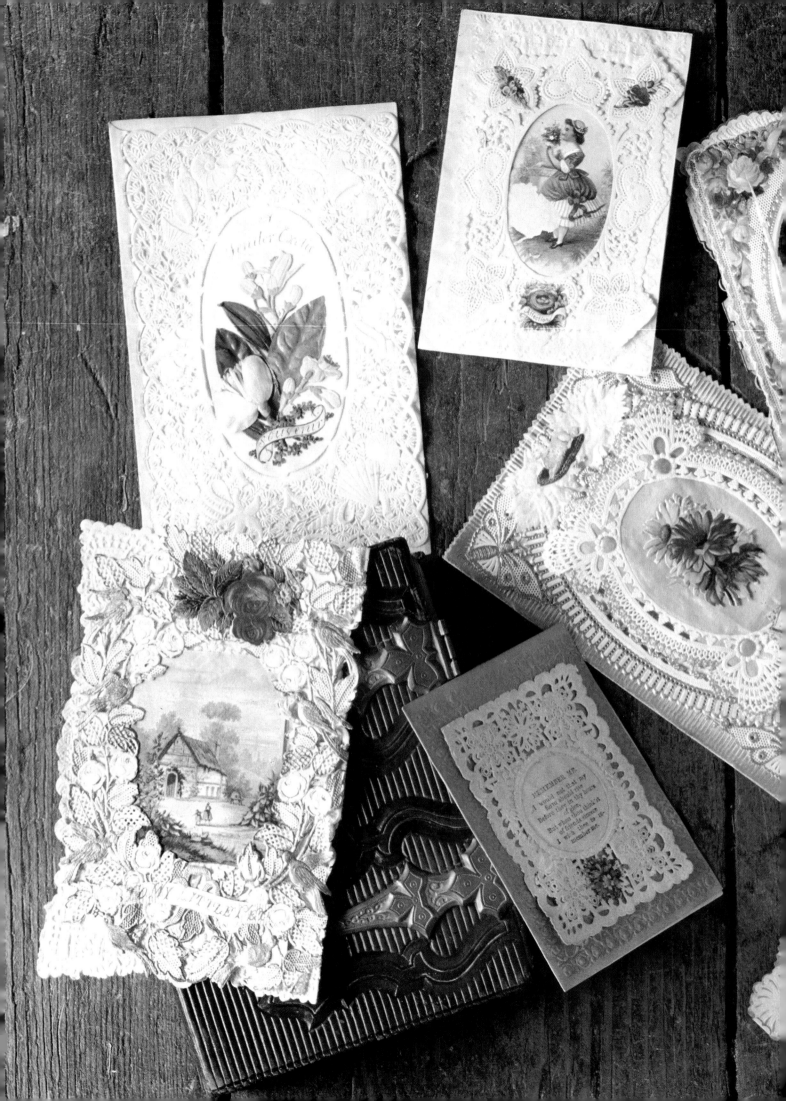

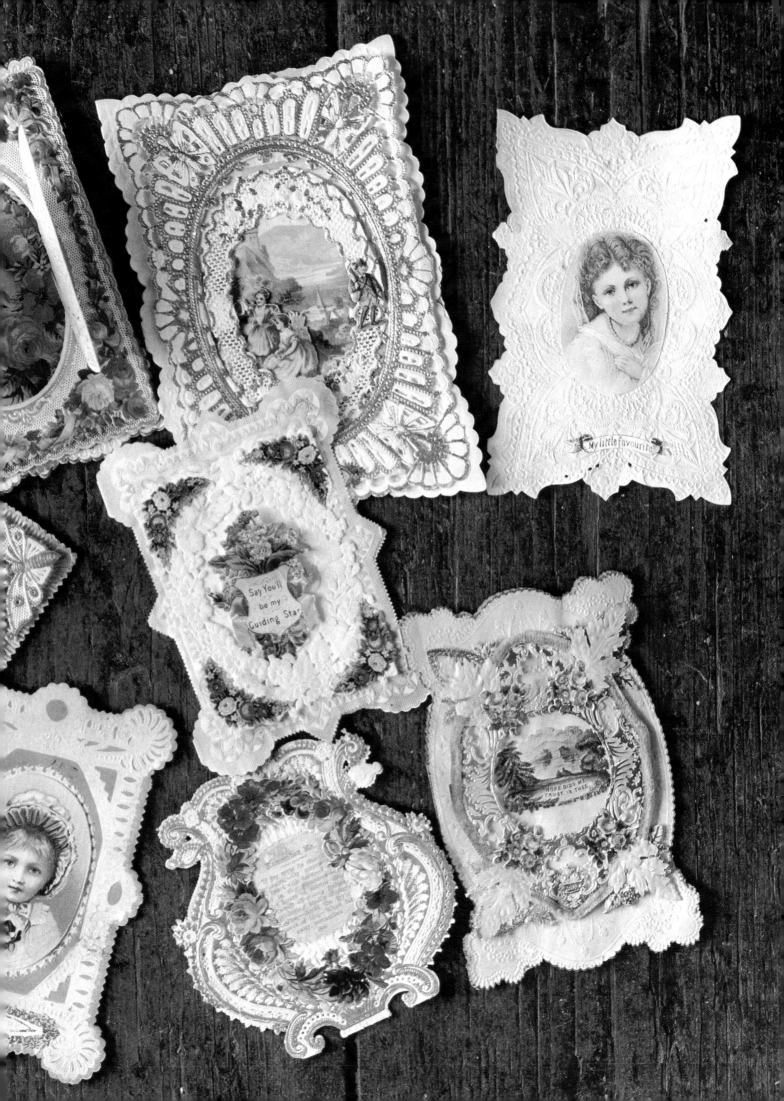

Love-Letters

In his great anthology *Love*, Walter de la Mare pointed out how 'lovers never weary of craving to communicate what no mere words unaided can. Their parcels stubbornly refuse to be unpacked. . . . Sighs elude ink; crosses must stand for kisses; and, though not from any apprehension of wasting time, they have to find haven in such piteous exclamations as "Words cannot express", "I cannot tell you", "If only I could say!", "My heart. . ."'

In a few love letters which have survived, the heart speaks aloud, and so movingly that one feels guilty at invading the lover's privacy. The love-letters of John Keats, for instance, are almost unbearably moving to read. His was an unhappy love; a victim of tuberculosis, which in his time was almost always fatal, and of the social conventions of the early nineteenth century, Keats could celebrate his love only in words. And the illness so built up erotic tension within him that his jealousy and even envy spilt over into anger and pain. These are not heartwarming or comforting love-letters; but they expose the naked nerves of love more clearly than any others we know, and more clearly than more self-conscious works of art.

Again and again in them we hear the note of astonishment that we all know – astonishment that the heart should be capable of such deep feeling:

> 'I am almost astonished that any absent one should have that luxurious power over my senses which I feel. Even when I am not thinking of you I receive your influence and a tenderer nature steals upon me. All my thoughts, my unhappiest days and nights have I find not at all cured me of my love of beauty, but made it so intense that I am miserable that you are not with me: or rather breathe in that dull sort of patience that cannot be called Life. I never knew before, what such a love as you have made me feel, was; I did not believe in it; my Fancy was afraid of it, lest it should burn me up . . .'

In his letters Keats expressed that infinite longing which is the mark of love at its most intense. To read them is to stare into the open abyss which waits for any lover, if circumstances turn against him. No one could wish to receive them; they show the extremes of despair in love, and, by contrast, the extremes of delight. Other surviving, happier letters remind us of a more pedestrian, yet infinitely easier love. There are the charming letters of Dorothy Osborne and Sir William Temple, parted by the English Civil War. He sent her, to keep, a lock of his hair:

> '. . . How fond I am of your lock. Well, in earnest now, and setting aside all compliments, I never saw finer hair, nor of a better colour; but cut no more on't. I am combing, and curling, and kissing this lock all day, and dreaming on't all night. The ring, too, is very well, only a little of the biggest. Send me a tortoise one that is a little less

than I sent for a pattern. I would not have the rule absolutely true without exception that hard hairs be ill-natured, for then I should be so. But I can allow that all soft hairs are good, and so are you, or I am deceived as much as you are if you think I do not love you enough. Tell me, my dearest, am I? You will not be if you think I am,

<div align="right">Yours.'</div>

The tone in this courtly letter from Henry VIII to Anne Boleyn is, by contrast, formal but ardent:

Mine own Sweetheart,
This shall be to advertise you of the great melancholy that I find here since your departing, for I ensure you methinketh the time longer since your departing now last than I was wont to do a whole fortnight. I think your kindness and my fervency of love causeth it; for otherwise I would not have thought it possible that for so little a while it should have grieved me. But now I am coming towards you, methinketh my pains be half removed. Wishing myself (especially of an evening) in my sweetheart's arms whose pretty duckies I trust shortly to kiss. Written by the hand of him that was, is and shall be yours by his own will,

<div align="center">H.R.</div>

Napoleon's letters to Josephine were wild and passionate:

I awake all filled with you. Your image and the intoxicating pleasures of last night, allow my senses no rest. Sweet and matchless Josephine, how strangely you work upon my heart. Are you angry with me? Are you unhappy? Are you upset? My soul is broken with grief and my love for you forbids repose. But how can I rest any more, when I yield to the feeling that masters my inmost self, when I quaff from your lips and from your heart a scorching flame? Yes! One night has taught me how far your portrait falls short of yourself! You start at midday: in three hours I shall see you again. Till then, a thousand kisses, mio dolce amor! but give me none back, for they set my blood on fire.

<div align="center">Dec. 29 1795</div>

To read such letters is disquieting – because of the invasion of privacy – and yet at the same time extremely rewarding. What we hear when we read Henry VIII's love-letters is his very voice. This does not mean, of course, that it cannot be a false voice; men were deceivers ever. But it is not an artificial voice. And that is how to write a good love-letter (how indeed to write a good *letter*): forget about the niceties of syntax, and be oneself; the success of a love-letter has nothing to do with literature or education.

overleaf, left: Escaping to read a love-letter in private. (*Photograph by John Hedgecoe.*)

overleaf, right: The course of true love may not always run smoothly. (*Broken Vows* by Philip Hermogenes Calderon.)

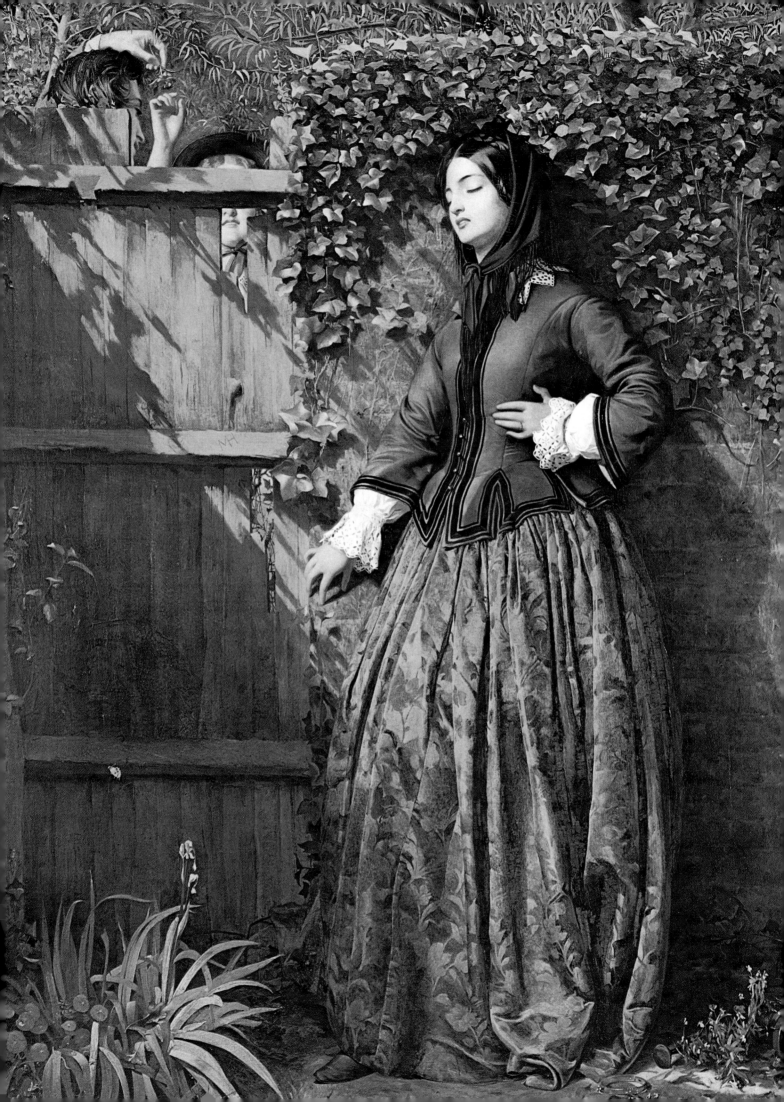

Hearts and Flowers for Ever

A written message was not the only way of conveying amorous sentiments, even from a distance. Long before the invention of printing, and possibly even before the invention of writing, flowers served as a mark of admiration, as a testimony of affection, love or adoration. A thousand years before the birth of Christ, a Greek poet, Meleagros, wrote:

> *White violets I'll bring*
> *And soft narcissus*
> *And myrtle and laughing lilies*
> *The innocent crocus*
> *Dark hyacinth also*
> *And roses heavy with love.*
> *And these I'll twine for Heliodora*
> *And scatter the bright petals in her hair.*

The petals will fall from different flowers in different countries, of course – in England, perhaps daisies and buttercups, roses and cowslips; in America, goldenrod and stargrass, June daisies, Mayapple and asters; in India, hibiscus and dattura and champa flowers; and in Australia wattle, and strange heathflowers; in Mexico, cactus flowers – 'roses of the desert' – or the feet-long clusters of the cream bells of the yucca.

In any country, to compare your mistress to a flower is fairly obvious; to do it with grace has always been the aim of a lover. For years, the simple *gift* of flowers was enough; Napoleon sent Marie Louise flowers every day he was absent from her. But the Victorians, bringing sentimentality to an art, were not content to pay the simple tribute: they *literally* 'said it with flowers', inventing a language for the purpose. Some 'phrases' were ancient: a single red rose had always meant, plainly, 'I love you'; but then enterprising students of love compiled whole dictionaries of flowers, which could only be properly interpreted if the person beloved happened to possess the same dictionary, for there were endless nuances of meaning in even the most common of flowers.

One industrious floral etymologist was G. R. M. Devereux, who in *The Lover's Guide*, published in 1909, pointed out that one could send one's love stephanotis, enquiring 'Will you accompany me to the East?' A spiderwort, returned, would mean: 'I esteem, but do not love you.' 'Jonquil!' you might reply (or, 'I desire a return of affection!') To which the girl might respond with a single dandelion, meaning, simply, 'Go!' Whole sentences could be composed – provided one's garden were big enough! A sequence of garden daisy, Virginia creeper leaf, speedwell and bay leaf, would be translated by the initiated as: 'I share your sentiments, offer a woman's fidelity, and change but in death.' But, even in the presentation of a bouquet or a single flower, care was needed: a moss-rosebud, handed to one's love, was widely interpreted as an honest confession of adoration. If, however, one had the bad luck or absent-mindedness to hand it to her upside down, it signified something quite different.

It was all, of course, a carefully contrived game, fun to play and not to be taken too seriously by the participants. As a novel language it paved the way for many a pretty compliment made later in earnest, and many a daring proposal doubtless followed such introductory ice-breaking moves. And if the various books disagreed amongst themselves as to the meaning of some flowers, confusing the issue and covering one's traces at an instant gave the game added spice. No bones or hearts would be irrevocably broken at that stage. Or so we might be tempted to think today. But the moods of lovers are devious and deep and it is quite likely that a romance at the turn of the century could in fact be wrecked by a casually inverted moss-rosebud. Even today most of us have mental corners where a belief in magic dies hard. The ancient superstitions of love are, moreover, still celebrated in many rituals and customs throughout the world, as we shall shortly see.

Black humour from an artist's brush: *The Persecuted Lovers* by the Australian painter Arthur Boyd.

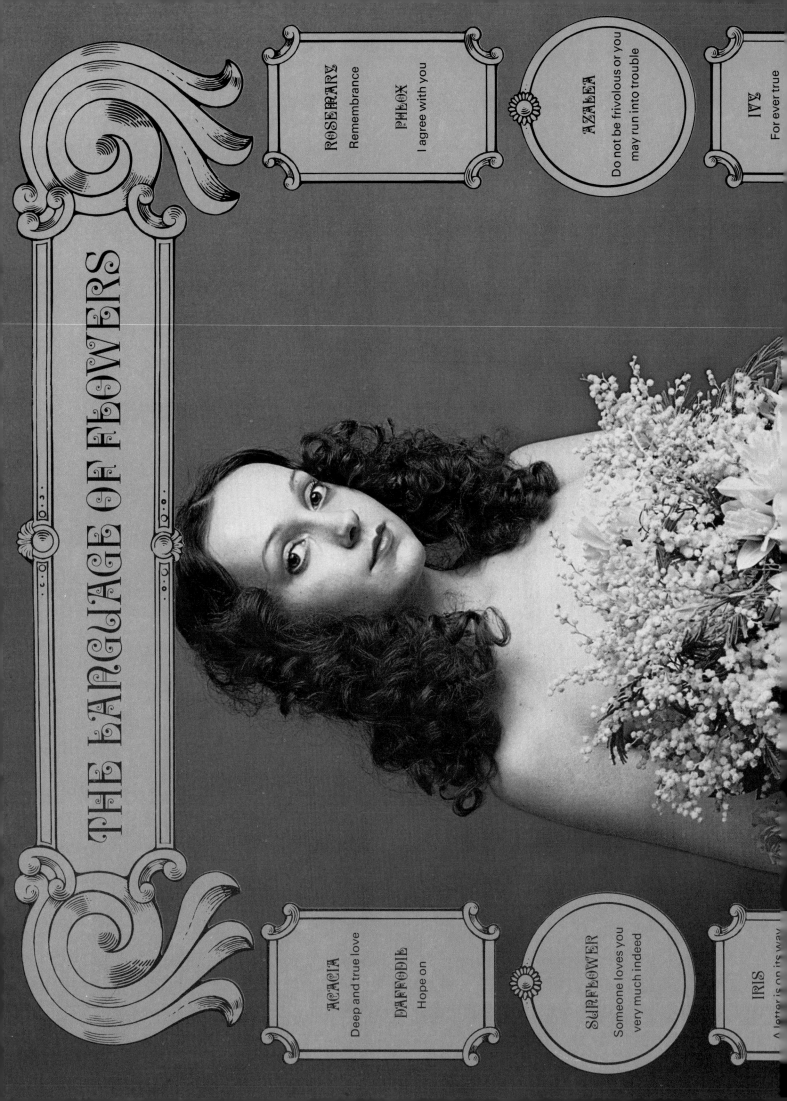

THE LANGUAGE OF FLOWERS

ROSEMARY
Remembrance

PHLOX
I agree with you

AZALEA
Do not be frivolous or you
may run into trouble

IVY
For ever true

ACACIA
Deep and true love

DAFFODIL
Hope on

SUNFLOWER
Someone loves you
very much indeed

IRIS
A letter is on its way

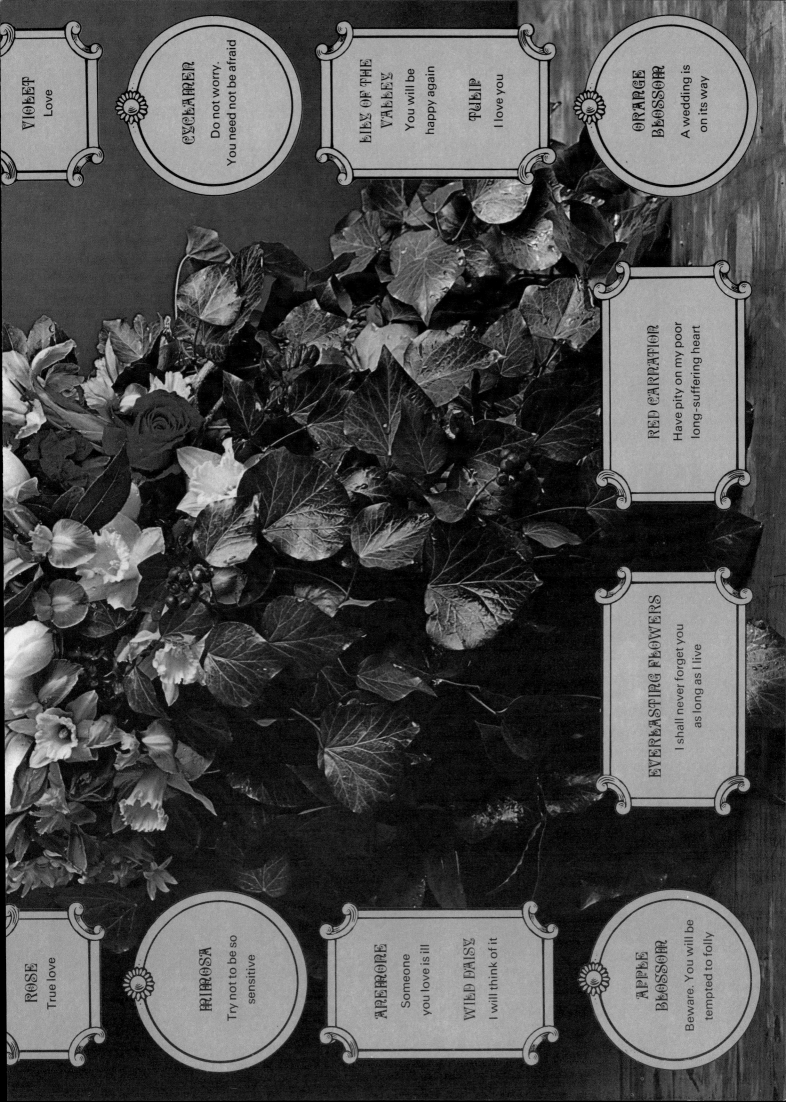

VIOLET
Love

CYCLAMEN
Do not worry.
You need not be afraid

LILY OF THE VALLEY
You will be
happy again

TULIP
I love you

ORANGE BLOSSOM
A wedding is
on its way

RED CARNATION
Have pity on my poor
long-suffering heart

EVERLASTING FLOWERS
I shall never forget you
as long as I live

ROSE
True love

MIMOSA
Try not to be so
sensitive

ANEMONE
Someone
you love is ill

WILD DAISY
I will think of it

APPLE BLOSSOM
Beware. You will be
tempted to folly

Rhymes and Spells and Amorous Potions

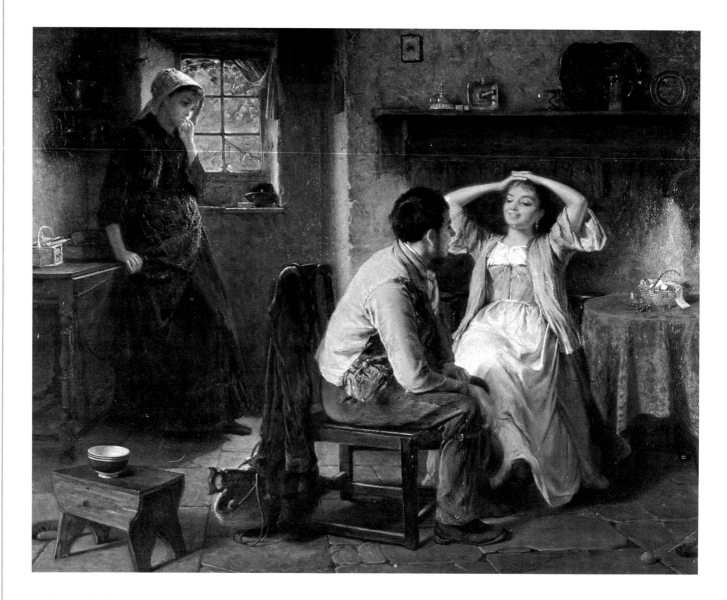

Jealousy and Flirtation by Haynes King.

Love and magic have always been attracted one to the other. The great love stories of antiquity hummed with activity as gods changed into swans or bulls, and Jupiter roamed about disguised as a fly in order to surprise many an unsuspecting mortal. Later, wizards busily stirred bubbling cauldrons of love charms, and mumbled abstruse spells. In ancient Britain, King Uther Pendragon launched the Arthurian saga by commissioning Merlin to change him into the likeness of Gorlais, Duke of Cornwall, so that he could enjoy the latter's wife, Ygerna. And young King Arthur, the result of that union, ruled over a country in which lovers fought unrelentingly against, or with the help of, strange magic.

Other European sagas – the Ring, for instance – are equally alive with love-spells. Tristan and Iseult were thrown into their catastrophic affair as the result of a magic potion, and incantations visited unsuspecting lovers with drama, delirious joy, or sometimes deep tragedy. Gradually,

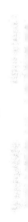

the incantations turned into love-rhymes and spells, and often they were specially designed to comfort young girls who had not yet found a lover or husband. One amateur magician in the early nineteenth century set out this recipe for discovering a future husband:

'The seeds of butter-dock (coltsfoot) must be sowed by a young unmarried woman half an hour before sunrise on a Friday morning, in a lonesome place. She must strew the seeds gradually, on the grass, saying these words –

> I sow, I sow
> Then, my own dear,
> Come here, come here,
> And mow and mow!

The seed being scattered, she will see her future husband mowing with a scythe at a short distance from her. She must not be frightened, for if she says "Have mercy on me!" he will immediately vanish. This method is said to be infallible, but it is looked upon as a bold, desperate and presumptuous undertaking.'

John Aubrey, the inveterate seventeenth-century scholar and gossip, noted down several country spells, among which, 'on St Agnes night, 21 January, take a row of pins, and pull out every one, one after another, saying a paternoster, sticking a pin in your sleeve, and you will dream of him or her you shall marry. You must lie in another county, and knit the left garter about the right-legg'd stocking . . . and as you rehearse the following verses, at every comma knit a knot:

> *This knot I knit,*
> *To know the thing I know not yet,*
> *That I may see*
> *The man that shall my husband be,*
> *How he goes and what he wears,*
> *And what he does all the days.*

Accordingly in your dream you will see him.'

Superstition also had much to do with the little keepsakes of love: the band of hair worn in a ring or locket – no doubt this had connections with the Samson and Delilah legend; the idea was that with a little of the loved one's hair one possessed a little of his or her strength, for ever.

Within living memory, gifts have been given with some faint idea of their magical properites; and girls have used rhymes and charms to bring their loved ones into their dreams, or even their arms. No doubt the spells often seemed to work: if a girl was so determined to win her man as to go through the complex procedures sometimes demanded by these spells, she probably won him in the end!

overleaf: Keepsakes of love. (*Photograph by John Hedgecoe.*)

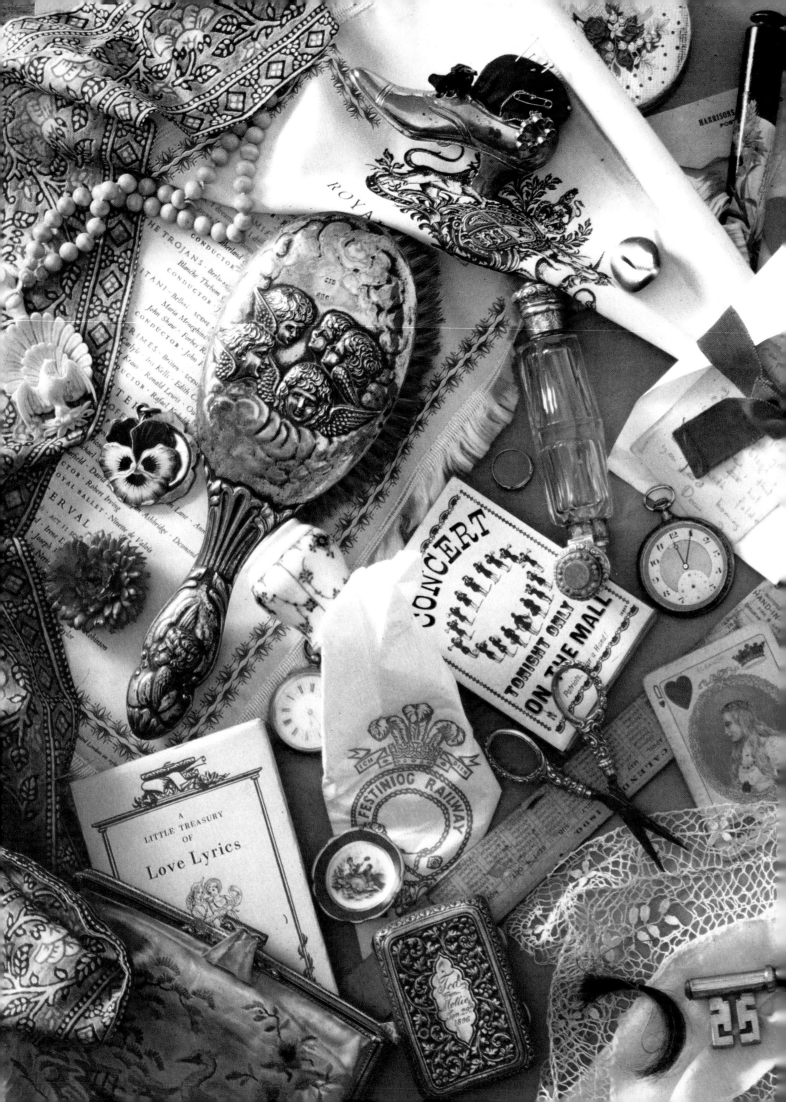

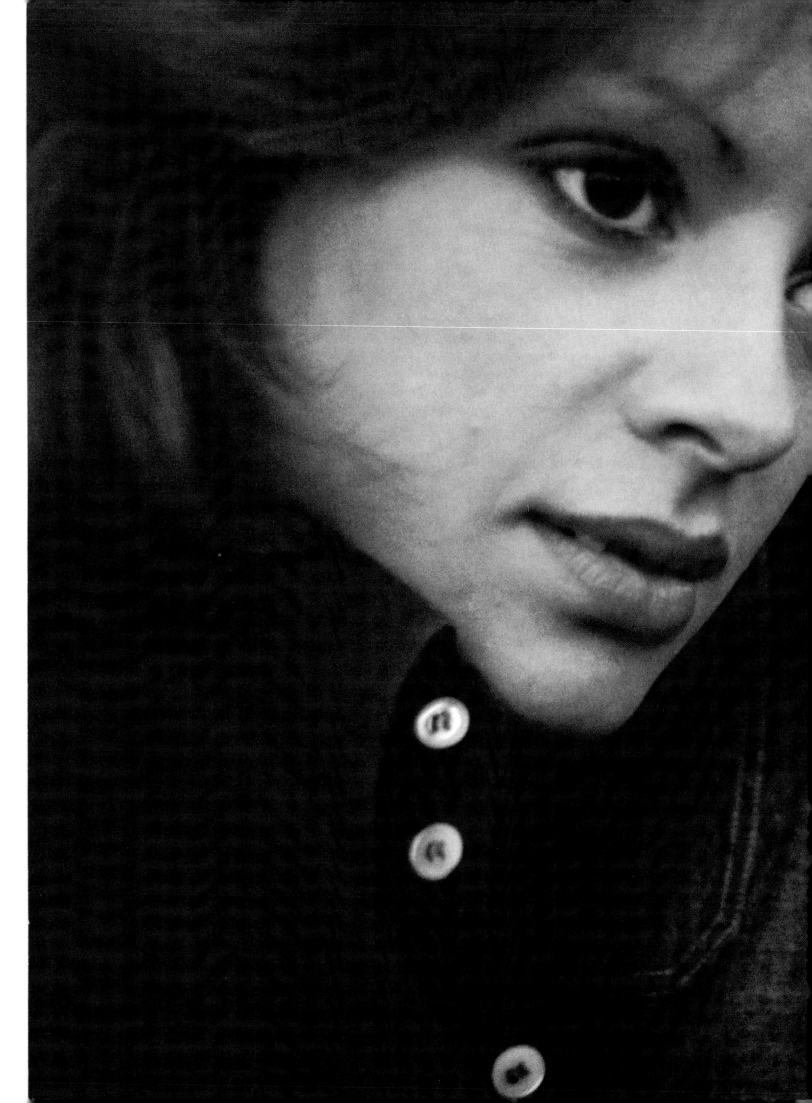

The Simple Magic of Togetherness

Sometimes the course of true love runs smoothly but such cases have usually been the exception. Yet love is often strengthened by the prospect or the experience of danger: a man who fought a duel for his mistress could show no more fiercely how much he loved her than to risk life and limb; while she could only hope that the right man won. Similarly, there is no surer way of driving lovers together than to deny each to the other, as many worried parents have found. What is perhaps not so clearly understood is that jealousy is an admirable aphrodisiac, too, and can rebound. There is a story told by Inge and Sten Hegeler of a young man who for years had been the lover of a girl who one day began to show an interest in someone else; she began turning down his invitations, obviously became bored with him, and seemed to want to end the whole affair. At first he thought of bursting into her flat; then he wrote her a seven-page letter, filled with sentimental memories and pleas. Then he tore it up, and instead sent her two dozen dark red roses, with a card on which he wrote: 'Dear Else – Thank you for the time we had together. Thanks for – you. Hans.' They have now been happily married for several years.

Not all love stories have happy endings. And the greatest are often tragic: Antony and Cleopatra, Hero and Leander, Petrarch and Laura, Dante and Beatrice, Romeo and Juliet – these real and fictional lovers, loving with all their strength, loved finally in vain. It seems that living 'happily ever after' is really the reward of those who love steadily, truly and passionately but in a more relaxed fashion – a prescription that may prove very difficult to follow, however hard we try.

If there is any truth in the simple ideal of 'love in a cottage' it is that the company of one's lover is enough. Diamonds, perfume and mink stole – all the accoutrements of courtship – are in the end superfluous.

Come live with me and be my love,
And we will all the pleasures prove.

CHRISTOPHER MARLOWE

Togetherness is what matters.

Falling
in Love
An Anthology

Introduction

Words are almost as natural to the expression of love as bodily caresses. And love can turn the least adequate of us into a poet. The first hint of it and we are away, carefully rhyming *love* and *dove*, *moon* and *June*!

But most of us in our moments of emotion find ourselves turning to the song writers and the poets and novelists to express our love for us. Passionate or light hearted, flip or tender, ironic or ecstatic, all the many contradictory faces of love are caught and reflected in their writings.

from Anna Karenina

Vronsky followed the guard to the carriage, and at the door of the compartment he stopped short to make room for a lady who was getting out.

With the insight of a man of the world, from one glance at this lady's appearance Vronsky classified her as belonging to the best society. He begged pardon, and was getting into the carriage, but felt he must glance at her once more; not that she was very beautiful, not on account of the elegance and modest grace which were apparent in her whole figure, but because in the expression of her charming face, as she passed close by him, there was something peculiarly caressing and soft. As he looked round, she too turned her head. Her shining grey eyes, that looked dark from the thick lashes, rested with friendly attention on his face, as though she were recognizing him, and then promptly turned away to the passing crowd, as though seeking someone. In that brief look Vronsky had time to notice the suppressed eagerness which played over her face, and flitted between the brilliant eyes and the faint smile that curved her red lips. It was as though her nature were so brimming over with something that against her will it showed itself now in the flash of her eyes, and now in her smile.

LEO TOLSTOY, *1828–1910, translated by Constance Garnett*

Not to Sleep

Not to sleep all the night long, for pure joy,
Counting no sheep and careless of chimes,
Welcoming the dawn confabulation
Of birds, her children, who discuss idly
Fanciful details of the promised coming—
Will she be wearing red, or russet, or blue,
Or pure white?—whatever she wears, glorious:
Not to sleep all the night long, for pure joy,
This is given to few but at last to me,
So that when I laugh and stretch and leap from bed
I shall glide downstairs, my feet brushing the carpet
In courtesy to civilized progression,
Though, did I wish, I could soar through the open window
And perch on a branch above, acceptable ally
Of the birds still alert, grumbling gently together.

ROBERT GRAVES, *b. 1895*

Madam,

It is the hardest thing in the world to be in love, and yet attend to business. As for me, all who speak to me find out, and I must lock myself up, or other people will do it for me.

A gentleman asked this morning, 'What news from Lisbon?' and I answered, 'She is exquisitely handsome.' Another desired to know 'when I had last been at Hampton Court?' I replied, 'It will be on Tuesday come se'nnight.' Pr'ythee allow me at least to kiss your hand before that day, that my mind may be in some composure. O Love!

> *A thousand torments dwell about thee,*
> *Yet who could live, to live without thee?*

Methinks I could write a volume to you; but all the language on earth would fail in saying how much, and with what disinterested passion,

I am ever yours,
Rich. Steele.

SIR RICHARD STEELE *to Mrs Scurlock*

The Two

She carried the goblet in her hand
—Her chin and mouth shaped like its rim—
Her walk was light and sure,
Not a drop fell from the cup.

So light and sure was his hand:
He rode a spirited charger
And with one casual gesture
Brought it to a shivering halt.

But when from her gentle hand
He went to take the goblet
Difficulty overtook them:
Both began to tremble,
Their hands never came together
And dark wine stained the ground.

HUGO VON HOFMANNSTHAL,
1874–1929, translated
by Derek Parker

Girl Lithe and Tawny

Girl lithe and tawny, the sun that forms
the fruits, that plumps the grains, that curls seaweeds

filled your body with joy, and your luminous eyes
and your mouth that has the smile of the water.

A black yearning sun is braided into the strands
of your black mane, when you stretch your arms.
You play with the sun as with a little brook
and it leaves two dark pools in your eyes.

Girl lithe and tawny, nothing draws me towards you.
Everything bears me farther away, as though you were noon.

You are the frenzied youth of the bee,
the drunkenness of the wave, the power of the wheat-ear.

My sombre heart searches for you, nevertheless,
and I love your joyful body, your slender and flowing voice.

Dark butterfly, sweet and definitive
like the wheat-field and the sun, the poppy and the water.

PABLO NERUDA, *b. 1904, translated by W. S. Merwin*

from The History of Mr Polly

And Mr Polly fell in love, as though the world had given way beneath him and he had dropped through into another, into a world of luminous clouds and of a desolate, hopeless wilderness of desiring and of wild valleys of unreasonable ecstasy, a world whose infinite miseries were finer and in some inexplicable way sweeter than the purest gold of the daily life, whose joys—they were indeed but the merest remote glimpses of joy—were brighter than a dying martyr's vision of heaven. Her smiling face looked down upon him out of the sky, her careless pose was the living body of life. It was senseless, it was utterly foolish, but all that was best and richest in Mr Polly's nature broke like a wave and foamed up at the girl's feet, and died, and never touched her. And she sat on the wall and marvelled at him, and was amused.

H. G. WELLS, *1866–1946*

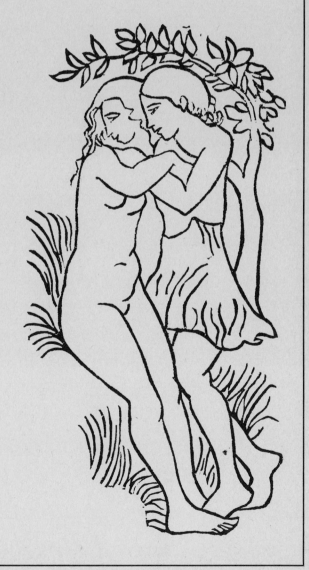

The Dalliance of the Leopards

Very afraid
I saw the dalliance of the leopards.
In the beauty of their coats
They sought each other and embraced.
Had I gone between them then
And pulled them asunder by their manes,
I would have run less risk
Than when I passed in my boat
And saw you standing on a dead tree
Ready to dive and kindle the river.

ANON. *From* the Sanskrit, *5th Cent. A.D.*

Blow, Wind, to Where My Loved One Is

Blow, wind, to where my loved one is,
Touch her, and come and touch me soon:
I'll feel her gentle touch through you,
And meet her beauty in the moon.
These things are much for one who loves—
A man can live by them alone—
That she and I breathe the same air,
And that the earth we tread is one.

Translated from the Sanskrit of the RĀMĀYANA
by John Brough

from *Marriage and Morals*

I believe myself that romantic love is the source of the most intense delights that life has to offer. In the relation of a man and a woman who love each other with passion and imagination and tenderness, there is something of inestimable value, to be ignorant of which is a great misfortune to any human being.

<div align="right">

BERTRAND RUSSELL, *1872–1971*

</div>

Upon Julia's Clothes

Whenas in silks my Julia goes,
Then, then (methinks) how sweetly flows
The liquefaction of her clothes.

Next, when I cast mine eyes and see
That brave vibration each way free,
O how that glittering taketh me!

<div align="right">

ROBERT HERRICK, *1591–1674*

</div>

Teresa Guiccioli meets Lord Byron

I became acquainted with Lord Byron in the April of 1819; he was introduced to me at Venice by the Countess Benzoni at one of that lady's parties. This introduction, which had so much influence over the lives of us both, took place contrary to our wishes, and had been permitted by us only for courtesy. For myself, more fatigued than usual that evening on account of the late hours they keep at Venice, I went with great repugnance to this party, and purely in obedience to Count Guiccioli. Byron, too, who was averse to forming new acquaintances – alleging that he had entirely renounced all attachments, and was unwilling any more to expose himself to their consequences – on being requested by the Countess Benzoni to allow himself to be presented to me, refused, and, at last, only assented from a desire to oblige her. His noble and exquisitely beautiful countenance, the tone of his voice, his manners, the thousand enchantments that surrounded him, rendered him so different and so superior a being to any whom I had hitherto seen that it was impossible he should not have left the most profound impression upon me. From that evening, during the whole of my subsequent stay in Venice, we met every day.

From a letter from the COUNTESS TERESA GUICCIOLI *to Thomas Moore*

from *To Earthward*

Love at the lips was touch
As sweet as I could bear;
And once that seemed too much;
I lived on air

That crossed me from sweet things,
The flow of – was it musk
From hidden grapevine springs
Down hill at dusk?

I had the swirl and ache
From sprays of honeysuckle
That when they're gathered shake
Dew on the knuckle.

ROBERT FROST, *1875–1963*

A Birthday

My heart is like a singing bird
 Whose nest is in a water'd shoot;
My heart is like an apple-tree
 Whose boughs are bent with
 thickest fruit;
My heart is like a rainbow shell
 That paddles in a halcyon sea;
My heart is gladder than all these,
 Because my love has come to me.

Raise me a daïs of silk and down;
 Hang it with vair and purple dyes;
Carve it in doves, and pomegranates,
 And peacocks with a hundred eyes;
Work it in gold and silver grapes,
 In leaves and silver fleurs-de-lys;
Because the birthday of my life
 Is come, my love is come to me.

CHRISTINA ROSSETTI, *1830–94*

The Sonnets

Between about 1593 and 1600, William Shakespeare wrote a sequence of 154 sonnets, which are among the greatest records of love in world literature. There is still some mystery about the men and women mentioned in the poems, though various scholars claim to have solved the puzzle: but the handsome young man to whom many of the sonnets are addressed, the stolen mistress, the rival poet and the 'dark Lady' immortalized by Shakespeare remain shadowy figures whose clothes we may all wear. . .

18

Shall I compare thee to a summer's day?
Thou art more lovely and more temperate:
Rough winds do shake the darling buds of May,
And summer's lease hath all too short a date:
Sometime too hot the eye of heaven shines,
And often is his gold complexion dimm'd;
And every fair from fair sometime declines,
By chance, or nature's changing course, untrimm'd;
But thy eternal summer shall not fade,
Nor lose possession of that fair thou ow'st;
Nor shall Death brag thou wander'st in his shade,
When in eternal lines to time thou grow'st:
 So long as men can breathe, or eyes can see,
 So long lives this, and this gives life to thee.

29

When, in disgrace with fortune and men's eyes,
I all alone beweep my outcast state,
And trouble deaf heaven with my bootless cries,
And look upon myself, and curse my fate,
Wishing me like to one more rich in hope,
Featured like him, like him with friends possest,
Desiring this man's art, and that man's scope,
With what I most enjoy contented least;
Yet in these thoughts myself almost despising,
Haply I think on thee, – and then my state,
Like to the lark at break of day arising
From sullen earth, sings hymns at heaven's gate;
 For thy sweet love remember'd such wealth brings,
 That then I scorn to change my state with kings.

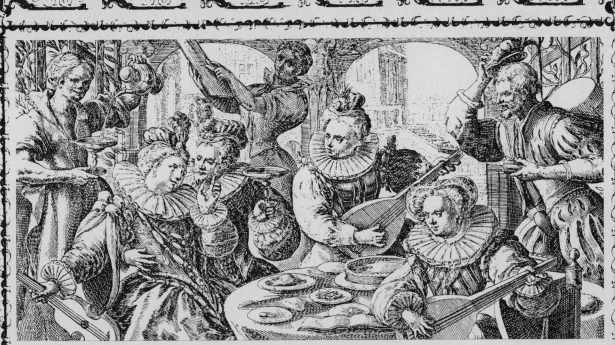

30

When to the sessions of sweet silent thought
I summon up remembrance of things past,
I sigh the lack of many a thing I sought,
And with old woes new wail my dear time's waste:
Then can I drown an eye, unused to flow,
For precious friends hid in death's dateless night,
And weep afresh love's long since cancell'd woe,
And moan the expense of many a vanish't sight:
Then can I grieve at grievances foregone,
And heavily from woe to woe tell o'er
The sad account of fore-bemoaned moan,
Which I new pay as if not paid before.
 But if the while I think on thee, dear friend,
 All losses are restored, and sorrows end.

116

Let me not to the marriage of true minds
Admit impediments. Love is not love
Which alters when it alteration finds,
Or bends with the remover to remove.
O no! it is an ever-fixèd mark
That looks on tempests, and is never shaken;
It is the star to every wandering bark,
Whose worth's unknown, although his height be taken.
Love's not Time's fool, though rosy lips and cheeks
Within his bending sickle's compass come;
Love alters not with his brief hours and weeks,
But bears it out even to the edge of doom.
 If this be error and upon me proved,
 I never writ, nor no man ever loved.

from To His Coy Mistress

Had we but world enough, and time,
This coyness, lady, were no crime . . .
. . . My vegetable love should grow
Vaster than empires, and more slow.
A hundred years should go to praise
Thine eyes, and on thy forehead gaze;
Two hundred to adore each breast,
But thirty thousand to the rest.
An age at least to every part,
And the last age should show your heart.
For lady you deserve this state,
Nor would I love at lesser rate.
But at my back I always hear
Time's winged chariot hurrying near,
And yonder all before us lie
Deserts of vast eternity.

ANDREW MARVELL, *1621–75*

In Praise of Cocoa

*(Lines written upon hearing the startling
news that cocoa is, in fact, a mild
aphrodisiac)*

Half past nine – high time for supper;
'Cocoa, love?' 'Of course, my dear.'
Helen thinks it quite delicious,
John prefers it now to beer.

Knocking back the sepia potion,
Hubby winks, says, 'Who's for bed?'
'Shan't be long,' says Helen softly,
Cheeks a faintly flushing red,

For they've stumbled on the secret
Of a love that never wanes,
Rapt beneath the tumbled bedclothes,
Cocoa coursing through their veins.

STANLEY J. SHARPLESS, *b. 1910*

The Message of the Rose

Go, lovely Rose –
Tell her that wastes her time and me,
That now she knows
When I resemble her to thee,
How sweet and fair she seems to be.

Tell her that's young,
And shuns to have her graces spied,
That hadst thou sprung
In deserts where no men abide,
Thou must have uncommended died.

Small is the worth
Of beauty from the light retired:
Bid her come forth,
Suffer herself to be desired,
And not blush so to be admired.

Then die – that she
The common fate of all things rare
May read in thee;
How small a part of time they share
That are so wondrous sweet and fair!

EDMUND WALLER, *1606–87*

from *Washington Square*

He looked straight into Catherine's eyes. She answered nothing; she only
listened, and looked at him; and he, as if he expected no particular reply,
went on to say many things in a comfortable and natural manner.
Catherine, though she felt tongue-tied, was conscious of no embarrass-
ment; it seemed proper that he should talk, and that she should simply
look at him. What made it natural was that he was so handsome, or,
rather, as she phrased it to herself, so beautiful. The music had been silent
for a while, but it suddenly began again; and then he asked her, with a
deeper, intenser smile, if she would do him the honor of dancing with
him. Even to this inquiry she gave no audible assent; she simply let him
put his arm round her waist – as she did so, it occurred to her more
vividly than it had ever done before that this was a singular place for a
gentleman's arm to be – and in a moment he was guiding her round the
room in the harmonious rotation of the polka.

HENRY JAMES, *1843–1916*

viva sweet love

'sweet spring is your
time is my time is our
time for springtime is lovetime
and viva sweet love'

(all the merry little birds are
flying in the floating in the
very spirits singing in
are winging in the blossoming)

lovers go and lovers come
awandering awondering
but any two are perfectly
alone there's nobody else alive

(such a sky and such a sun
i never knew and neither did you
and everybody never breathed
quite so many kinds of yes)

not a tree can count his leaves
each herself by opening
but shining who by thousands mean
only one amazing thing

(secretly adoring shyly
tiny winging darting floating
merry in the blossoming
always joyful selves are singing)

'sweet spring is your
time is my time is our
time for springtime is lovetime
and viva sweet love'

E. E. CUMMINGS, *1894–1962*

from **The Angel in the House**

'I saw you take his kiss!' 'Tis true.'
'O, modesty!' 'Twas strictly kept:
He thought me asleep; at least, I knew
He thought I thought he thought I slept.'

COVENTRY PATMORE, *1823–96*

Recuerdo

We were very tired, we were very merry—
We had gone back and forth all night on the ferry.
It was bare and bright, and smelled like a stable—
But we looked into a fire, we leaned across a table,
We lay on a hill-top underneath the moon;
And the whistles kept blowing, and the dawn came soon.

We were very tired, we were very merry—
We had gone back and forth all night on the ferry;
And you ate an apple, and I ate a pear,
From a dozen of each we had bought somewhere;
And the sky went wan, and the wind came cold,
And the sun rose dripping, a bucketful of gold.

We were very tired, we were very merry,
We had gone back and forth all night on the ferry.
We hailed, 'Good-morrow, mother!' to a
 shawl-covered head,
And bought a morning paper, which neither
 of us read;
And she wept, 'God bless you!' for the
 apples and the pears,
And we gave her all our money
 but our subway fares.

EDNA ST VINCENT MILLAY,
 1892–1950

The Look

Strephon kissed me in the spring,
 Robin in the fall,
But Colin only looked at me
 And never kissed at all.

Strephon's kiss was lost in jest,
 Robin's lost in play,
But the kiss in Colin's eyes
 Haunts me night and day.

SARAH TEASDALE, *1884–1933*

Meeting at Night

The grey sea and the long black land;
And the yellow half-moon large and low;
And the startled little waves that leap
In fiery ringlets from their sleep,
As I gain the cove with pushing prow,
And quench its speed i' the slushy sand.

Then a mile of warm sea-scented beach;
Three fields to cross till a farm appears;
A tap at the pane, the quick sharp scratch
And blue spurt of a lighted match
And a voice less loud, thro' its joys and fears,
Than the two hearts beating, each to each!

ROBERT BROWNING, *1812–89*

My dear Teresa,

I have read this book in your garden; – my love, you were absent, or else I could not have read it. It is a favourite book of yours, and the writer [Madame de Staël] was a friend of mine. You will not understand these English words, and other will not understand them – which is the reason I have not scrawled them in Italian. But you will recognize the handwriting of him who passionately loved you, and you will divine that, over a book which was yours, he could only think of love. In that word, beautiful in all languages, but most so in yours, – *amor mio* – is comprised my existence here and hereafter. I feel I exist here, and I fear that I shall exist hereafter, – to what purpose you will decide; my destiny rests with you, and you are a woman, eighteen years of age, and two out of a convent. I wish that you had stayed there, with all my heart, – or, at least, that I had never met you in your married state.

But all this is too late. I love you, and you love me, – at least you *say* so, and act as if you *did* so, which last is a great consolation at all events. But *I* more than love you, and cannot cease to love you.

Think of me, sometimes, when the Alps and the ocean divide us, – but they never will, unless you *wish* it.

Byron

LORD BYRON *to the Countess Teresa Guiccioli*

Summer Poem

I will bring you flowers
every morning for your breakfast
and you will kiss me
with flowers in your mouth
and you will bring me flowers
every morning when you wake
and look at me with flowers in your eyes

HEATHER HOLDEN, *b. 1946*

from *In the Midnight Hour*

When we meet
In the midnight hour
country girl
I will bring you nightflowers
coloured like your eyes
in the moonlight
in the midnight hour

I remember

Your cold hand
held for a moment among strangers
held for a moment among dripping trees
in the midnight hour

I remember

. . .

walking in city squares in winter rain
kissing in darkened hallways
walking in empty suburban streets
saying goodnight in deserted alleyways

in the midnight hour

ADRIAN HENRI, *b. 1932*

from *Cyrano de Bergerac*

But all this time your letters—every one was like hearing your voice there in the dark, all around me. At last I came to you. Anyone would. Do you suppose the prim Penelope had stayed at home embroidering if Ulysses wrote like you?

I read them over and over. I grew faint reading them. I belonged to you. Every page of them was like a petal fallen from your soul, like the light and fire of a great love, sweet and strong and true. Forgive me for loving you only because you were beautiful . . . afterwards I loved you for yourself too—knowing you more and loving more of you. It is yourself I love now, your own self.

EDMOND ROSTAND, *1868–1918*

The Passionate Shepherd to his Love

Come live with me and be my Love,
And we will all the pleasures prove
That hills and valleys, dales and fields,
Woods or steepy mountain yields.

And we will sit upon the rocks,
Seeing the shepherds feed their flocks
By shallow rivers, to whose falls
Melodious birds sing madrigals.

And I will make thee beds of roses
And a thousand fragrant posies;
A cap of flowers, and a kirtle
Embroidered all with leaves of myrtle;

A gown made of the finest wool
Which from our pretty lambs we pull;
Fair lined slippers for the cold,
With buckles of the purest gold;

A belt of straw and ivy-buds
With coral clasps and amber studs;
And if these pleasures may thee move,
Come live with me and be my Love. . .

CHRISTOPHER MARLOWE, *1564–93*

Making Love

*An exploration of the physical
world of love*

The Language of the Body

It is only when we are freshly in love that we realize the enormous
potential that we have for feeling rather than thinking. Everything
is sharper, brighter and richer.

Suddenly we look at the world from a different angle and new
vistas open up. We feel more in tune with our surroundings and with
ourselves. Half the joy of love is this unchaining from mental
constraint.

As children we live primarily in the world of the senses. A baby
examines his toes with his eyes, hands and mouth. A child hears the
sound of leaves, feels the wind on his cheek and sees branches swaying.
This combination of sensations mingles to produce the experience of
trees on a windy day. If we say to the child, 'Imagine a tree on a
windy day,' his mind-picture will be a positive one, but to an adult
it will be an idea not a fact, for as adults we live primarily in a
world of abstract thoughts, shut off from the senses by the pressures
and speed of everyday living. Many of us suffer from an almost
total sense-deprivation, most of us from blunted perceptions.

In the following pages we have tried to capture this world
of feeling in pictures that express some of the variety and
wonder of the sensations of the body.

The first step towards a full reawakening
of the senses is to slow up. Concentrate on
the thousands of everyday things you do but
take for granted: for example, the most
automatic of your life-processes – breathing.
Try for a change focusing your attention
on the air moving slowly through your
nostrils and down into your lungs.
Imagine the oxygen flowing
through your body,
bringing life. Then

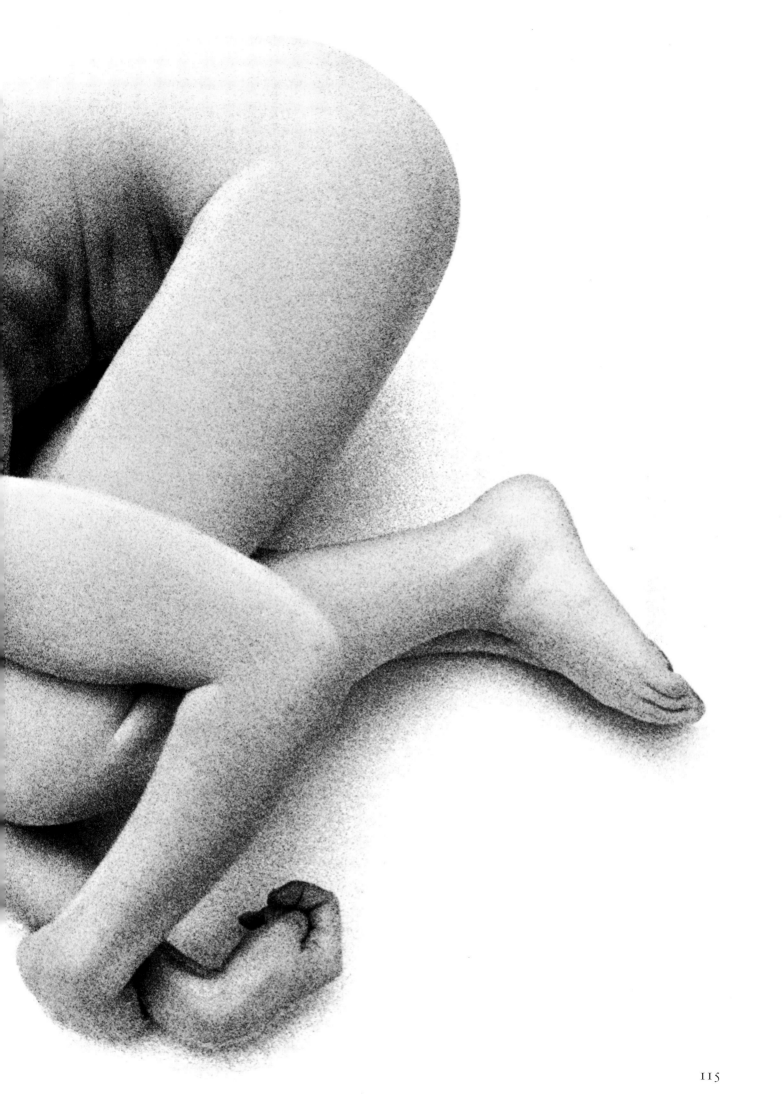

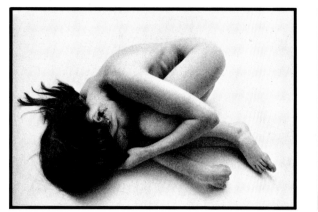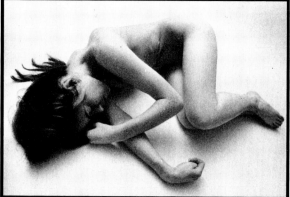

concentrate on breathing out. Become conscious of how you feel.

Repeat this process for everything that you do – drinking, eating, yawning, laughing, stretching, growing. Run your hands over your face and body, experience the different textures of hair and skin, feel the cells you are made of, get to know yourself.

An essential part of reawakening to the world of the senses is to become alive to the world outside. To do this you have to isolate a single experience from the crowding world, like picking up a stone and feeling its smoothness lying in your hand, or trickling sand through your fingers. Return to the simplicity of a child's involvement with kicking up dead leaves in the street, or running in the rain.

It is the individuality and uniqueness of your experience that is important. Learn to encourage and treasure it.

As with exploring the world of your own senses, so with caressing your partner; the secret is to take time to notice and appreciate details of texture and feeling. All too often we are totally absorbed in our own sensations, hurrying on from one feeling to another without savouring them to the full. This is the antithesis of love and of the giving that is inherent in it.

The whole of the body is sensitive and needs to be explored. The skin, all of it, is our biggest sexual resource and capable of great variations of feeling. Remember that you can caress with your hands, hair, nose, mouth, eyelashes.

There are no hard and fast rules – everyone is different, everyone is special. Slowly, by gentle exploration you will discover both your-selves and each other. It is this affectionate journey over the most sensitive areas of your bodies that is much of the joy of love.

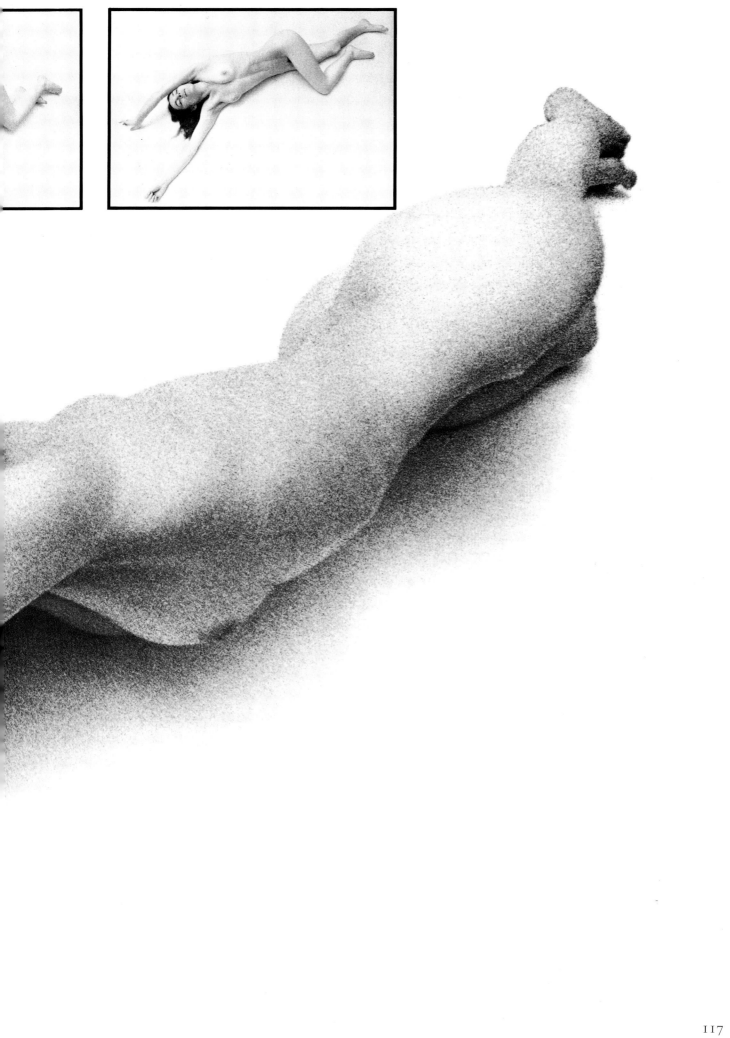

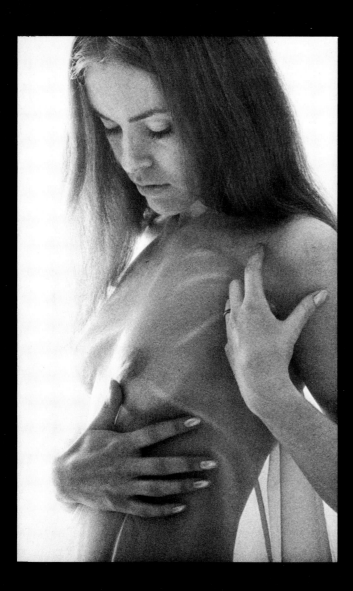

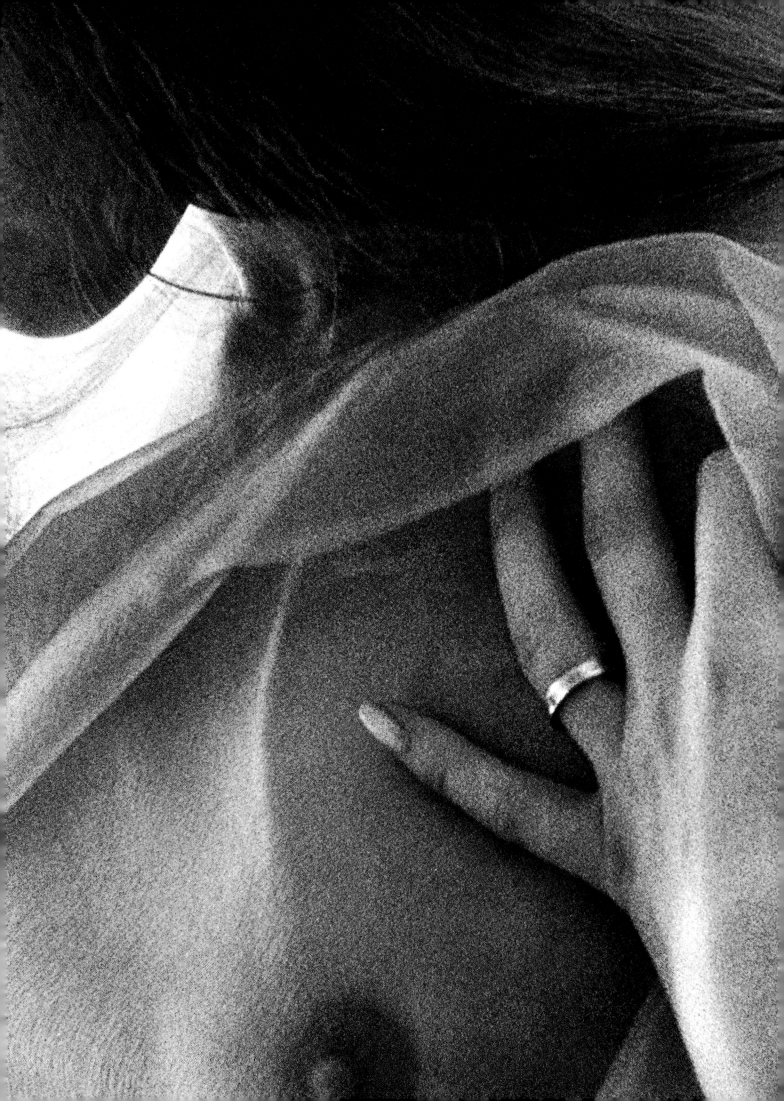

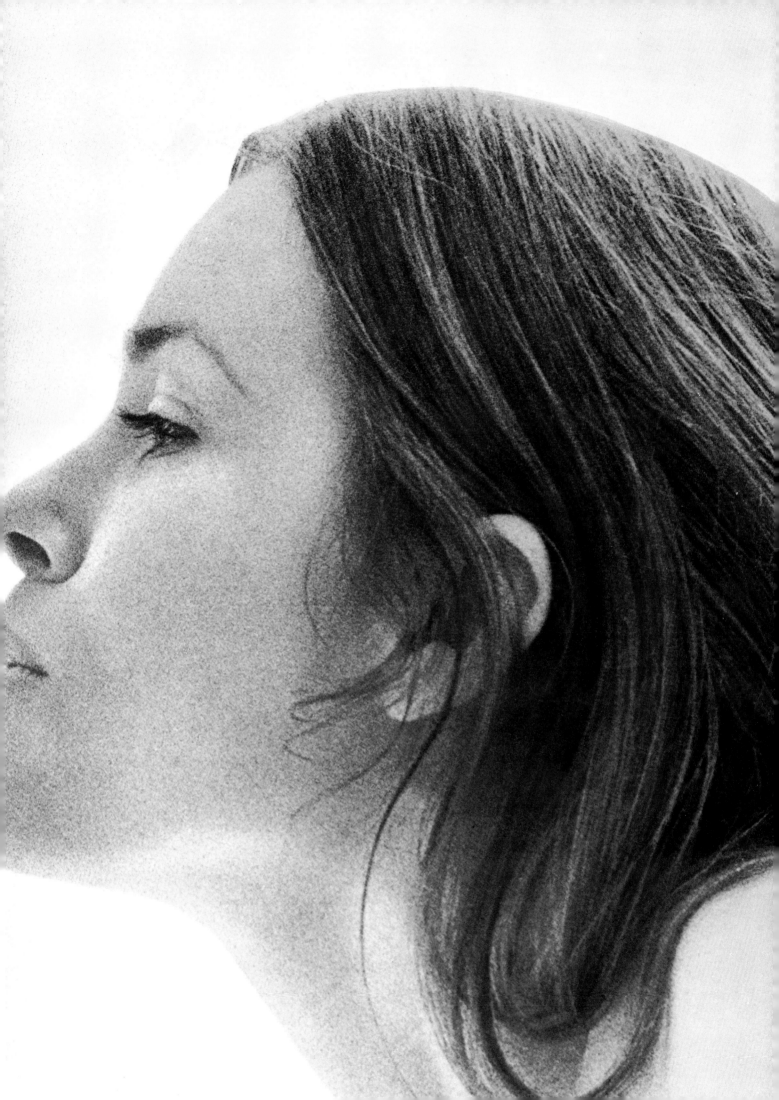

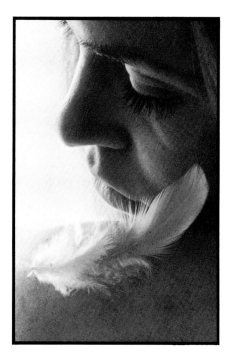

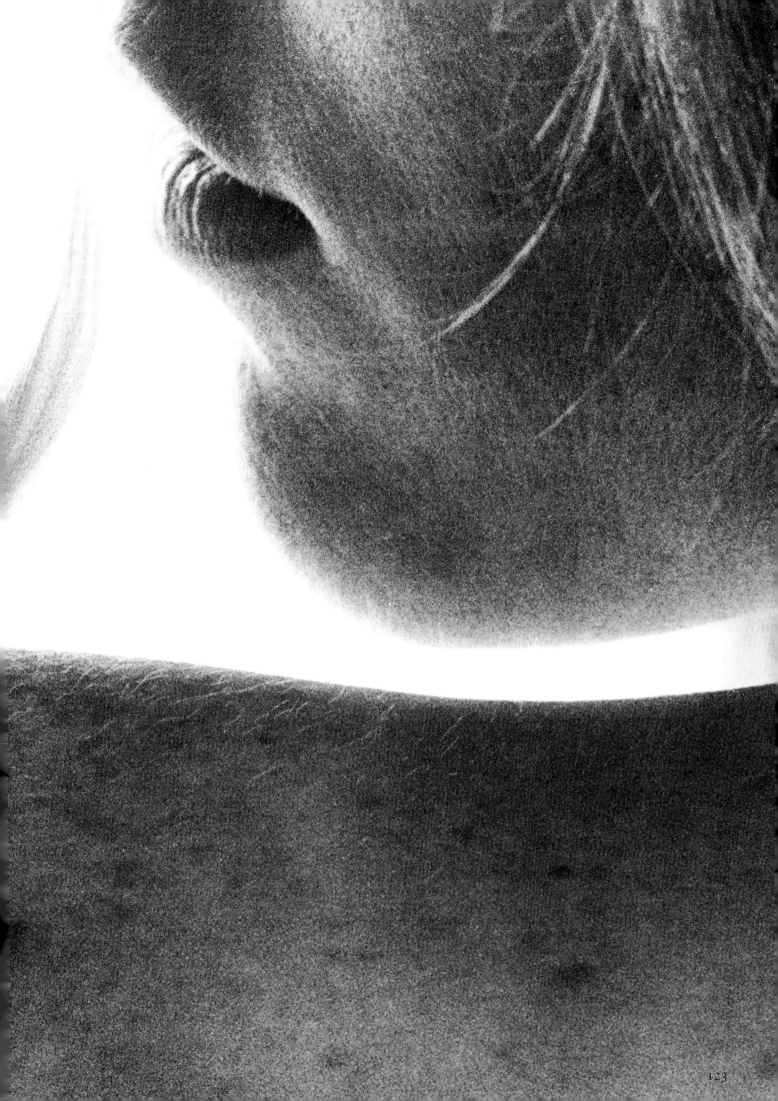

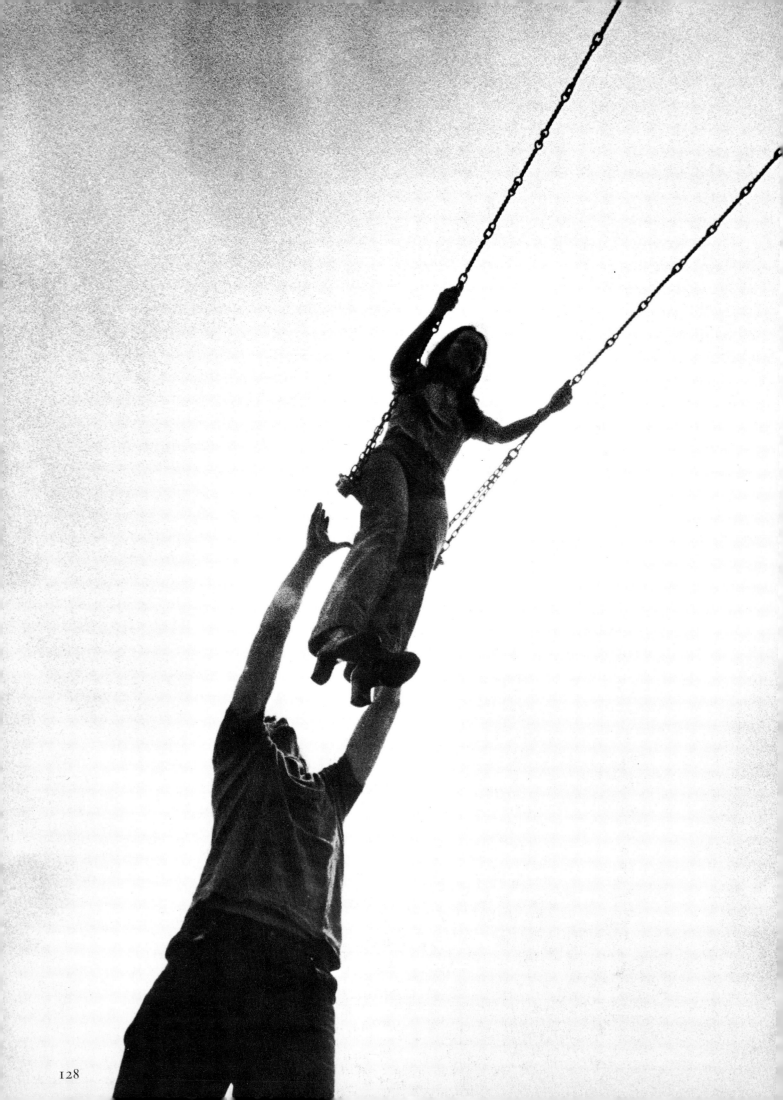

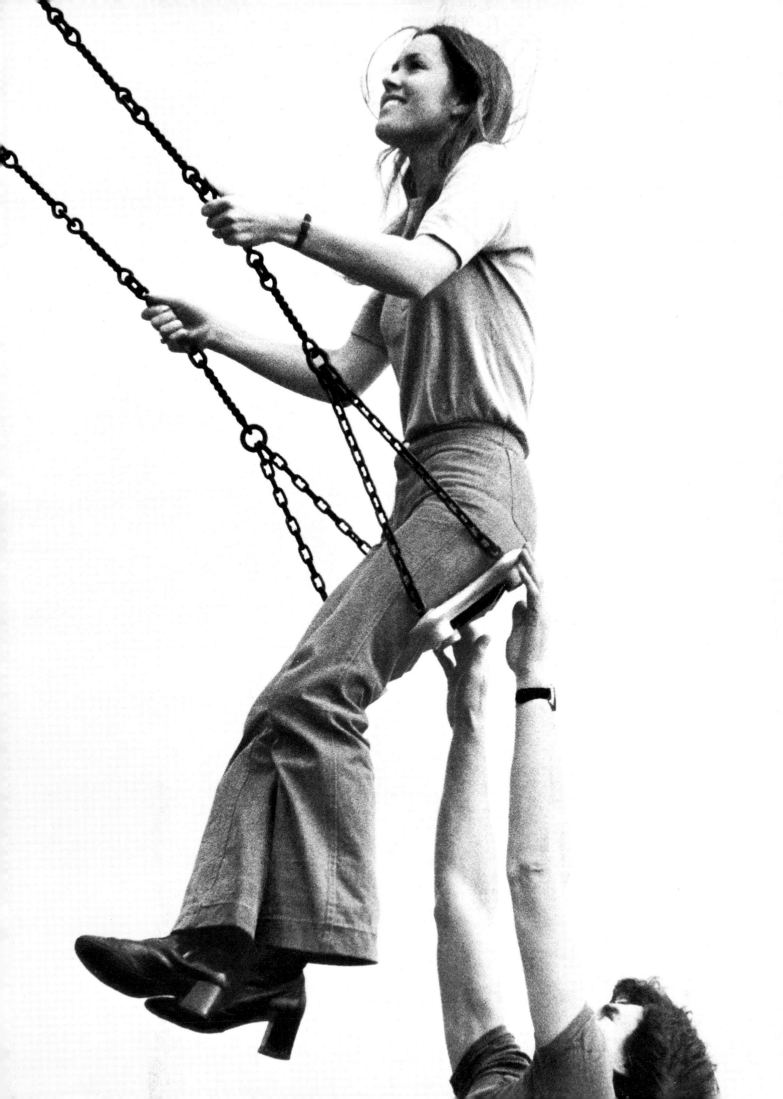

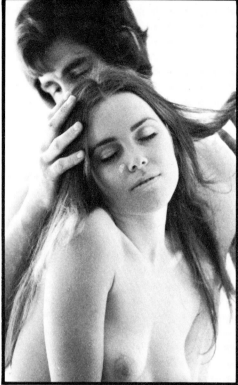

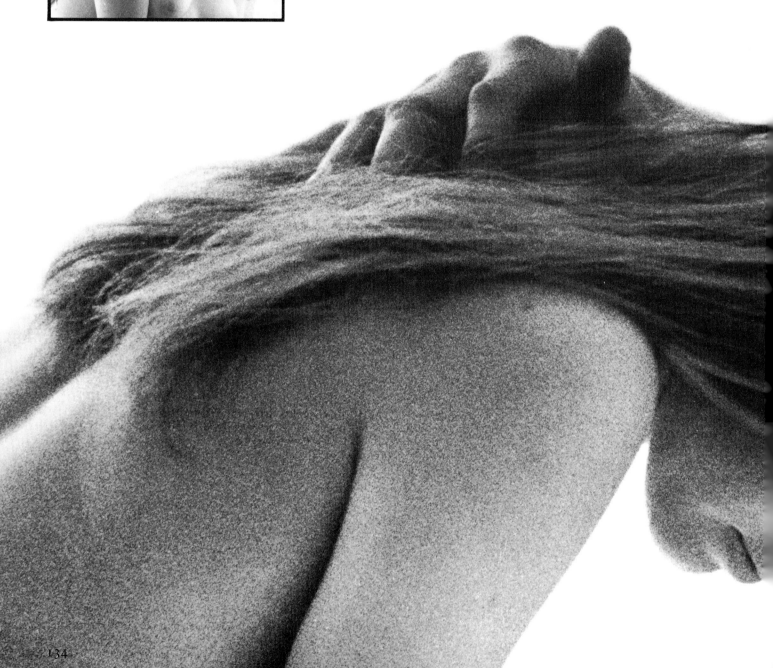

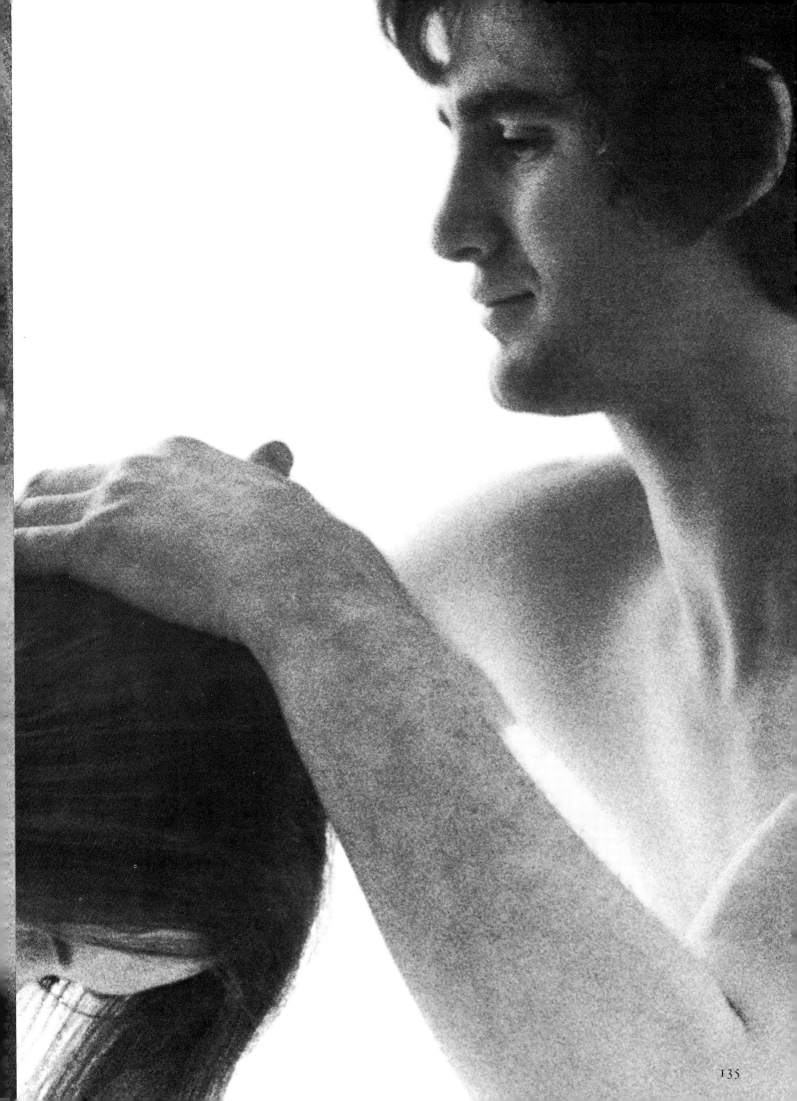

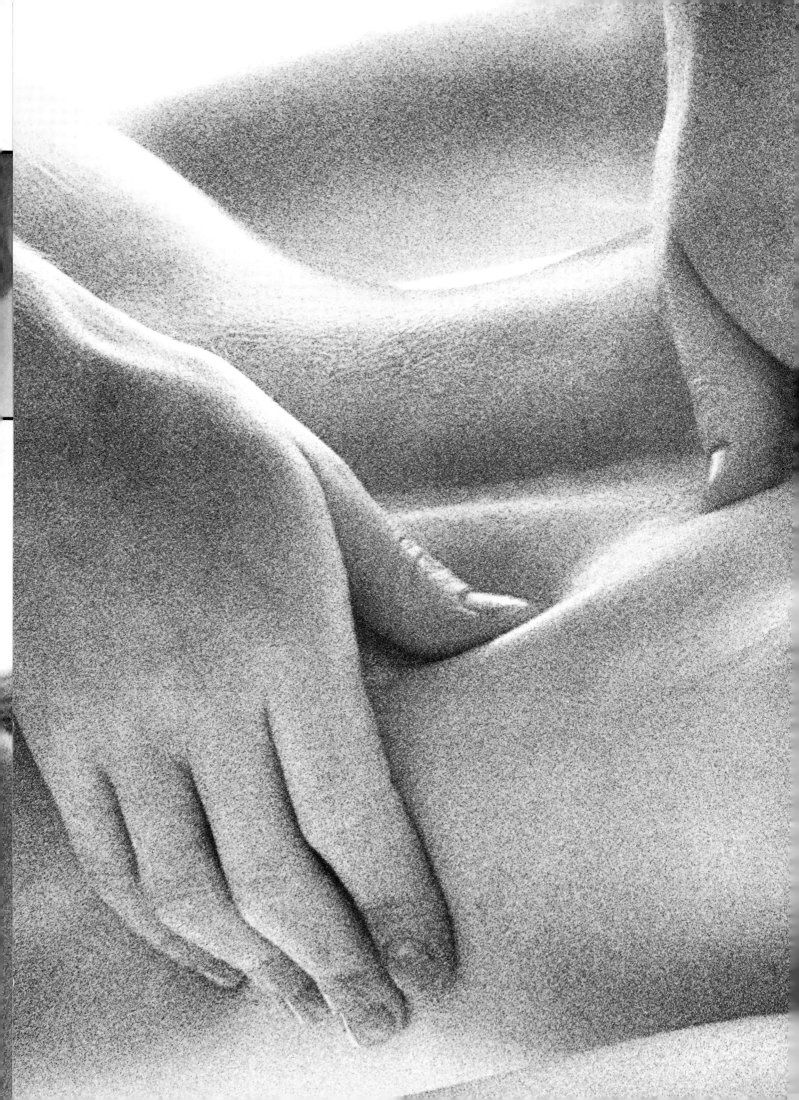

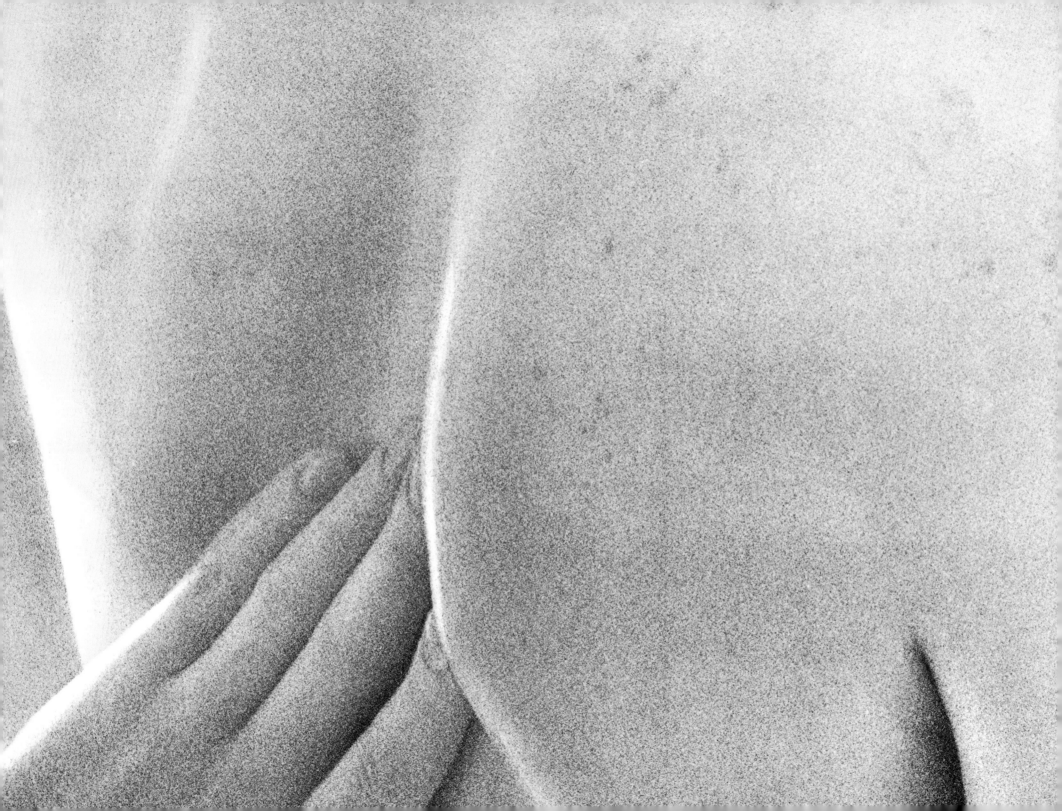

On Making Love

It is only when we have lost ourselves in the totally relaxed, glorious freedom of true love-making that we can begin to glimpse its life-enhancing nature, or the wonderful sense of peace and fulfilment which follows. This is indeed to be born anew, to have every nerve and sinew, every apprehension of life refreshed, for both man and woman. It is as though in making love we re-make our whole world in reflection of our happiness, and with it comes a pleasure – no, more than a pleasure, a joy – which should be at the very centre of life together.

Physical love is so much a part of the whole love relationship that it is silly and even dangerous not to pay it great attention. Who, travelling in a strange country, does not consult a phrase-book and make at least some attempt to understand the general style of an unknown language? It would of course be horrible to force anyone to read one of the explicit pornographic magazines which are now very freely available. But it would be sad, too, if anyone in the 1970s felt that it would be improper or immodest to read one of the many tactfully and often very well written books of sex education that are also available. It should at last, almost for the first time since the destruction of our primal innocence, be possible for every man and woman to relax and free themselves from fear of embarrassment, or the tendency to suspect that anything in love-making can be 'wrong' that the partner accepts and takes pleasure in.

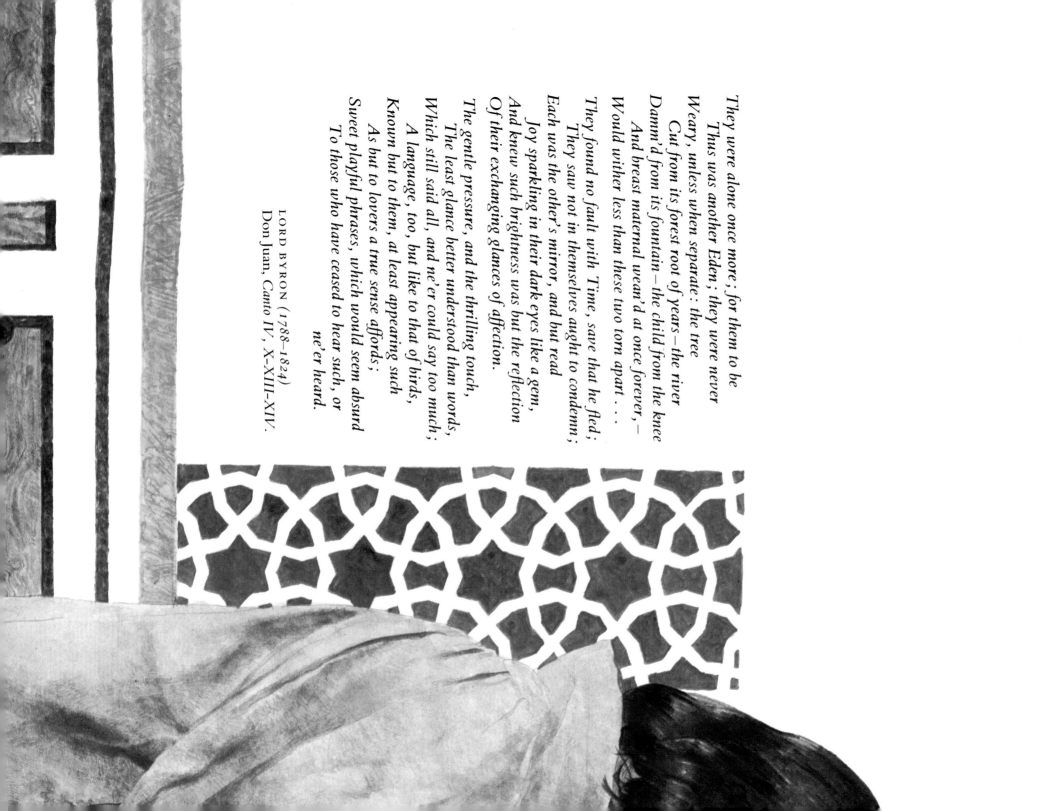

They were alone once more; for them to be
 Thus was another Eden; they were never
Weary, unless when separate: the tree
 Cut from its forest root of years—the river
Damm'd from its fountain—the child from the knee
 And breast maternal wean'd at once forever,—
Would wither less than these two torn apart . . .

They found no fault with Time, save that he fled;
 They saw not in themselves aught to condemn;
Each was the other's mirror, and but read
 Joy sparkling in their dark eyes like a gem,
And knew such brightness was but the reflection
Of their exchanging glances of affection.

The gentle pressure, and the thrilling touch,
 The least glance better understood than words,
Which still said all, and ne'er could say too much;
 A language, too, but like to that of birds,
Known but to them, at least appearing such
 As but to lovers a true sense affords;
Sweet playful phrases, which would seem absurd
 To those who have ceased to hear such, or
 ne'er heard.

LORD BYRON (1788–1824)
Don Juan, Canto IV, X–XIII–XIV.

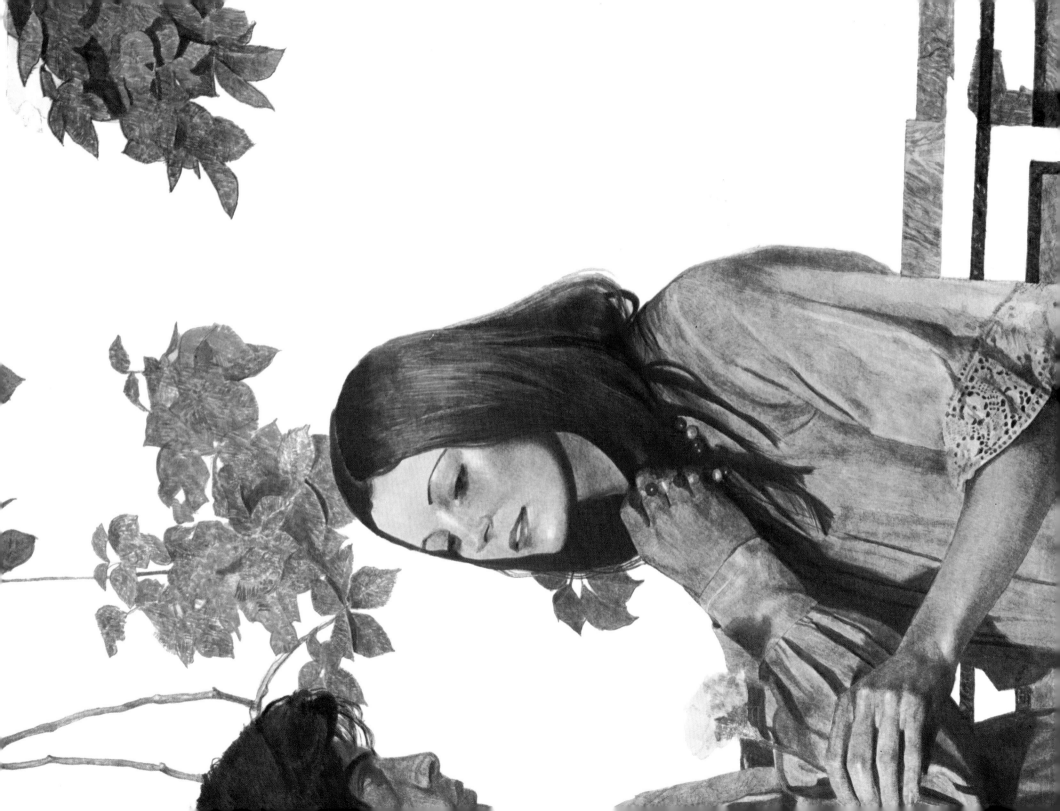

148

above: '... With our clothes we should also shed our inhibitions, any sense of embarrassment, let alone shame.' (*Boisgeloup* by Pablo Picasso.)

right: The tenderness of love. (Detail from *The Month of April* by Francesco del Cossa.)

The language of love is complex and difficult, rewarding and delightful; the greatest fun, yet able to communicate the deepest and most tender truth. We pity the illiterate whose vocabulary is so small that it only allows him to express himself in the simplest, most basic terms; no-one denies that he misses a great deal. And similarly, if we lack the grammar and dictionary of love, if we are not able to express ourselves through our bodies with elegance, charm, force and humour, we are missing out on something essential to happiness. The language of love, of the body, is as individual and personal as our own speech: properly understood and spoken, it never fails. It is the language of life itself.

But only a hundred years ago a main tenet of the Victorian attitude to love-making was expressed in the often stated opinion that 'a lady does not move'. Although there were no doubt many happy couples in the Victorian age, there were also many marriages in which, inhibited from the slightest physical expression of her feelings, the frightened bride remained a frightened wife throughout her married life, the beauty and fulfilment of physical love a closed book to her. Indeed few things are more pitiful to contemplate than the fear and horror with which so many Victorian girls entered marriage, knowing nothing about the physical side of love, told only that there were certain actions on the part of their husbands with which it would be their duty to bear—forced to suffer virtual rape even from the kindest lover, simply because of the conspiracy of silence that surrounded the whole subject. And that conspiracy was virtually complete: in 1887, a doctor was struck off the

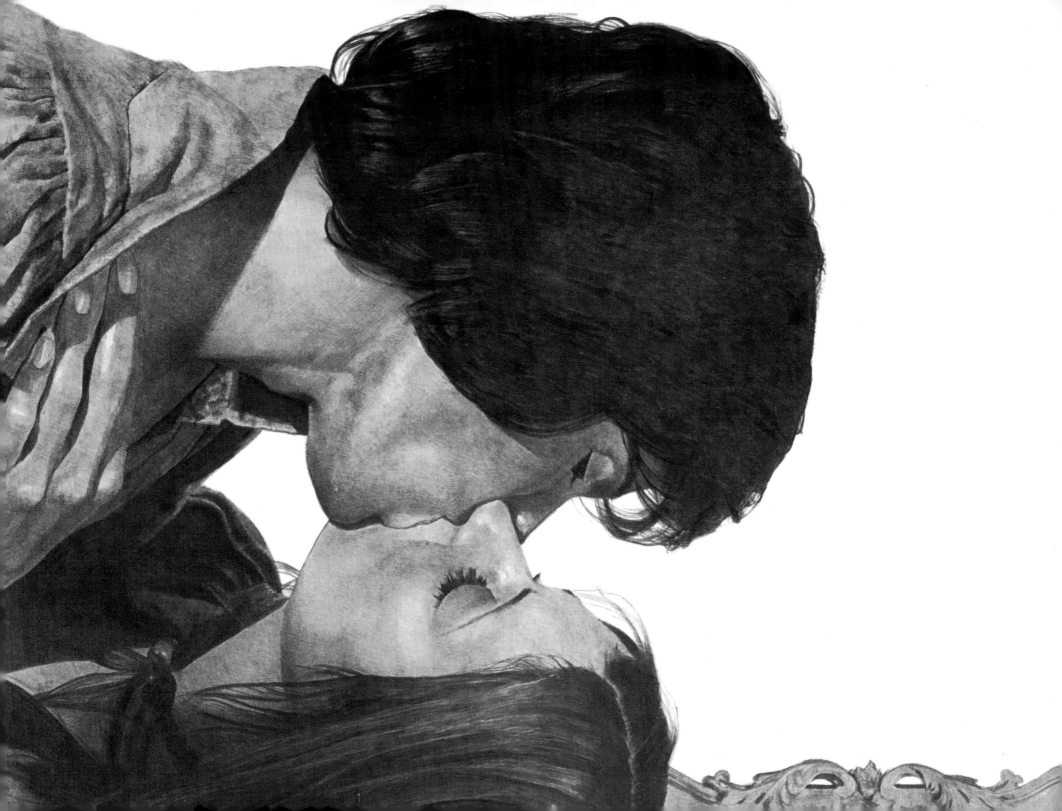

A long, long kiss, a kiss of youth, and love,
And beauty, all concentrating like rays
Into one focus, kindled from above;
Such kisses as belong to early days,
Where heart, and soul, and sense, in concert move,
And the blood's lava, and the pulse a blaze,
Each kiss a heart-quake . . .

LORD BYRON (1788–1824)
Don Juan, Canto II, CLXXXVI.

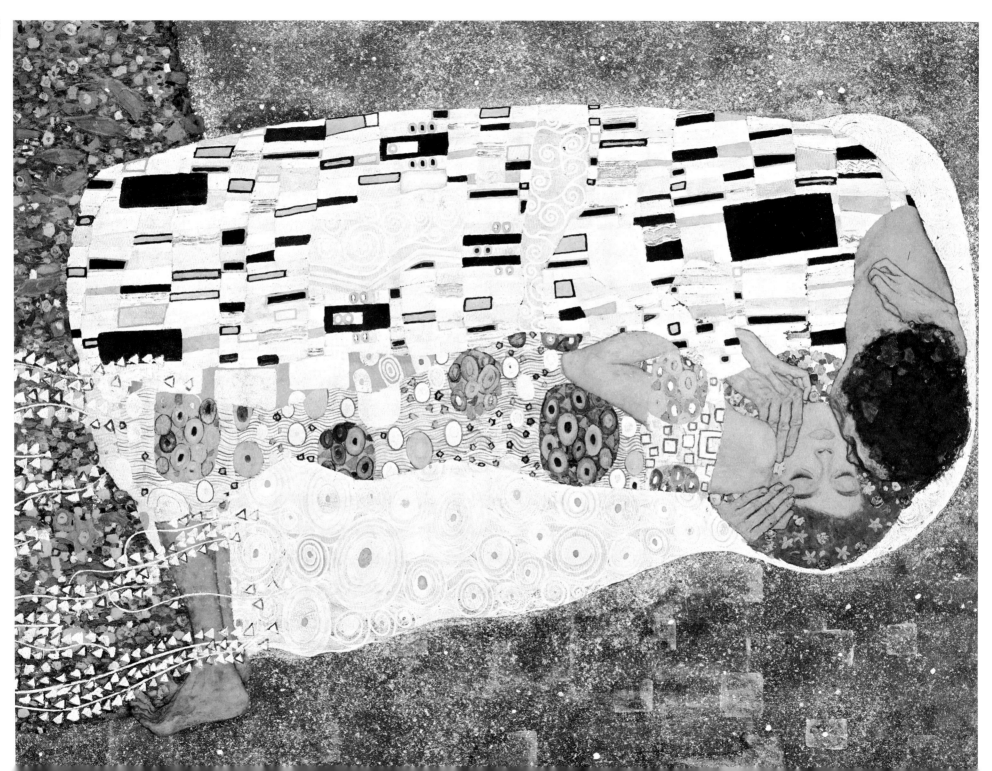

Dalliance by Eric Gill.

register in Britain for selling for sixpence *The Wife's Handbook*, a simple, straightforward and tactful book of sex education. Nor should we pity only the wife: many a husband, too, must have been deeply frustrated by the coldness of his wife, loving enough during their courtship, but, married, 'the sort of girl who while being made love to would calmly reflect that tomorrow was the day for cleaning the parlour' (as Arnold Bennett depicted her).

At least the fear bred of ignorance has now largely vanished. But knowledge and a lack of fear are not in themselves sufficient to make love, early or late, a happy experience. If the new freedom of thought and expression in our own time means anything, it should mean that the last barriers of inhibition are broken down between man and woman; that the disappointments and failures which are almost inevitable in the early stages of a relationship, can be talked about, laughed over, surmounted. There must too be a sense of fun, adventure and enjoyment, and – perhaps most important – a deep desire for the happiness of one's partner. Even today, some people find it difficult to relax, to make love not only without nervousness but without embarrassment. In 1972, the copious nightgowns of the 1880s (when man and woman prepared for bed were often almost as fully dressed as for a tea-party, certainly more fully than for bathing) have gone. And with our clothes we should also shed our inhibitions, any sense of embarrassment, let alone shame. We must realise that we cannot, naked, hold on to the pretences which may be (perhaps essentially) a part of our everyday life. Love-making must not be betrayed by the polite social graces with which we fill our daily lives: our partner is more important than that. We must in fact strive once more to enter Eden, where man and woman were 'both naked, and were not ashamed'.

Lack of ignorance and anxiety in love-making is perhaps one of the greatest gifts the twentieth century offers us. Yet ironically, there is today, perhaps mainly among an older generation, an unmistakable feeling that everyone knows, and says, and writes, a great deal too much about 'love'; that there is no mystery left; that almost before they leave school, a boy and girl know too much about 'the facts of life'.

Even if this were true – and it is at least arguable that there is no such thing as too much information on *any* subject – what is forgotten is that all this information is simply academic: that the most explicit illustration of love-making does not begin to convey the real mystery of the act. The danger is that a boy and girl may 'know' precisely what *happens* in the act of love without beginning to realize even faintly the depth of emotion stirred by its very first gesture, or the extent to which one's body can become the instrument of one's very self, so that making love can be 'a gesture of the spirit'.

The danger of 'knowing too much' is that with the vanished mystery, with the final disappearance of the fear which always accompanies the unknown, will vanish also the gentleness, the tenderness which at

left: *The Kiss* by Gustav Klimt.

153

It was such pleasure to behold him, such
 Enlargement of existence to partake
Nature with him, to thrill beneath his touch,
 To watch him slumbering, and to see him wake;
To live with him for ever were too much;
 But then the thought of parting made her quake:
He was her own, her ocean-treasure, cast
Like a rich wreck—her first love, and her last.

LORD BYRON (1788–1824)
Don Juan, Canto II, CLXXIII

So fared they night and day as queen and king
Crowned of a kingdom wide as day and night.
Nor ever cloudlet swept or swam in sight
Across the darkling depths of their delight
Whose stars no skill might number, nor man's art
Sound the deep stories of its heavenly heart

Deep from the starry depth beyond the stars,
A yearning ardour without scope or name
Fell on them, and the bright night's breath of flame
Shot fire into their kisses; and like fire
The lit dews lightened on the leaves, as higher
Night's heart beat on toward midnight

Only with stress of soft fierce hands she pressed
Between the throbbing blossoms of her breast
His ardent face, and through his hair her breath
Went quivering as when life is hard on death;
And with strong trembling fingers she strained fast
His head into her bosom; till at last,
Satiate with sweetness of that burning bed,
His eyes afire with tears, he raised his head
And laughed into her lips; and all his heart
Filled hers; then face from face fell, and apart
Each hung on each with panting lips, and felt
Sense into sense and spirit in spirit melt.

So sped their night of nights between them: so,
For all fears past and shadows, shine and snow,
That one pure hour all-golden where they lay
Made their life perfect and their darkness day
Nor woke they till the perfect night was past,
And the soft sea thrilled with blind hope of light.
But ere the dusk had well the sun in sight
He turned and kissed her eyes awake and said,
Seeing earth and water neither quick nor dead
And twilight hungering toward the day to be,
'As the dawn loves the sunlight I love thee'.

ALGERNON CHARLES SWINBURNE (1837–1909)
from Tristram of Lyonesse

The most tender and moving moments of love-making often follow the most passionate; after the storm comes the still centre of love at which lovers can feel more at one with each other than at any other moment in their lives. To reach this ideal, perfect equilibrium, one needs sympathy, patience, understanding, skill. Yet the skill cannot really be taught, however many books we may read: there are no specific rules: we learn to love by loving – by trial and error, tact, adventure, exploration. There is no more important lesson to learn in life, than the lesson of love.

From Pablo Picasso's *Vollard Suite.*

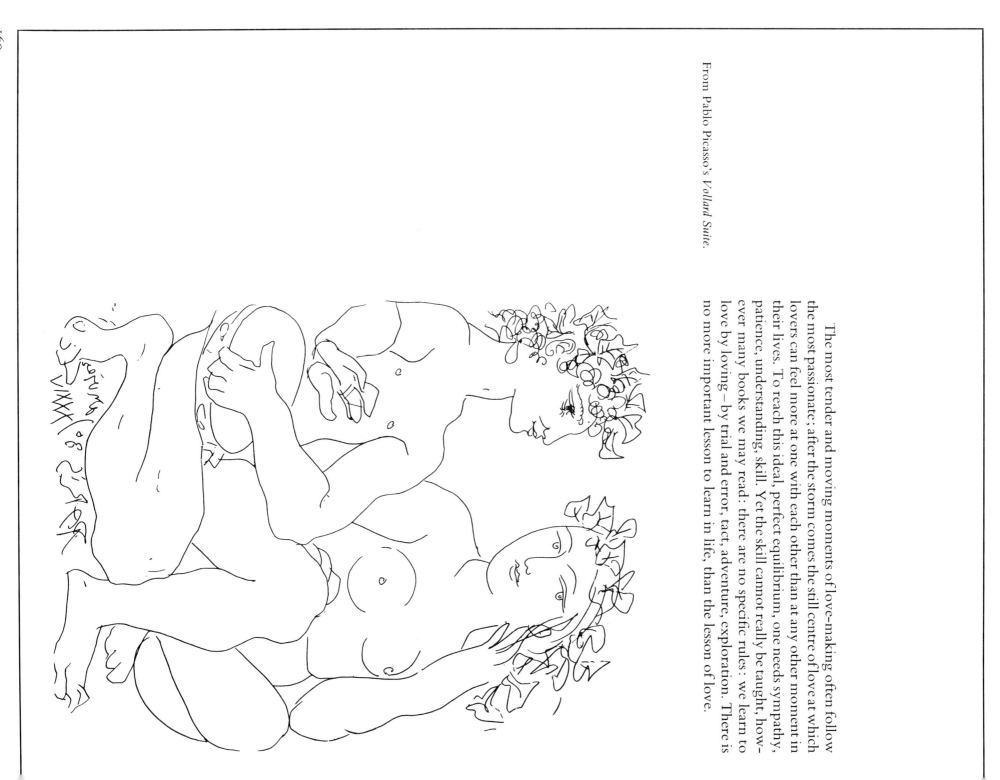

Making Love
An Anthology

Introduction

Urgent demand or tender wooing, fierce possession or intimate communion, this experience of physical love is so individual and so unlike anything else in life that it may seem impossible to convey it adequately in words. Yet it has been done, both in verse and prose. In this anthology from the writings of the poets and the novelists the door to this private world is set ajar for just a moment. For this brief segment of time we are allowed to share their deepest emotions, and sharing them recognize them as our own.

Bid Adieu to Maidenhood

Bid adieu, adieu, adieu,
 Bid adieu to girlish days.
Happy Love is come to woo
 Thee and woo thy girlish ways—
The zone that doth become thee fair,
The snood upon your yellow hair,

When thou hast heard his name upon
 The bugles of the cherubim
Begin thou softly to unzone
 Thy girlish bosom unto him
And softly to undo the snood
That is the sign of maidenhood.

JAMES JOYCE, 1882–1941

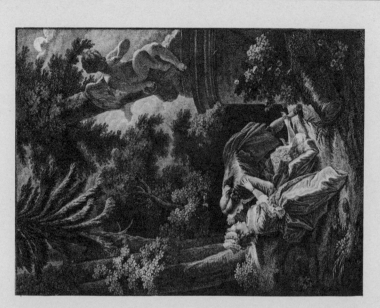

A Red, Red Rose

O my love's like a red, red rose
 That's newly sprung in June;
O my love's like the melody
 That's sweetly play'd in tune!

As fair art thou, my bonnie lass,
 So deep in love am I;
And I will love thee still, my dear,
Till a' the seas gang dry.

Till a' the seas gang dry, my dear,
 And the rocks melt wi' the sun;
I will love thee still, my dear,
 While the sands o' life shall run.

And fare thee well, my only love!
 And fare thee well awhile!
And I will come again, my love,
 Tho' it were ten thousand mile.

ROBERT BURNS, 1759–96

The Kiss

For Love's sake, kiss me once again!
I long, and should not beg in vain,
 Here's none to spy, or see;
 Why do you doubt, or stay?
I'll taste as lightly as the bee,
That doth but touch his flower, and flies away.

Once more, and (faith) I will be gone,
Can he that loves ask less than one?
 Nay, you may err in this,
 And all your bounty wrong;
This could be called but half a kiss.
What we're but once to do, we should do long!

I will but mend the last, and tell
Where, how it would have relished well;
 Join lip to lip, and try:
 Each suck each other's breath.
And while our tongues perplexèd lie,
Let who will think us dead, or wish our death!

BEN JONSON, 1572–1637

from *The Courtier*

Although the mouth be a parcel of the body, yet is it an issue for the words, that be the interpreters of the soul, and for the inward breath, which is also called the soul. And therefore hath a delight to join his mouth with a woman's beloved with a kiss; not to stir him to any dishonest desire, but because he feeleth that that bond is the opening of an entry to the souls, which, drawn with a coveting the one of the other, pour themselves by turn the one into the other body, and be so mingled together that each of them hath two souls.

BALDASSARE CASTIGLIONE, *1478–1529,*
translated by Sir Thomas Hoby

Warm Are the Still and Lucky Miles

Warm are the still and lucky miles,
White shores of longing stretch away,
A light of recognition fills
The whole great day, and bright
The tiny world of lovers' arms.

Silence invades the breathing wood
Where drowsy limbs a treasure keep,
Now greenly falls the learned shade
Across the sleeping brows
And stirs their secret to a smile.

Restored! Returned! The lost are borne
On seas of shipwreck home at last:
See! In a fire of praising burns
The dry dumb past, and we
Our life-day long shall part no more.

W. H. AUDEN, *b. 1907*

from *Liber Amoris*

In her sight there was Elysium; her smile was heaven; her voice was enchantment; the air of love waved round her, breathing balm into my heart; for a little while I had sat with the gods at their golden tables, I had tasted of all earth's bliss.

WILLIAM HAZLITT, *1778–1830.*

The Metaphor

The act of love seemed a dead metaphor
For love itself, until the timeless moment
When fingers trembled, heads clouded,
And love rode everywhere, too numinous
To be expressed or greeted calmly:
O, then it was, deep in our forest,
We dared revivify the metaphor,
Shedding the garments of this epoch
In scorn of time's wilful irrelevancy;
So at last understood true nakedness
And the long debt to silence owed.

ROBERT GRAVES, *b. 1895*

In a Gondola

The Moth's kiss, first!
Kiss me as if you made believe
You were not sure, this eve,
How my face, your flower, had pursed
Its petals up: so, here and there
You brush it, till I grow aware
Who wants me, and wide open burst.

The Bee's kiss, now!
Kiss me as if you entered gay
My heart at some noonday,
A bud that dares not disallow
The claim, so all is rendered up,
And passively its shattered cup
Over your head to sleep I bow.

ROBERT BROWNING, *1812–89*

Sweet, Let Me Go

Sweet, let me go! sweet, let me go!
What do you mean to vex me so?
Cease your pleading force!
Do you think thus to extort remorse?
Now, now! no more! alas, you overbear me,
And I would cry—but some, I fear, would hear me.

WILLIAM CORKINE, *fl.* 17th cent.

Jig

That winter love spoke and we raised no objection, at
Easter 'twas daisies all light and affectionate,
June sent us crazy for natural selection—not
Four traction-engines could tear us apart.
Autumn then coloured the map of our land,
Oaks shuddered and apples came ripe to the hand,
In the gap of the hills we played happily, happily,
Even the moon couldn't tell us apart.

Grave winter drew near and said, 'This will not do at all—
If you continue, I fear you will rue it all.'
So at the New Year we vowed to eschew it
Although we both knew it would break our heart.
But spring made hay of our good resolutions—
Lovers, you may be as wise as Confucians,
Yet once love betrays you he plays you and plays you
Like fishes for ever, so take it to heart.

CECIL DAY LEWIS, 1904–72

from *Wuthering Heights*

'Do come to me, Heathcliff.'
In her eagerness she rose and supported herself on the arm of the chair.
At that earnest appeal he turned to her, looking absolutely desperate.
His eyes wide, and wet at last, flashed fiercely on her; his breast heaved
convulsively. An instant they held asunder, and then how they met I
hardly saw, but Catherine made a spring, and he caught her, and they
were locked in an embrace from which I thought my mistress would
never be released alive: in fact, to my eyes, she seemed directly insensible.

EMILY BRONTË, *1818–48*

from *The Morning is Full*

The numberless heart of the wind
beating above our loving silence.

Orchestral and divine, resounding among the trees
like a language full of wars and songs.

Wind that bears off the dead leaves with a quick raid
and deflects the pulsing arrows of the birds.

Wind that topples her in a wave without spray
and substance without weight, and leaning fires.

Her mass of kisses breaks and sinks,
assailed in the door of the summer's wind.

PABLO NERUDA, *b. 1904, translated by W. S. Merwin*

At the East Gate

At the East Gate of the City are young women,
Gracious and light as clouds in Spring time;
But it does not move me that they have the lightness of clouds—
Under her thick veil and the whiteness of her robe, my love gives me
all joy.

At the West Gate of the City are young women,
Sparkling and beautiful like the flowers of Spring time;
But it does not move me that they have the sparkling beauty
of flowers—
Under her thick veil and the whiteness of her robe, my love
gives me all joy.

From the Chinese of SHI KING, *1776 B.C.*

And Your Dress Is White

You have bent your head, are looking at me;
and your dress is white,
and a breast blooms from the loosed
lace on your left shoulder.

The light exceeds me; trembles
and falls on your naked arms.

Again I see you. Your words
were quick, tight—spoken,
giving me heart
in the weight of a life
I knew circus-like.

The road was deep
that the wind went down
certain March nights,
and woke us unknown
like the first time.

SALVATORE QUASIMODO, 1901–71,
translated by Jack Bevan

from Day of these Days

Such a morning it is when love
leans through geranium windows
and calls with a cockerel's tongue.

When red-haired girls scamper like roses
over the rain-green grass,
and the sun drips honey. . . .

When all men smell good,
and the cheeks of girls
are as baked bread to the mouth.

As bread and beanflowers
the touch of their lips,
and their white teeth sweeter than cucumbers.

LAURIE LEE, b. 1914

Song of the Pink Bird

Let the pink bird sing; it's at your breast
In a room we're sharing
And your head on my chest confirms
Its glad domination.
Let the world play its games beyond the curtains,
We are certain of only one thing,
Let the pink bird sing.
We have lost interest in wars and political situations,
There are craters in our hearts,
We must not neglect them,
Let the pink bird sing.
Let it sing as long as singing matters,
Look through the curtains
The clouds are blushing,
The moon apologizing—
Let the pink bird bring home to us
One reason for living,
Let the pink bird sing.

BRIAN PATTEN, b. 1946

from *Chanson d'Après-Midi*

Your hips are amorous
Of your back and breasts,
And you ravish the cushions
With your langorous poses.

Sometimes, to appease
A mysterious rage
Prodigally, seriously,
You kiss and bite.

You harrow me, dark one,
With mocking laughter,
Then lay on my heart
Your eye, gentle as moonlight.

CHARLES BAUDELAIRE, 1821–67,
translated by Derek Parker

The Goodmorrow

I wonder, by my troth, what thou and I
Did, till we loved? Were we not weaned till then?
But sucked on country pleasures, childishly?
Or snorted we in the Seven Sleepers' den?
'Twas so. But this, all pleasures fancies be.
If ever any beauty I did see
Which I desired and got, 'twas but a dream of thee.

And now good morrow to our waking souls,
Which watch not one another out of fear;
For love all love of other sights controls,
And makes one little room an everywhere.
Let sea-discoverers to new worlds have gone,
Let maps to other, worlds on worlds have shown,
Let us possess one world; each hath one, and is one.

My face in thine eye, thine in mine appears,
And true plain hearts do in the faces rest.
Where can we find two better hemispheres
Without sharp north, without declining west?
Whatever dies, was not mixed equally.
If our two loves be one, or thou and I
Love so alike, that none do slacken, none can die.

JOHN DONNE, 1573–1631

from 'Sex versus Loveliness'

Why is a woman lovely, if ever, in her twenties? It is the time when sex
rises softly to her face, as a rose to the top of a rose bush.

And the appeal is the appeal of beauty. We deny it wherever we can.
We try to make beauty as shallow and trashy as possible. But, first and
foremost, sex appeal is the appeal of beauty . . .

But the plainest person can look beautiful, can be beautiful. It only
needs the fire of sex to rise delicately to change an ugly face to a lovely
one. That is really sex appeal: the communicating of a sense of beauty

What sex is, we don't know, but it must be some sort of fire. For it
always communicates a sense of warmth, of glow. And when the glow
becomes a pure shine, then we feel the sense of beauty.

D. H. LAWRENCE, 1885–1930

from *To His Mistress Going to Bed*

Licence my roving hands, and let them go
Before, behind, between, above, below.
O my America! my new-found-land,
My kingdom, safliest when with one man manned,
My mine of precious stones, my emperie,
How blest am I in thus discovering thee!
To enter in these bonds, is to be free;
Then where my hand is set, my seal shall be.
 Full nakedness! All joys are due to thee;
As souls unbodied, bodies unclothed must be,
To taste whole joys. Gems which you women use
Are like Atlanta's balls, cast in men's views,
That when a fool's eye lighteth on a gem,
His earthly soul may covet theirs, not them.
Like pictures, or like books' gay coverings made
For laymen, are all women thus arrayed;
Themselves are mystic books, which only we
(Whom their imputed grace will dignify)
Must see revealed. Then since that I may know,
As liberally, as to a midwife, show
Thyself: cast all, yea this white linen, hence;
There is no penance due to innocence.
 To teach thee, I am naked first; why then
What needst thou have more covering than a man?

JOHN DONNE, *1573–1631*

↱ *Carpe Noctem*

There is no future, there is no more past,
No roots nor fruits, but momentary flowers,
Lie still, only lie still and night will last,
Silent and dark, not for a space of hours,
But everlastingly. Let me forget
All but your perfume, every night but this,
The shame, the fruitless weeping, the regret.
Only lie still: this faint and quiet bliss
Shall flower upon the brink of sleep and spread,
Till there is nothing else but you and I
Clasped in a timeless silence.

ALDOUS HUXLEY, *1894–1963*

Lullaby

Lay your sleeping head, my love,
Human on my faithless arm;
Time and fevers burn away
Individual beauty from
Thoughtful children, and the grave
Proves the child ephemeral:
But in my arms till break of day
Let the living creature lie,
Mortal, guilty, but to me
The entirely beautiful.

Soul and body have no bounds:
To lovers as they lie upon
Her tolerant, enchanted slope
In their ordinary swoon,
Grave the vision Venus sends
Of supernatural sympathy,
Universal love and hope;
While an abstract insight wakes
Among the glaciers and the rocks
The hermit's sensual ecstasy.

Certainty, fidelity
On the stroke of midnight pass
Like vibrations of a bell
And fashionable madmen raise
Their pedantic, boring cry:
Every farthing of the cost,
All the dreaded cards foretell
Shall be paid, but from this night
Not a whisper, not a thought,
Not a kiss nor look be lost.

Beauty, midnight, vision dies:
Let the winds of dawn that blow
Softly round your dreaming head
Such a day of sweetness show
Eye and knocking heart may bless,
Find the mortal world enough;
Noons of dryness see you fed
By the involuntary powers,
Nights of insult let you pass
Watched by every human love.

W. H. AUDEN, b. 1907

Serenata

Down by the shore of the river
the night embraces itself
and within Lolita's breasts
the branches are dying of love.

The branches are dying of love.

The night, naked, sings
above the bridges of March.
Lolita bathes herself
with salt water and with roses.

The branches are dying of love.

The nights, alcoholic, silver,
Shine over the rooftops.
Silver of streams and mirrors.
Alcohol of your sweet thighs.

The branches are dying of love.

GARCIA LORCA, 1889–1936,
translated by Derek Parker

from *Madame Bovary*

The soft night was all about them. Curtains of shadow hung amid the leaves. Emma, her eyes half-closed, breathed in with deep sighs the cool wind that was blowing. They did not speak, caught as they were in the rush of their reverie. Their early tenderness returned to their hearts, full and silent as the river flowing by, soothing-sweet as the perfume the syringas wafted, casting hunger and more melancholy shadows on their memory than those the unmoving willows laid upon the grass . . . now and again a ripe peach could be heard softly dropping from the tree.

'What a lovely night!' said Rodolphe.

'We shall have many!' answered Emma. She went on as though speaking to herself: 'Yes, it will be good to travel. . . Then why am I sad at heart? Is it dread of the unknown, the wrench of parting? Or is it . . . ? No, it's just that I'm too happy! What a weak creature I am! Forgive me!'

'There is still time!' he cried. 'Think! You may repent!'

'Never!' she declared impetuously. And, moving closer to him – 'What harm could come to me? There is no desert or precipice or ocean where I would not follow you. Our life together will be every day a closer, completer embrace.

GUSTAVE FLAUBERT, 1821–80, *translated by Alan Russell*

from *Love and Marriage*

. . . with women love usually proceeds from the soul to the senses and sometimes does not reach so far . . . with man it usually proceeds from the senses to the soul and sometimes never completes the journey.

<div align="right">

ELLEN KEY, *1849–1926*

</div>

The Mosquito

Fly to her, swiftly fly, Mosquito, bearing my greeting:
Perch on the tip of her ear, and whisper it to her:
Say 'He lies waking, longing for you: and you sleeping,
Sleeping, O shameless girl!, have never a thought for
 who loves you?'

Buzz!

 Chirr!

 Off to her, sweetest Musician!

Yet speak to her softly, lest
Her bedfellow wake and hurt her because of my love.

. . . or bring me the girl herself, Mosquito, and I
Will crown your head with the lion's mane and give you
Strong Hercules' bludgeon to brandish in your paw.

<div align="right">

MELEAGROS, *c. 700 B.C., translated by Dudley Fitts*

</div>

from *Glory of Life*

When, as occasionally happens, there is an utter, impassioned, and heroical love between two people, when the thought of each other's bodies causes them day and night to stand as worshippers before the throne of Aphrodite, quivering, shivering with idolatry, fidelity becomes as natural as to breathe . . . When love of this kind visits the earth, as it does visit the earth rarely and by chance, then preserve it, shelter it, sacrifice everything to it! . . To know that you will be loved, even to the grave's edge, deprives the Icarus-like falling from life to death of half its horror . . . In moments of profane love we should be possessed by an ultimate rapture, our spirits under their foolish bewitchment, awake with gladness, knowing the high fortune of so tender, so savage, so God-like an experience!

<div align="right">

LLEWELLYN POWYS, *1884–1939*

</div>

Break of Day

Stay, O sweet, and do not rise,
The light that shines comes from thine eyes.
The day breaks not; it is my heart,
Because that thou and I must part.
Stay, or else my joys will die,
And perish in their infancy.

'Tis true, 'tis day; what though it be?
O, wilt thou therefore rise from me?
Why should we rise because 'tis light?
Did we lie down because 'twas night?
Love, which in spite of darkness brought us hither,
Should in despite of light keep us together.

Light hath no tongue, but is all eye.
If it could speak as well as spy,
This were the worst, that it could say:
That being well, I fain would stay,
And that I lov'd my heart and honour so
That I would not from her, that had them, go.

Must business thee from hence remove?
O that's the worst disease of love!
The poor, the foul, the false, love can
Admit, but not the busied man.
He which hath business, and makes love, doth do
Such wrong as when a married man doth woo.

JOHN DONNE, *1573–1631*

Daybreak

At dawn she lay with her profile at that angle
Which, when she sleeps, seems the carved face of an angel.
Her hair a harp, the hand of a breeze follows
And plays, against the white cloud of the pillows.
Then, in a flush of rose, she woke, and her eyes that opened
Swam in blue through her rose flesh that dawned.
From her dew of lips, the drop of one word
Fell like the first of fountains: murmured
'Darling', upon my ears the song of the first bird.
'My dream becomes my dream,' she said, 'come true.
I waken from you to my dream of you.'
Oh, my own wakened dream then dared assume
The audacity of her sleep. Our dreams
Poured into each other's arms, like streams.

STEPHEN SPENDER, *b. 1909*

The Postures of Love

There is a white mare that my love keeps
unridden in a hillside meadow – white
as a white pebble, veined like a stone
a white horse, whiter than a girl.

And now for three nights sleeping I have seen
her body naked as a tree for marriage
pale as a stone that the net of water covers
and her veined breasts like hills – the swallow islands
still on the corn's green water: and I know
her dark hairs gathered round an open rose
her pebbles lying under the dappled sea.
And I will ride her thighs' white horses.

ALEX COMFORT, *b. 1920*

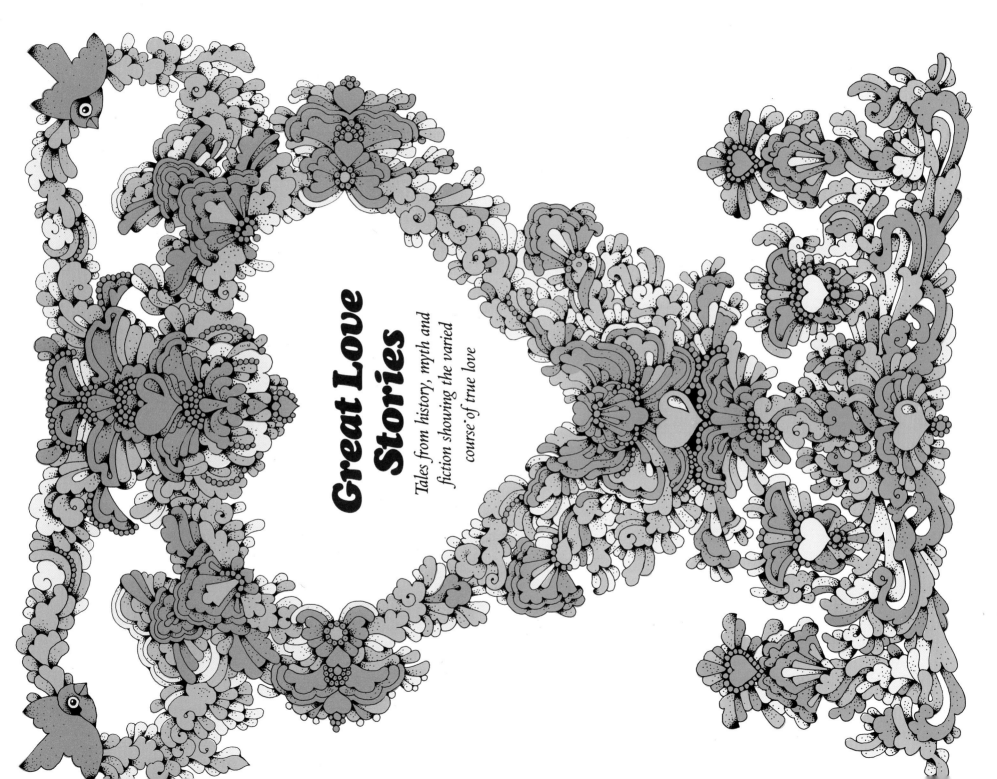

Great Love Stories

Tales from history, myth and fiction showing the varied course of true love

Robert and Elizabeth Browning

A more improbable love story – or for that matter, a happier one – has seldom been told than that of Elizabeth and Robert Browning. Under the selfish and tyrannical rule of her father, Elizabeth Barrett, as she then was, was for years condemned to lead the life of a helpless invalid. She was a gay and cheerful child, and particularly fond of riding. But when she was quite young, she was injured in a fall from a horse, and damaged her spine. Her father, Edward Barrett, took the opportunity of exercising his power and confined Elizabeth to the house, later to her room. She was soon not allowed to stir from the sofa, not even to cross two rooms to her bed. Her room was sombre and silent, with lowered blinds and an air of sickness. Apart from the oppressive presence of her father, which seemed as permanent as the dim light and the medicine bottles, her only interest was literature. Visitors were strictly forbidden, and courtship, to say nothing of marriage, was absolutely unthinkable. So she turned to writing as a solace, achieving some moderate success with the poems that were eventually collected into the volume she published in 1844.

This book of poems attracted the attention of Robert Browning, who was already well established as a poet. Browning read the book, and found there a reference to his own work. A mutual friend, John Kenyon, encouraged him to write to Elizabeth. He did so, and proposed that they should meet. Such a suggestion seemed to her fantastic. Her father's overpowering influence had reduced her, as it had reduced her brothers and sisters, to complete dependence on his will, and his will was that the thought of embarking upon even friendship was not to be entertained.

Into her life of sickly seclusion Browning's letter came, therefore, like a breath of fresh air – of warm, sensuous air. He spoke of an occasion when they had been on the point of meeting, but for some reason or other had not done so. He compared it to the sensation of having found a chapel

marvellously illuminated, but with its door barred. Elizabeth answered his letter, and he replied. Thus began a correspondence which culminated after a while in the almost blasphemous suggestion that he should call on her. Terrified at the thought of her father's reaction, Elizabeth made every excuse she could think of, above all, the state of her health and the danger from east winds. 'If my truest heart's wishes avail,' Robert replied, 'you shall laugh at east winds as I do'.

Gradually their letters became more personal and more relaxed, and at last, in the early summer of 1846, they met. Not long afterwards, Robert, deeply in love with her, proposed. It was an electrifying prospect. For the first time in her life, Elizabeth was offered the activity and the pleasures of a normal life. But the thought of her father's outraged reaction horrified her. Later, she wrote to Robert: 'I will tell you what I once said in jest: if a Prince of El Dorado should come with a pedigree of lineal descent from some signory on the moon in one hand, and a ticket of good behaviour from the nearest Independent chapel in the other . . . "Why, even then," said my sister Anabel, "it would not *do*." And she was right; we all agreed that she was right'.

And so she would not hear of marriage: not only because her father had forbidden *all* his children to think of it, but also because she genuinely believed herself to be seriously ill, condemned, as G. K. Chesterton wrote, 'to an elegant death-bed, forbidden to move, forbidden to see proper daylight, forbidden to receive a friend lest the shock should destroy her suddenly'.

Then came a sudden crisis: Elizabeth's doctors declared it was essential that she should be taken to Italy, where there was a faint possibility that she might recover her health. Mr Barrett refused absolutely to consider the idea. Browning thereupon decided there was only one way in which he could save the woman he loved. He proposed that they should elope. How deeply her affections were by this time engaged may be judged from her reaction to this plan. She ordered a carriage to take her and one of her sisters to Regent's Park. There she got out, and for a little while stood leaning against a tree, looking about her at the trees and the flowers and up at the sky. Then she got back into the carriage, drove home, and sent a message to Robert agreeing to elope. The decision was made: a new life lay ahead.

One morning in September, 1846, Elizabeth walked out of her father's house, became Mrs Robert Browning in a church in Marylebone, and returned home as if nothing had happened. A week later, she surreptitiously left her father's house for ever, taking with her her maid and her spaniel, Flush, who had lived almost all his life lying on his mistress' couch. They were met by Robert and together crossed the channel to France, and then travelled south to Pisa.

Before her marriage, Elizabeth's life had been uneventfully miserable; now it became uneventfully happy. She would never perhaps have been a strong woman, but it soon became clear that her sickness had been to a large extent psychosomatic and encouraged by her odiously selfish father. In the summer of 1846, she had seemed on the point of death; a year or two later, in Italy, she was being dragged uphill in a wine hamper, climbing mountains at four in the morning, riding a donkey for five miles over rugged country.

After three years, she bore Browning a son; then in 1861, she died after a supremely happy marriage that had lasted fifteen years.

The elopement was a *cause célèbre*. The publication of Elizabeth's sonnet-sequence, *Sonnets from the Portuguese*, which tells the story of the love affair, revealed not only the depth of her passion but that love had been for her the means of breaking from the oppressive domination of her father, and discovering the reality of a world that hitherto she had only dreamed of.

How do I love thee? Let me
 count the ways.
I love thee to the depth and
 breadth and height
My soul can reach, when feeling
 out of sight
For the ends of Being and ideal
 Grace
I love thee with a love I seemed
 to lose
With my lost saints

With the publication of their letters after Browning died, their romance seemed more like a story than reality. Finally it was made into a musical, bringing the Brownings' story to thousands more people on both sides of the Atlantic. But a reality it was; Browning did call Elizabeth Barrett to life, and they did live a life of great happiness together, so that, as Chesterton wrote, after Elizabeth's death Browning 'closed a door in himself, and none ever saw Browning upon earth again, but only a splendid surface'.

Romeo and Juliet

A number of versions of the story of Romeo and Juliet existed before Shakespeare adapted the theme and through his art transformed it into one of the world's greatest tragedies of love. What follows is an account of his version, the most famous, and the most moving of all.

There lived in Verona two merchant families, the Montagues and the Capulets, between whom there existed a feud. After a public brawl between the members of both families, the Prince of Verona has threatened execution as the penalty for further strife between them. Romeo, Montague's son, is unconcerned by the Prince's warning, being pre-occupied by an unrequited love for Rosaline, a beautiful young Veronese girl.

Capulet decides to hold a feast for all the notable families of the city, and he sends his servant about the city to invite the guests. But the servant cannot read, and the names upon the list are a mystery to him. He happens to come upon Romeo and his cousin, Benvolio, and asks them to read him the names. Romeo, seeing that Rosaline is among them, agrees with Benvolio to invade the party, taking along a group of their friends.

Capulet has decided it is time his only daughter, Juliet, who is fourteen years old, should be betrothed, and chooses as her suitor Paris, a kinsman of the Prince. Many of her friends are already married, and with children; indeed Juliet's own mother bore her at that age. Juliet is uncertain of her own feelings but consents (to the delight of her old Nurse, a cheerful, richly humoured, bawdy companion) to listen to a proposal from the handsome Paris.

At the feast, Romeo and his friends, mingling uninvited with the other guests, is recognised by Capulet's nephew, Tybalt, a fiery youth, who straightway seeks to have them turned out. But on this evening of the year Capulet is in a good enough humour to tolerate their society.

During the evening, Romeo and Juliet see each other for the first time. They touch hands, exchange words, and with soft, courtly gentleness offer to each other the first of many kisses. Immediately they realize that they have fallen in love, but each is unaware of who the other is. Only as all depart from the feast do they discover, through the offices of the Nurse, the truth of their identities. Romeo begins to feel uneasy. When Juliet finds that Romeo is a Montague, she is in despair:

'My only love, sprung from my only hate.'

After the feast has ended, Romeo evades his friends, climbs the orchard wall of Capulet's estate and makes his way to a spot beneath the balcony of Juliet's chamber. There, in the moonlight, they pledge their love for each other, each prepared to deny name and family in order that they may love freely. Both know only too well what difficulties the dispute between their two families must cause, yet with the innocent ardour of youth they are confident that love will overcome all obstacles. At least, up to a point they are confident. In a tense, breathless dialogue their love and their fears are alternately uppermost

in their minds. As dawn breaks, Juliet's Nurse begins to interrupt from an inner room. Their emotion cannot be contained and in rapid whispers they agree to marry. In haste they arrange to exchange messages before nine the next day. Once more they bid each other farewell, the sun rises, and they must part.

Next morning, Romeo tells his father confessor, Friar Laurence, of his love, and the Friar, believing that he sees in the situation a means of reconciling the two families, promises Romeo his support. So, by Juliet's Nurse, Romeo sends her a message telling her to go to Friar Laurence for confession that afternoon and that there in his cell the Friar will marry them.

Later that same day, Tybalt, meeting Romeo by chance, greets him as usual with an insult. But Romeo, since he has now become secretly a kinsman of Tybalt, returns a soft answer. A friend of his, Mercutio, outraged on Romeo's behalf by Tybalt's insult, draws his sword and fights with Tybalt. Romeo comes between them, trying to stop the fray, but instead only hinders Mercutio from ably defending himself. Mercutio is struck, and falls mortally wounded. After his death Romeo turns on Tybalt and kills him. The whole city is aroused, and the Prince, summoned from his Palace, finds Lady Capulet mourning her nephew. After hearing what has happened from Benvolio, the Prince decides not to condemn Romeo to death, but instead to banish him from Verona, whence he has already fled.

The lovers are in despair. To Romeo, banishment from his bride seems like death itself. Juliet, aware that this must be the penalty for his murder of her cousin, is distraught

with grief. However, her Nurse contrives the dispatch of a message to Romeo, who, returning secretly to Verona, climbs up to Juliet's balcony and spends the night with her. Once more dawn breaks to part the lovers. Lady Capulet stirs and hurries to Juliet's bedroom to inform her of the betrothal plans. The Nurse warns Romeo and Juliet, they take one final kiss, and Romeo disappears into the garden, to begin his sad flight to Mantua.

Next day, Capulet announces Juliet's betrothal to Paris, whom she is to marry within a few days. Juliet, though unable to explain her reluctance, swears that she will never marry him. Her father becomes furious and declares that if she continues to refuse, he will disown her. Juliet flies to Friar Laurence for comfort, and the Friar suggests a plan. He is skilled as a herbalist and has a potion which, when drunk, induces a temporary appearance of death. He suggests that Juliet shall drink the potion and that then her family, believing her to be dead the night before her wedding, will bury her in the family vault. Meanwhile, the Friar will send a message to Romeo, bidding him to return secretly to Verona, and there to enter the tomb. When Juliet awakes, the two of them will emerge and declare their marriage to their families, who in their relief at Juliet's survival, will become reconciled.

Juliet agrees to the Friar's plan and on returning to her father's house, declares her readiness to marry Paris the next day. That night, in fear and trembling, she drinks the Friar's draught and the next morning is found by her Nurse, apparently dead. With full funeral pomp her body is placed in the family vault, near that of Tybalt.

Meanwhile, plague has broken out in the countryside between Verona and Mantua, and the Friar's messenger has been turned back. But news has nevertheless reached Romeo that his wife is dead. In an extremity of grief, he decides to end his own life, buys some poison from a hermit, and returns post haste to Verona. At night he breaks into the Capulet tomb, after killing Paris, who has come there too to mourn Juliet. He finds her body apparently lifeless lying close to Tybalt's. Without Juliet, Romeo is weary of the world. He mourns by her body, vowing that even in death he will never leave her side. He drinks the hermit's poison and after kissing Juliet farewell, dies.

Friar Laurence, having heard that his message has failed to reach Romeo, hastens to the tomb to explain to Juliet what has happened. As he arrives, Juliet begins to awaken from her drugged state. The Friar tries to bring her away, but she refuses to go with him, and hearing others approaching, he flees. Juliet, seeing Romeo dead, kisses him, hoping some trace of the poison will have remained on his lips; but in vain. Seizing his dagger, she stabs herself and dies.

The Capulets, summoned by Paris's servant, are horrified at what they find. The Prince has also been summoned, and to him Friar Laurence confesses his part in the tragedy. His motive, however, vindicates his actions, for the two fathers mourning their dead children, make peace with each other.

In their deaths Romeo and Juliet transcended the age-old family feud. Their loves were stronger than hate, and eventually brought peace. But peace at what price?

Tristan and Iseult

Fathoms deep beneath the sea, where it runs between the Isles of Scilly and the Land's End, off the westernmost tip of England, lies the drowned land of Lionesse, once a rich and prosperous kingdom ruled by King Meliodas. Meliodas and his beautiful wife Elizabeth conceived a son, but at the time of his birth Meliodas was a prisoner. Elizabeth, seeking her husband, bore the baby unattended and in great distress. She called him Tristan, or 'sorrowful birth', and soon afterwards she died.

King Melodias, rescued from the spell by the magician Merlin, brought up his son Tristan nobly, and sent him into France, where he learned the arts of knighthood, music and hunting. When he returned to his father's court, a handsome young man of eighteen, he was the finest musician and the bravest huntsman ever known, and was greatly honoured.

One day he heard that his uncle, Mark, King of Cornwall, was in great difficulty: Agwisance, the Irish king, had sent Sir Marhaus to claim taxes owing to him, and threatened to seize the kingdom. Tristan offered his services to his uncle, who made him a knight, and on his behalf issued a challenge to Sir Marhaus. The challenge was accepted and Sir Tristan and Sir Marhaus fought for many hours, at first on horseback, and then on foot. Sir Marhaus badly wounded Sir Tristan in the side with a poisoned spear; but summoning all his strength, Sir Tristan struck his opponent such a blow that the sword went clean through the knight's helmet and into his skull, and when he withdrew it, a sliver of steel remained in the wound.

For some months it seemed that Tristan might die, and King Mark was told that only in Ireland could the poison in his wound be healed. So under a false name, Tristan travelled dangerously to the court of King Agwisance, where his musicianship and his gentle and noble bearing made him popular. The King was so struck by his nobility that he put him in the charge of his own daughter, Iseult, 'the fairest maid and lady of the world'. Her nursing soon cleansed the wound of poison, and Sir Tristan grew strong again.

But one day Iseult's mother, the Queen, saw Tristan's sword, and matched with the chip in it the sliver of steel which had been recovered from the wound in Sir Marhaus' skull. Sir Tristan, discovered, was banished from the court, and Iseult wept bitterly.

King Mark grew violently jealous of the handsome young knight, and believing that he would be killed if ever he entered Ireland again, commanded him to go to King Agwisance and seek on Mark's behalf the hand of Iseult (of whose great beauty Tristan had spoken) as Queen of Cornwall. As a member of the Irish court, Tristan fought boldly for Agwisance, and the King was once more impressed by his courage and strength. So he granted Tristan permission to take Iseult to Cornwall to be King Mark's bride. And Iseult's mother, wanting to cement an alliance with Mark, gave Iseult's servingwoman, Brangwaine, a love potion to be placed in the drinks on their wedding night, which would ensure immortal love.

But on the journey to Cornwall, Tristan and Iseult drank the potion at dinner one evening, and fell immediately into an eternal love.

When they came to Cornwall, King Mark received them with great honour, and led them to his castle on a hill – the Castle d'Or – where the King took Iseult for his Queen. For a while the lovers met secretly, whenever they could; but Tristan at last could no longer bear the sight of his mistress on the King's arm, and left the court for Brittany, where he became a knight of his kinsman King Howel, and fought many battles on his behalf. His adventures became famous: he fought always on behalf of the weak or the oppressed, rescued many beautiful women, and in the Forest Perilous saved the life of King Arthur himself.

All this time, Queen Iseult was faithful to King Mark at his Cornish court. But one day a jealous knight persuaded his mistress to tell Iseult, falsely, that Sir Tristan was dead; and she took a sword, and prepared to kill herself, kneeling down and praying aloud, 'Sweet Lord Jesu, have mercy upon me, for I may not live after the death of Sir Tristan, for he was my first love and he shall be my last'. But King Mark overheard her, took her in his arms, and carried her to her room, where she lay sick for many weeks.

Meanwhile, Sir Tristan had fought the giant Taeleas in a distant part of Mark's kingdom, and was found resting naked in a wood. Mark's knights, not knowing who he was, took him to the King's castle at Tintagel, and entertained him. There, Queen Iseult set eyes on him, but weakened by her illness, did not at first notice him – until a little dog which he had given her when she first came to Cornwall leaped towards him, wild with delight. Then suddenly she recog-

nized her lover, and fainted. The King summoned his Council, and asked them to condemn Sir Tristan to death; but instead they advised that he should be banished from the kingdom for ten years.

So Sir Tristan once more began his travels, and had many more adventures. In much danger, Brangwaine brought him letters from Iseult; but they could not meet.

Then, in Brittany, Tristan was wounded by a poisoned arrow, and fell desperately ill. A Breton noblewoman, deeply in love with Tristan, and also called Iseult, nursed him devotedly; but in his delirium he called again and again for her namesake in Cornwall, and at last

sent by his servant a message beseeching her to come to him before he died; if the returning ship was carrying his love, it was to have white sails; if the sails were black, she would not have come.

Looking one day from the window of Tristan's room, high above the sea, his nurse saw the ship approaching, its white sails glittering in the sun. But unable to bear to see him overjoyed at his love's coming, she told him that the sails were black as pitch. Despairing, he turned his face to the wall, and died. Minutes later, trumpets sounded as Iseult of Cornwall set foot on the Breton coast. She hurried at once to her lover; but too late to be reunited

with him in life, she lay down at his side, and embracing him, she died.

Reunited in death, Tristan and Iseult became legendary. Their story was set down by Thomas of Erceldoune in the thirteenth century, and later by Malory. For hundreds of years it was thought to be purely fictional: but in the last century an inscription on a Cornish cross standing at Castle Dore, near Fowey, in Cornwall, was deciphered, and proved to be the tombstone memorial of Tristan himself. The story has been retold by many poets and musicians, including Swinburne and Richard Wagner, whose *Tristan und Isolde* is perhaps the fullest expression of passionate love in opera.

Antony and Cleopatra

Mark Antony was at the height of his career when he first met Cleopatra. He was one of the foremost generals of Imperial Rome, a brave commander who had fought in Gaul with Julius Caesar. During the civil wars he supported Caesar, and after his murder took arms against the conspirators and defeated them, becoming thereafter one of the triumvirate—Octavius Caesar, Lepidus and himself—that ruled the empire.

Antony was by nature a sensualist and a lover of pleasures, facts that endeared him to the men under his command. But he also drank heavily and gambled, and in his time he had had many love affairs. Indeed, as the result of one of them he had divorced his wife.

In 41 BC, he set forth confidently to conquer Egypt. Paradoxically, it was he himself who was conquered—though not by Egypt. It was to her great queen, Cleopatra, that he fell a victim. She was then twenty-eight years old, he was forty-two. Cleopatra, the daughter of King Ptolemy XIII, had become queen when she was seventeen. Having later been driven from her kingdom by her ambitious brother Ptolemy XIV, she had appealed to Caesar, had become his mistress, and then persuaded him to go to war on her behalf and make her queen once more. She had accompanied Caesar to Rome and was there at the time of his murder; but then had returned hastily to Egypt and declared Caesarion, her son by Caesar, to be her successor.

It was while Antony was voyaging to Greece that he first set eyes on Cleopatra. At Cilicia, where he had made preparations to receive her, she sailed in state up the river Cydnus. The historian Plutarch, writing not much more than a hundred years after the event, recorded her triumphal progress: '... in a barge with gilded stern and outspread sails of purple, while oars of silver beat time to the music of flutes and fifes and harps. She herself lay all along under a canopy of cloth of gold, dressed as Venus in a picture, and beautiful young boys, like painted Cupids, stood on each side to fan her.'

So wondrous was the spectacle that the people of Cilicia, leaving Antony alone in the market place where he had gone to greet her, ran to watch the royal progress of this fabled queen.

Cleopatra had no difficulty in capturing the affections of so susceptible a character as Antony. According to Plutarch's description, she must have been one of the most fabulously attractive women in history. 'For her actual beauty, it is said, was not in itself so remarkable that none could be compared with her, or that no one could see her without being struck by it, but the contact of her presence, if you lived with her, was irresistible; the attraction of her person, joining with the charm of her conversation, and the character that attended all she said or did, was something bewitching. It was a pleasure merely to hear the sound of her voice, with which, like an instrument of many strings, she could pass from one language to another ...!'

She flattered and amused Antony, matching his every mood; and at last captured him entirely. Ignoring the wars which had now broken out in Rome, and forgetting his wife,

Fulvia, who was much involved in them, he went with Cleopatra to Alexandria, where they lived throughout the winter like two young people in love for the first time.

In due course, events forced Antony to leave his mistress and return to Rome. His wife having died, Antony, for reasons of diplomacy, consented to marry Octavia, a cold, passionless woman, but Caesar's sister.

For some years politics and war conspired to separate Antony from Cleopatra; but when once more he set sail for Asia Minor, his passion for her was rekindled, and when they met he presented her with vast tracts of land, the conquests of the empire – Cyprus, Phoenicia, Cilicia, and parts of Judaea and Arabia. He also acknowledged publicly that she had borne him two children, on whom he bestowed the titles of 'Sun' and 'Moon'. This, allied with his treatment of his wife Octavia, proved his undoing. He was deprived of all his titles by the Roman Senate, and war was declared on Cleopatra.

Antony immediately flew to her defence. So tenacious was her renewed hold upon him that when she insisted on commanding her forces personally, he not only consented, but accepted her advice before that of his own commanders. Though his land forces were superior to those opposing him, he agreed to her wish that the first battle should be fought at sea.

While this battle was in the balance, Cleopatra's ships were seen to be in retreat. At once Antony deserted his forces to follow her. Even so, some of those forces remained loyal to him for a time. Then came the final battle, in which they and Cleopatra's faithful Egyptians were defeated.

Such were his feelings of shame

and chagrin that for the time being he could not bear to face Cleopatra. Instead, according to Plutarch, 'without seeing her or letting himself be seen by her, he went forward by himself and sat alone without a word in the ship's prow, covering his face with his hands'.

In his bitterness, he declared at first that Cleopatra had betrayed him. Eventually, he petitioned the Roman senate, asking that his children by Cleopatra should be allowed to become the rulers of Egypt and that he himself should be allowed to live there. The only response to this appeal was a message sent to Cleopatra – that she would be pardoned for her offence against Rome if she would agree to have Antony put to death. This she refused, but fearing that he might attack her, she shut herself in a magnificent tomb that she had built and sent forth a message from it that she was dead. On hearing this, Antony fell upon his sword and was mortally wounded.

When news that he was dying reached Cleopatra, she sent for him to be brought to her, but fearing to unfasten the door of the tomb, had a platform let down on which Antony was raised up and taken into the tomb. 'Those that were present', says Plutarch, 'say that nothing was ever more sad than this spectacle, to see Antony, covered all over with blood and just expiring, thus drawn up, still holding up his hands to her, and lifting up his body with the little force he had left'.

Cleopatra was allowed by the Romans to give her lover a magnificent funeral. Soon afterwards, she entered the tomb where his body was lying, carrying with her a basket of figs in which was hidden a poisonous asp. She provoked the creature into biting her and died with Antony's name on her lips.

Beauty and the Beast

Once upon a time there lived in France a rich merchant whose huge fleets sailed the seven seas, bringing home treasures of gold and jewels, piles of tapestries and barrels of spices.

He had six children – three tall, handsome sons, and three beautiful daughters, the youngest of whom was so fair, so kind and so graceful, that she was known far and wide as 'Little Beauty'. Suitors came from all over Europe to pay court to the merchant's three daughters: but the two elder girls rejected everyone, for they valued themselves so highly that they were determined to wait for a Duke each, at the least. And Beauty, though she was sad to turn away so many handsome young men, decided to marry because she wanted to stay for a few more years with her father whom she dearly loved.

Then, one awful year, disaster struck the merchant's fleets. One by one his ships were seized by pirates, sunk in dreadful storms, or cheated by unscrupulous traders; and within a twelvemonth he was penniless. His great house and most of his fine furniture were sold to pay his creditors, and he was forced to retire to a small farm. He and his sons rose early each morning to work in the fields, and Beauty spent her day cleaning the house, cooking the meals, and feeding the chickens.

Soon the freshness of this new life began to appeal to her, though she work was hard; and she was not unhappy. For her sisters, though, it was another matter: bored to distraction, they remained in bed for

most of the day, grumbling at the emptiness of their lives – for no suitors now came to call, not even the sons of gentlefolk.

One day, news reached the merchant that one of his ships, crippled but safe, had come to harbour in a distant port. He set off to welcome its captain, in high hopes of restoring his fortune, and asked his daughters what he should bring them from the town. The elder sisters asked for jewels and trinkets; but Beauty, thinking that her father would need all the money he could raise, asked only for a single rose.

The merchant found the ship alongside the quay; but on board were his creditors, demanding money that he still owed them. He

left as penniless as he had been before. To add to his misery, when he was halfway home, he was overtaken by pouring rain which soon soaked him to the skin. At last he noticed some tall gates and went through them to seek shelter. At the end of the drive was a great mansion, every window ablaze with light. As he raised the knocker, the door swung open, and revealed a warm cheerful hall in which a glowing fire was burning. No-one answered his call, and when at length he dared to explore the mansion, he found it empty – though a table was laid with a feast of food and wine. Exhausted, the merchant ate some food, drank a cup of wine, and finding a bedroom, fell upon the bed and slept.

In the morning he was startled to find laid out at the bedside a handsome new suit of clothes, which fitted him perfectly. He dressed and made his way downstairs, where a good breakfast waited for him. Having eaten, he left the mansion, and on his way through the garden he passed a bush of rich red roses. Remembering his promise to Beauty, he picked one and immediately from a nearby maze appeared a terrifying monster, whose face was so grotesque that the merchant cowered from him in terror.

'Not content with my hospitality', the Beast growled, 'you now have the audacity to steal my roses! I

should kill you on the spot – but if within three months you bring me your youngest daughter, I may have mercy upon you. Go! – and take this to sustain you on the journey.' And he threw the merchant a leather bag. Catching it, the man ran, and only paused when he was far from the Beast's estate. To his amazement he found the bag was full of gold pieces. By the time he reached home, the merchant had made up his mind: the gold would sustain his sons and daughters, and he would return to the Beast and give himself up.

After hearing his story, the two elder daughters could barely disguise their joy at the sight of the gold. But Beauty cared nothing for it; she only insisted that she should go to the Beast in place of her father.

Battered by the insistence of the other two girls, the merchant reluctantly consented, and escorted Beauty to the Beast's mansion. There, she found a magnificent apartment, with her name on its door; and dressing in one of the wonderful gowns which hung in a vast wardrobe, she made her way downstairs to dinner. The Beast appeared before her, terrifying her to speechlessness by his hideousness. But he was extremely gentle, sitting to watch her eat, and talking with

her in a voice which was harsh and rough, but at the same time seemed soft and almost human. As she rose to leave the table he said: 'Beauty, I have a question to ask you. Will you be my wife?'

Beauty was no longer quite so frightened, but could never bring herself to think of the revolting monster as a husband, and firmly refused him. He looked at her for a moment, and then left. Each evening, he sat to watch her eat, talked politely and kindly with her, and then asked the same question – and received the same answer. Living in the Beast's mansion, Beauty had almost everything she could wish for. Her day was filled by examining the fine books and pictures, and walking in the beautiful gardens. As the time went on she almost forgot the Beast's ugliness, so kindly was she treated. But she still could not think of him as a husband.

Soon, she begged permission to visit her father, and with great reluctance, the Beast allowed her to go to him for a week. Her sisters were intensely jealous when they saw her beautiful clothes, and the fine presents she brought from the Beast. At the end of the week the whole family persuaded her to stay just two more days. But on the second night, Beauty had a dream: in his fine garden, beneath a handsome rosetree, the Beast lay dying.

Next morning she returned in haste and searched the mansion from roof to cellar, but there was no sign of the Beast. Then, in the garden, just as in her dream, she found him. He had starved himself to the point of death for love of her, believing that she had deserted him. 'O, Beauty', he said, 'it is better so; when I am dead you shall live here for ever, untroubled by my hideous presence'.

'Dear Beast', replied Beauty, 'do not die! I know that you have a soul of the greatest purity and simplicity, and I want nothing more than that you shall live to be my husband'.

And immediately she saw before her not the Beast, but a handsome young man of noble bearing. Taking her hand, he told her he was a Prince, changed into a Beast by a witch who promised that he should remain so until he found a beautiful young girl who would marry him. And so, of course, they were married: the Prince and the Beauty lived happily; the merchant became the Prince's Chamberlain, in charge of all his vast domains; and at the entrance to their palace stood her two sisters, turned to stone until their souls should become as pure and loving as that of Beauty. For all we know they stand there still.

Beauty and the Beast was one of the *Contes* retold from ancient sources by Mme de Villeneuve in 1744.

Alexandre Dumas the younger wrote, in 1848, one of the best-known love stories of modern times, *La Dame aux Camélias*. It was an immediate success and four years later Dumas dramatized it. Later, Verdi used the plot for his opera, *La Traviata*; but perhaps the most popular evocation was in Greta Garbo's film, *Camille*, in which Garbo played Marguerite Gautier, the most beautiful courtesan in France. The character of Marguerite is based solidly on life, on a contemporary of Dumas' who was a farmer's daughter, called Marie Plessis, and whose career very closely resembled that of Marguerite.

Like her real-life counterpart, Marguerite is weary of her so-called 'life of pleasure', and longs to lead a more tranquil life, to escape from the noise and bustle of Paris and live peacefully with someone for whom she can really care—and who really cares for her. Yet the endless social whirl continues; night after night her house is a scene of gaiety. One evening, however, a friend introduces her to Armand, a fashionable and handsome young man, who immediately falls in love with her. She, despite herself, for she knows that she is ill, falls in love with him.

She and Armand go to live in the country together and for a while they are idyllically happy. Away from Paris, the courtesan disappears and is replaced by a beautiful young woman who loves him and is loved in return. She is no longer the friendless love object that she had become, she feels a person again for their night together. Having failed in her final attempt to explain

Marguerite is moved by his plea and makes the ultimate sacrifice. She summons her maid and writes him a note, saying that she has left him, and she goes back to Paris, longing only for death. Dire poverty forces her to resume her old life style.

Armand is heartbroken and wild with pain. He immediately misjudges her and sets out to persecute her in public by flirting with her companion, the beautiful and heartless courtesan, Olympe. The hapless Marguerite makes a final attempt to see him and to beg for his pity and forgiveness, for she is by this time very weak with tuberculosis. They spend a night together and by morning, she is feverish. Armand sends her the final insult, three thousand francs as payment

ardent and happy. But his wealth is not great and soon Marguerite is forced secretly to sell some of her possessions to pay their way. When Armand discovers this, he is deeply embarrassed, though consoled by her explanation that she felt the need to make all possible sacrifices so that *their* love would not be debased by money. He returns to Paris to try to raise some money himself.

While he is away, Marguerite is visited unexpectedly by Armand's father and it is this encounter which is to cause the dying Marguerite to reject her beloved for ever. Armand's sister is to marry, but her fiancé's family are fearful of the scandal provoked by Armand's liaison with Marguerite and have threatened to break off the engagement. Armand's father appeals to Marguerite to reject her beloved and thus avert the ruination of this innocent young girl's life.

her conduct to him, Marguerite departs heartbroken from Paris for England. Armand in his turn goes off to the East on a Grand Tour.

It becomes known that Marguerite's illness is incurable and gradually her lovers and admirers, even Count N . . . in London who has kept her in the past, disappear from the scene. Soon, she can no longer afford her elegant and famed house parties. Accompanied only by her faithful maid, she prepares to spend the brief remains of her life in quiet poverty.

Then one day, a letter from Armand's father reaches him in Alexandria and summons him to return, but by the time he reaches Paris, she has been dead for three weeks. All that is left of her are some letters which she wrote to him on her death bed. She fully explains to him everything that happened and why she left him. Armand is overcome by remorse and shocked that he could have treated her so callously. Only his father had been aware of the truth and, in order that Marguerite might not be totally destitute, had given her money while she was living out her final days alone.

This is the story of a social outcast – a woman, who in Dumas' own words, had such a big heart that it

killed her.

This may be an exaggeration, but there are few women who are able to make the ultimate sacrifice in the way that Marguerite did. In spite of being a so-called woman of easy virtue, she proved to be a woman of dignity and selflessness: a woman of lowly origins who became the envy of Paris, but who wanted more than anything merely to be loved. She gave herself fully and was finally, tragically betrayed by the one man whom she had loved and who in turn had loved her.

In other interpretations of the story, Marguerite has different names: in the film, she becomes Camille, and in Verdi's opera, Violetta. Marie Plessis, upon whom

the story is based, was not known to have been particularly fond of camellias, but Dumas created the notion that in her dying state, his heroine could not bear the scent of flowers and therefore selected those, equally sumptuous and scentless, to form her sole adornment.

In the process of time, a tomb was raised to Marie in the cemetery of Montmartre, where Marguerite was said to be buried. A garland of camellias, carved out of white marble, formed an essential part of the decoration. The myth had become reality.

Edward, eldest son of King George V, was brought up strictly by his parents in the knowledge that one day he would be King of England. His childhood was not happy. For much of the time he was severely tutored, and he lived in some fear of his father, who was a stern and punctilious man. But Edward's character was strongly individual, and he maintained his independence of thought and action after he took on the title and duties of Prince of Wales. Early on, his opinions of the life the monarchy should lead were unconventional: after an official visit to Germany he wrote in his diary, 'What rot and a waste of time, money and energy all these state visits are!'

He had great personal charm, and, more important, in the years of unemployment and unrest in the decades after the First World War he had a very pronounced sympathy for families in distress, speaking out against poverty and unemployment in such strong terms that some British politicians began to feel very uneasy.

In 1930 he met for the first time a beautiful American woman, Mrs Simpson. She was born in Maryland, and in 1915 married a young lieutenant in the American Navy. In 1927, she divorced him, and became the wife of Mr Ernest Simpson, a member of a shipping firm, and they lived in London.

The Prince met Mrs Simpson at a house party, found her pleasant company, and began to entertain both her and her husband often at Fort Belvedere, his private home. In 1934, she and an aunt were his guests on a yachting cruise along the French Riviera. Pirated photographs of them together appeared in the American press; but no-one in England outside the Prince's own circle realized what was by now very obvious – that he was deeply in love with her.

Of course there had been attempts to arrange a marriage for him: in 1914 the Queen had tried to persuade him to marry a charming and 'suitable' Princess. But he said he would never marry anyone whom he did not love. Now, he had met that woman. But even if Mrs Simpson left her second husband, for the Prince of Wales to marry a divorced woman would be to many people absolutely unthinkable. As early as 1935 he began to realise that he might have to give up the throne – the only British King ever to do so.

In January 1936 George V died and Edward was proclaimed King Edward VIII. Flying to London, he went to St James's palace, and from the public view, he heard himself proclaimed King. Newsreels showed a glimpse of him as he stood at that window: but few people who saw the film realized the significance of the smiling woman in black who stood at his side.

Immediately he became King, Edward began to upset the conventional British establishment: he saw no point in many of the customs of court life, and began agitating to have them changed – to the disapproval of many people at court and in the government. Then, on a tour of Wales, he was saddened by the plight of the unemployed miners, and remarked to a local mayor that 'Something must be done'. Some sections of the British press compared his attitude favourably with that of the Conservative Government, to the embarrassment of Stanley Baldwin, the Prime Minister.

Meanwhile, for months the American press had been speculating about the King's future. During the summer, the New York Daily Mirror disclosed the 'true story' of the first meeting between the King and Mrs Simpson; Town and Country reported 'proofs of his affection are many and varied', and that 'he will go nowhere without her: hostesses who don't invite her don't get the King. In her company he never looks at another woman, he watches her all the time, fondly and intently'. Town and Country also speculated that the King might become the co-respondent in Mrs Simpson's second divorce; after the divorce had gone through, the Washington Post reported that the King had given his approval to the filing of the suit.

At this time, the British newspapers refrained from publicizing the matter; but sooner or later the storm had to break. It came, unexpectedly, when the Bishop of Bradford, in an address to a conference, referred to the King's 'need for God's grace', and added that he wished he was more aware of it. Although the Bishop always denied that this was a reference to the stories in the American press, the English newpapers took it as such, and the British public at last learned of the contemplation of 'a marriage incompatible with the throne'. Baldwin assured the King that 'the marriage was not one that would receive the approbation of the country'. The King replied instantly that he intended to marry Mrs Simpson the moment her divorce had been granted, and that if the Government opposed the marriage, he was 'prepared to go'. It is difficult to avoid the conclusion, now, that Baldwin may have been relieved at the prospect of getting rid of a monarch who had shown too much regard for 'the ordinary man', and too little respect for the Government. Backed by the influential London Times, the Prime Minister insisted after Mrs Simpson's divorce that the King's proposal of a morganatic marriage (by which Mrs Simpson would have married the King, but not become Queen) was impractical. On December 11, ten months after ascending the throne, the King signed the Bill of Abdication, and that evening broadcast a message to the country:

'You must believe me,' he said, 'when I tell you I have found it impossible to carry the heavy burden of responsibility and to discharge my duties as King as I would wish to do, without the help and support of the woman I love.'

On December 12, the ex-King – now created Duke of Windsor by his brother George VI – left Ports-

mouth on a British destroyer, and joined Mrs Simpson in France. In May, 1937, the divorce decree was made absolute, and in June the Duke married her according to French law. A little later, a British clergyman courageously performed the marriage ceremony, without his Bishop's permission.

The only King in history to have given up his throne for love lived in complete personal happiness with

her until the day of his death. Certainly he lived in exile, in France, returning only occasionally to England, and it must have been painful to him not to have been allowed to make a proper contribution to the war effort. But finally there was a reconciliation with Queen Elizabeth II, his niece; and he said firmly to the end that if the decision was his to make again, he would have taken no other course.

A Lifetime of Loving

The many faces of love from childhood to old age

A Baby's Love

Three ages of love are reflected in this nineteenth-century engraving of a dance: the dependent love of the child, sheltered within its family circle; the tender involvement of the young parents; the generous affection of love in old age.

Early childhood, in John Betjeman's words, 'is measured out by sounds and smells and sights'. Wide open to experience, the baby embraces it with infinite enthusiasm and a will of steel. The whole world is an invitation to love.

Infancy, early childhood—these are the much celebrated ages of innocence, of pure, spontaneous love, unsullied by contact with the world. Only very occasionally can we catch again, all too briefly, the complete simple assurance and confidence of the child's reaction to everything about him—from a blade of grass to a new doll.

Perhaps it is the general helplessness of all young creatures which renders them especially endearing. The helpless infant is totally dependent upon his parents; they are the sole focus of his love. It is they who feed him when he is hungry, who comfort him when he cries. In turn, the baby brings a new dimension to the parent's relationship; he marks a consummation of their love for each other, a love shared through and with the newborn child.

Teething problems aside, infancy is probably the easiest, the most unfraught period of our life. The baby enjoys a love and security, a devoted attention to his wants and needs, which is unlikely to be equalled at later stages in life. Life is rarely as simple again. Nor is love.

The First Age of Love

Childhood Love

The love of the months-old infant soon changes as the months become years. New sensations, new experiences are gradually amassed. The child's dependence on, and unquestioning love for, his father and mother, his delight in toys and books, are constant; but his horizon gradually widens as a new element enters into his life—the pleasure of childhood friends and the first hint of what will very soon become romantic love.

At school and at home, in the playground or in the backyard, the child plays the old, traditional games of childhood, so many of which reflect the complex, stately dances of courtship. Dancing in a ring, girls choose their boys, and after school, perhaps, there is the first reflection of what is to come as the five-year-old chooses to hold the hand of a particular friend, or sit next to him on the school bus. The chosen one's attention may be directed more to his latest comic than this female companion and he may seem light-years from the boy who will be kissing her in ten years' time; and yet the playground is a complete microcosm of adult life, with alternating rejection and acceptance, acts of friendship, acts of violence, cruelty and kindness, often gratuitous, often puzzling.

For the first time we begin to realize that we hardly ever know *exactly* what we mean in our dealings with other people; or what they mean either. Confusion begins. A small girl cries because an equally small boy prefers to play with her friend. The small boy completely fails to understand.

But even at this early stage in our life, the seed of true and lasting love can sometimes be sown. Edgar Allen Poe wrote of his childhood sweetheart:

> *I was a child and she was a child,*
> *In this kingdom by the sea;*
> *But we loved with a love that was more than love—*
> *I and my Annabel Lee.*

And yet for most of us, childhood 'loves' are usually very ephemeral. We transfer our affections as readily from friend to friend—and back again—as we would exchange a stamp or a comic. The favourite of the class one week, the boy or girl whom everyone wants to sit next to or to play with after school, may very well be demoted the next. The footballer hero of the classroom may find that his quota of love-letters, passed surreptitiously under desks by ardent admirers, suffers a dramatic decline if he fails to show his customary prowess in the next football game.

So far, love itself is still a game; it is still rather 'soppy', a peculiar charade enacted by adults. But none the less, love is knocking on the door. The knocking is insistent. The child may laugh as he slowly turns to answer it. But he already senses what is waiting outside. . .

Young Love

Youth's the season made for joys,
Love is then our duty.

JOHN GAY, The Beggar's Opera

For most of us, love is a very desirable 'duty', which we willingly undertake without any complaint or compulsion! For the adolescent, awakening to new physical and emotional needs, first love can be a very strange, if wonderful experience; a mixture of excitement, eagerness and expectation, and, often, at the same time, a hesitancy, an awkward gaucheness, the fear of venturing out along unknown paths. To the English poet John Dryden, first love was a truly wonderful and enjoyable experience:

Ah, how sweet it is to love!
Ah, how gay is young Desire!
And what pleasing pains we prove
When we first approach Love's fire . . .

Love, like spring-tides full and high,
Swells in every youthful vein

But if first love can be happy, can be a wonderful experience, how mysterious and infinitely sad it can be also. The lucky ones, for whom their first deep love is their last love, are few. In spite of what our hearts may be telling us at the time, we know all too well inside ourselves that we may have to love many times before finding a love that will endure.

Love inevitably brings the fear, and often the agony, of rejection, an agony no less intense in the adolescent relationship than in the affairs of later years. Scott Fitzgerald depicted the puzzlement and awkwardness of the young lover very tellingly in *This Side of Paradise*: 'If I start to hold somebody's hand they laugh at me and *let* me. As soon as I get hold of a hand they sort of disconnect it from the rest of them.' That puzzlement, that awkwardness has not suddenly vanished in the 1970s. It is as difficult to grow up now as it was in 1920, 1840 or 1770. In fact, it may be even more so. The adolescent is constantly under pressure, the persuasive pressure of advertising, the expectations of parents and friends, to find a girlfriend or boyfriend. The fourteen-year old may well feel a social outcast if he or she cannot produce a partner for the Saturday night party.

Clumsiness and shyness, inexperience and self-consciousness may all conspire against the adolescent. The boy struggles to control the comic, embarrassing tricks of a breaking voice; the girl is slightly worried, if at the same time proud, of her budding breasts; suddenly downy hair appears on the arms or legs, or worse still on the face. And there is nothing anyone can do about it – even the young lovers. But gradually, the adolescent comes to terms with his or her new physical self; the self-consciousness begins to diminish and the adolescent is ready to embark on the next stage of the labyrinthine highway of love.

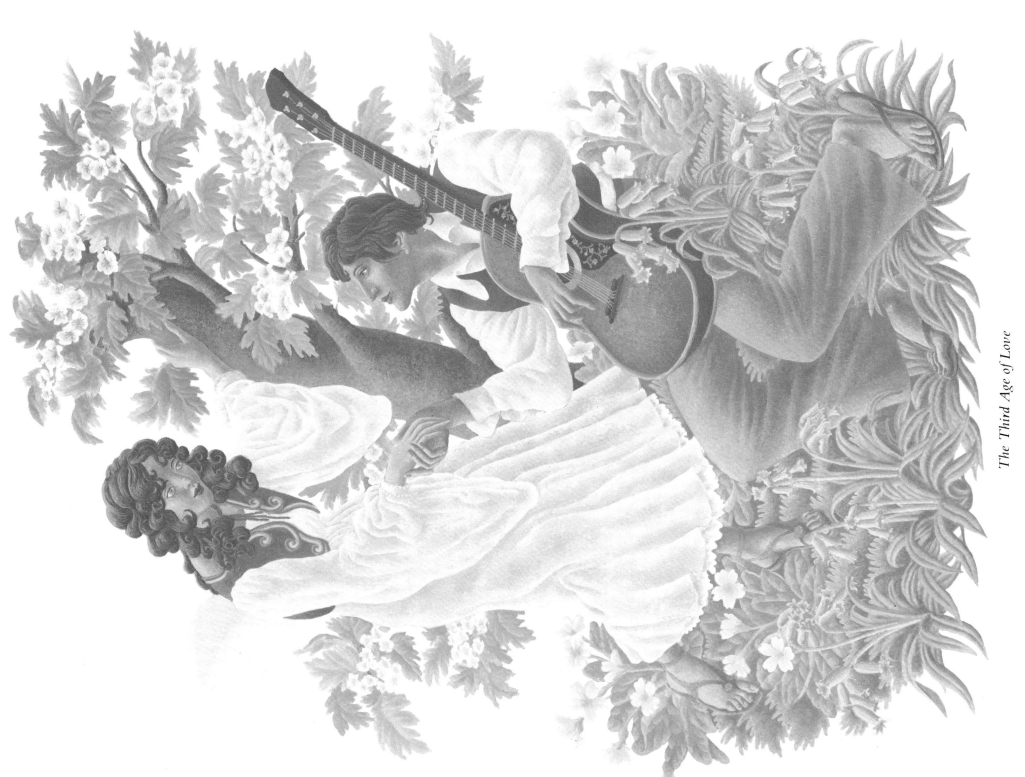

The Third Age of Love

The Age of Passion and Folly

Now, at last, the awkwardness of adolescence has fallen away and we are ready to be caught up in another maelstrom of emotions and passions. Life is alive with the prospect of love.

This is the age of flirtation, the averted but inviting eye, the tossed head, the not-so-shy glance. This is the age when a woman begins to know and exert her power; when, in the words of T. S. Eliot, 'lovely woman stoops to folly'.

This is the age all poets celebrate, and the age we go on celebrating in our hearts, our memories long after it is over. For most of us though, this is a relatively short-lived, if exciting phase. It is the in-between stage, the bridge between the transience of adolescent entanglements and a more lasting commitment, a deep and satisfying relationship. It is not always such a carefree whirlwind of excitement and romance as we tend to imagine. Behind the coquettish glances and whims, the gaiety and excitement there may often lurk a more serious note: the seemingly casual air, the frothy exuberance may be a kind of protective mask, concealing an ever-increasing need, a deep-rooted desire to love and be loved.

The search is on; and it may often lead us into dissimulation and self-delusion. It is all too easy to delude ourselves and succumb to an intensity of emotion, to be swept away by an intoxicating tide of passion and pleasure, but all too soon we find that the bubble bursts, and love itself, in its deepest sense, will be swept away on the floodtide of emotion.

For every genuine love-at-first-sight happy-ever-after match there are a hundred bright, bubbling romances that twinkle a moment and are gone. Dorothy Parker wrote:

> By the time you swear you're his,
> Shivering and sighing,
> And he vows his passion is
> Infinite, undying—
> Ladies, make a note of this:
> One of you is lying.

But does it really matter if the bubble bursts? We can after all console ourselves with the thought that the 'next time' may be different; we can always enter the chase anew.

What must be caught and kept, from these blazing years, is a lasting fervour, so that

> Were the bright day no more to visit us,
> Oh, then for ever would I hold thee thus,
> Naked, enchained, empty of idle fear,
> As the first lovers in the garden were.
>
> JOHN MILTON

Adult Love

So, the heyday of young love is past; we have found and committed ourselves to the one we love, and it is perhaps in this new phase of life, the middle years, that the real joys of love are within easier reach than at any other age. There is a new sureness, gained only by experience, which deepens emotion and begins to render it eternal. Pleasure comes not only from the sudden recognition of love—not only from its celebration—but from the startling revelation that it can last. Permanence begins to be attainable, a real partnership grows; one delights as much in knowing one's love as in discovering it. Now we begin to build a future through our children; part of our love is built into the course of their lives. Growing together, we grow forward, each year a binding together and an enrichment which touches everything in life:

Music I heard with you was more than music,
And bread I broke with you was more than bread.
CONRAD AIKEN

Lovers on a summer hillside. (*The Bright Cloud* by Samuel Palmer.)

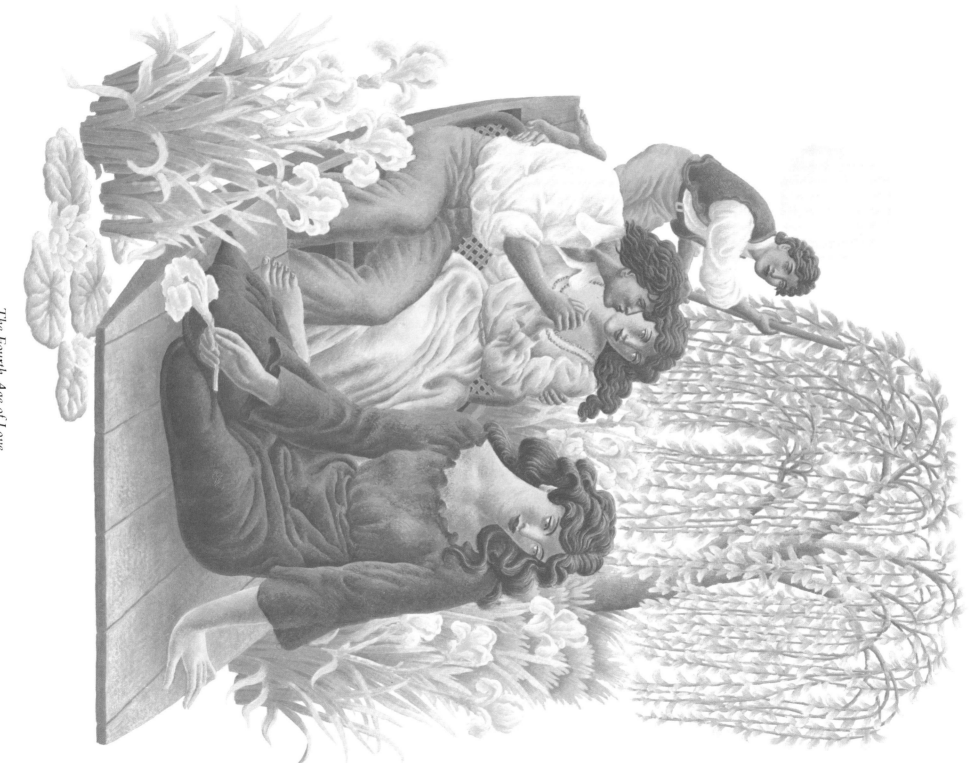

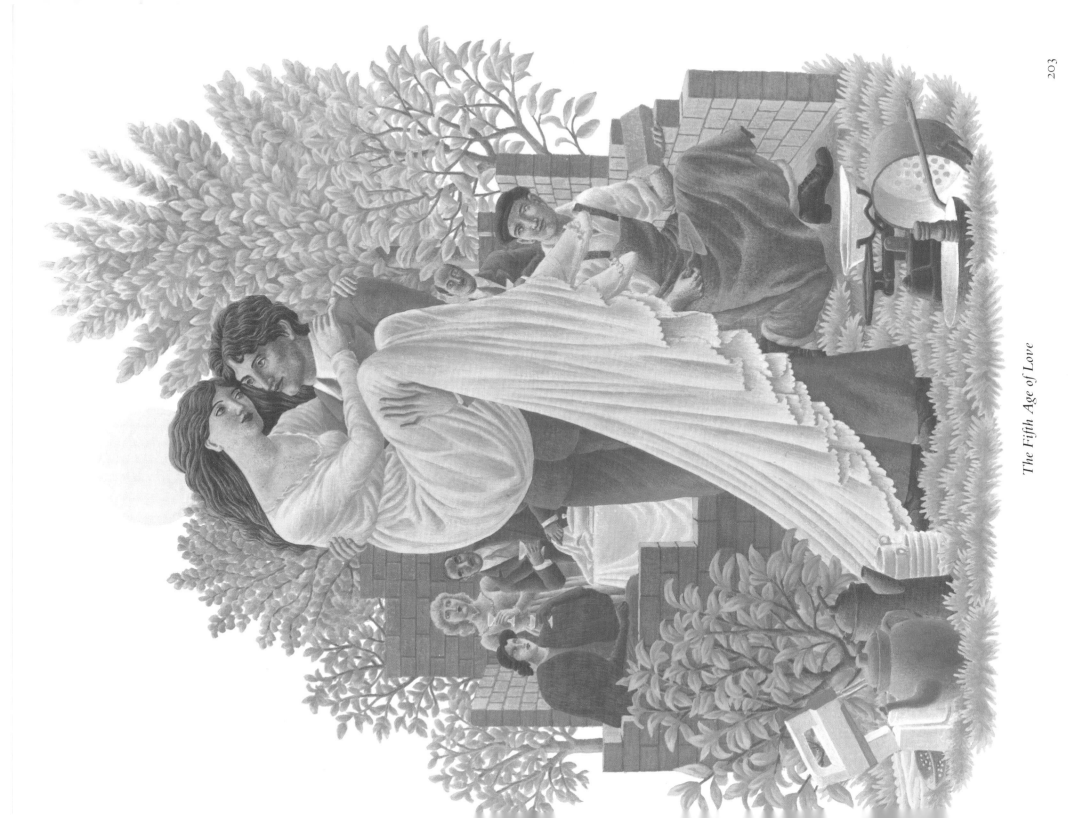

The Fifth Age of Love

The Seventh Age of Love

that in a long life a man needed many women to fulfil his love. 'It is as absurd to say that a man can't love one woman all the time', Balzac replied, 'as it is to say that a violinist needs several violins to play the same piece of music'. Well, every man's, every woman's experience of love will be different—as in each area of life there may be joy, tragedy, success, failure. There are no rules; there are no absolute standards to which everyone must attain; no-one can dictate how love should be. But love is something everyone must practise—and practise—until its music is so much a part of one's life that it scarcely needs rehearsing, until it is as much a part of oneself as one's own past. Indeed it will *be* one's past. So, whether we need one love or many in the course of a lifetime:

> *Let us always love! Let us love and love again!*
> *Love . . . is the flame that cannot be quenched,*
> *The flower that cannot die.*
>
> VICTOR HUGO

An eighteenth-century love knot by the Italian engraver Francesco Bartolozzi.

The Amorous Muse
An Anthology

Introduction

Apart from constantly attempting to define the meaning of love and celebrate its raptures in high poetry, poets have also always versified their minor amatory adventures in rhymes. Sometimes great poets have turned to limericks, sometimes unknown poets have become mildly famous for one amorous squib; and a great horde of completely anonymous poets have turned out ballads and sets of verses which are printed and reprinted in anthologies of poetry, without their author's name ever being known.

In this section, the Muse relates, climbing drainpipes to darkened windows, lifting a petticoat to glimpse a charming leg, or welcoming willing maidens into his arms and beds. Some of these poems are ballads sung three centuries ago, freshly composed for the ale-house by that most rumbustious of all poets, Anon. Others come from such lusty cavaliers as Sir John Suckling, or from the pen of the little clergyman Herrick, stranded in a rough Devonshire parish far from the lights and laughter of fashionable London. If there is sometimes an air of almost desperate gaiety about some of the verses, it is because they are more to do with adventure than with real love; but they are always witty, always fun. And here are some of them. Those printed without authors' names are unattributable and undatable.

Daphnis and Chloe

And at the beginning of the spring the snow melted, the earth reappeared, the grass began to show, and the shepherds went forth again with their flocks to the fields, Chloe and Daphnis leading the way. . . . They sat watching their flocks grazing, kissing the while, and afterwards wandering in search of flowers to weave garlands for the gods. . . . The rams followed the yoes that had not yet lambed, and having caught them, leapt, serving one after the other, and the bucks raced after the she-goats, jumping them in the same fashion and butting fiercely for love of them. Each had his own shes and kept guard lest another should do him wrong. And so by sights and sounds that would have enkindled the fires of Aphrodite in old men, the twain were afflicted, and compelled by their own nature to seek more eagerly than they had yet done that ease and content which kisses and embraces do not afford; but Daphnis the most. For he, being now lusty and well filled out, having spent the whole winter within doors doing nothing, thrilled after the kiss and was big, as the phrase runs, for embraces, more curious in every one, more hardy than he ever was before, pressing Chloe to grant him all he asked for, and to lie with him flesh to flesh longer than was their custom.

opposite: 'Be quiet, Sir! begone, I say:
Lord bless us! how you romp and tear!'

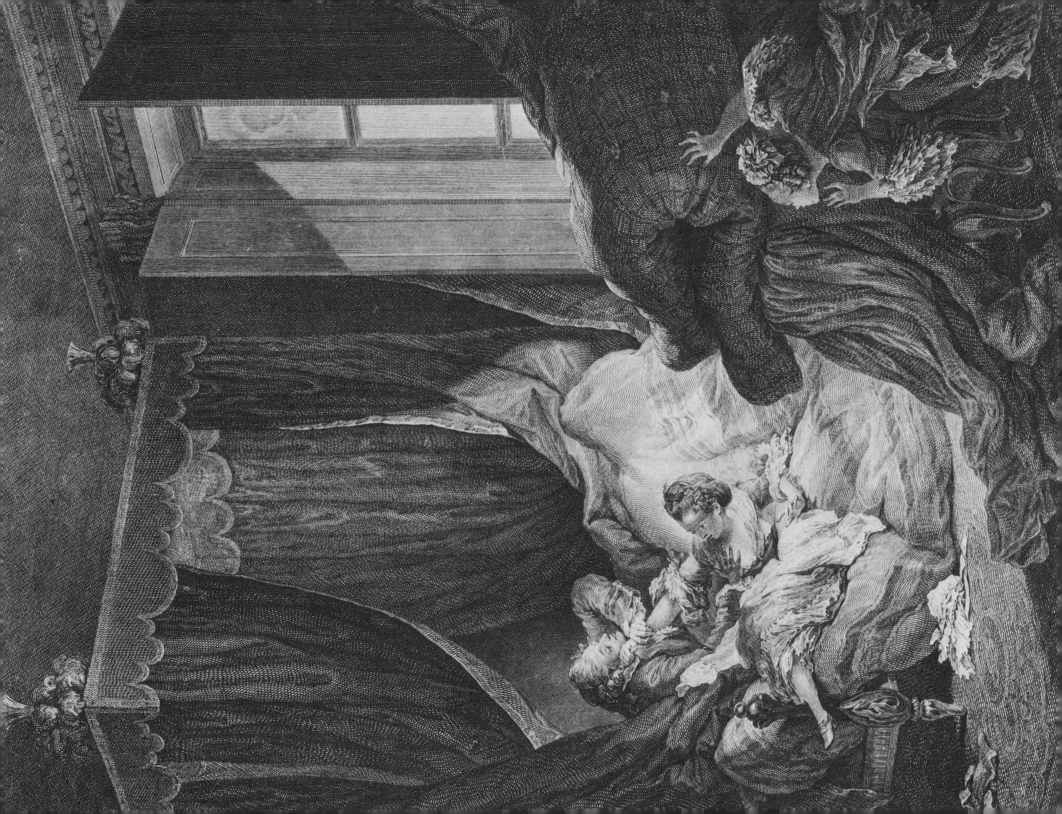

Chloe asked what else they could do but kiss and lie together as they were in their clothes, and what he thought he might do if they were to lie together naked. 'That which the rams do to the yoes and the bucks to the she-goats. Thou hast seen that after the jump the yoe runs no longer from the ram; they graze together, assuaged and content, so there is of a certainty a sweetness unknown to us, a sweetness that surpasses the bitterness of love.'

... 'But hast not seen', said she, 'that our beasties are clothed in wool and hair more closely than I am in these garments?' He believed her, and lay beside her, and for a long time he lay doing nothing, for he was without knowledge how to do that which he desired ardently to do.... He sat down beside her and began to weep, for it was sad to find that he knew less about the ways of love than a tup.

From Daphnis and Chloe by LONGUS, *c. 2nd cent. A.D. translated by George Moore*

The Girl Who Caught a Nightingale

Not long ago there lived in Romagna a handsome and comely young man named Ricciardo, who fell deeply in love with Caterina, the beautiful and charming daughter of Messer Lizio de Valbona. He concealed his love with the greatest care. But the girl noticed it, and began to love him too, which naturally delighted Ricciardo. One day he found the opportunity and courage to say:

'Caterina, I beseech you not to let me die of love.'

And the girl promptly answered:

'I hope to God you will not let me die of it.'

This answer gave Ricciardo great pleasure and eagerness; he thought for a while, and then said: 'My sweet Caterina, I can see no way to come to you unless you can sleep on the balcony overlooking your father's garden. If I knew you to be there at night, I would find some means of getting there, however high it might be.'

Approaching Dawn by Eric Gill.

It was about the end of May, and next day the girl began to complain to her mother that she had not been able to sleep on account of the heat. 'If my father and you are willing, I should like to have my bed on the balcony beside the bedroom overlooking the garden; and there I could sleep, and listen to the nightingale, and be in a cooler place, and be much more comfortable than in your bedroom.'

So that night she had a bed made up on the balcony. And when Ricciardo heard that everything was quiet, he climbed onto a wall with the help of a ladder, and then clinging to the wall, he reached the balcony – with great difficulty, and great danger if he had fallen – and was greeted softly but with the greatest delight by Caterina. After many kisses they lay down together, and took delight and pleasure of each other almost the whole night, making the nightingale sing many times.

Nights are short, and their delight was great, and already the day was at hand, though they did not know it. They were so warm with the weather and their play that they both went to sleep almost at once, Caterina with her right arm round Ricciardo's neck and her left hand holding the thing you are ashamed to mention among men. Thus they slept without waking until dawn came and Messer Lizio got up. Remembering that his daughter was sleeping on the balcony, he softly opened the door, saying to himself: 'Let us see how the nightingale made Caterina sleep last night.'

He crept up and gently lifted the curtain round the bed, and saw Ricciardo and Caterina sleeping naked and uncovered in the embrace I have just described. He called to his wife: 'Get up at once wife, and come and see how your daughter is so fond of the nightingale that she has caught it and still holds it in her hand.'

Then Ricciardo awoke and saw Messer Lizio, and felt as if the heart had been torn from his body. He sat up in bed, and said: 'Sir, I beg you mercy for God's sake.'

'Ricciardo,' said Messer Lizio, 'this is not the reward I should have had for my love of you, whom I have known since boyhood. But take Caterina as your legitimate wife so that, as she has been yours all night, she may be yours so long as she lives.'

So Messer Lizio borrowed one of his wife's rings, and without getting out of bed Ricciardo took Caterina as his wife in their presence. After which Messer Lizio and his wife went away, saying: 'Rest for a while; perhaps you need it more than to get up.'

After which, the two young people embraced each other, and, since they had not travelled more than six miles that night, they went on another two; and a few days later there was an honourable great wedding festival; and afterwards for a long time in peace and quietness Ricciardo hunted birds with his wife day and night as much as he pleased.

Condensed from The Decameron *of* GIOVANNI BOCCACCIO 1313–75, *translated by Richard Aldington*

'I'd Have You,' Quoth He

'I'd have you,' quoth he.
'Would you have me?' quoth she,
'O where, Sir?'

'In my chamber,' quoth he.
'In your chamber?' quoth she,
'Why there, Sir?'

'To kiss you,' quoth he.
'To kiss me?' quoth she,
'O why, Sir?'

'Cause I love it,' quoth he.
'Do you love it?' quoth she,
'So do I, Sir.'

ANON, *17th cent.*

Lucius and Fotis

I found nobody at home but my charming Fotis, who was preparing pork-rissoles for her master and mistress, while the appetizing smell of haggis-stew drifted to my nostrils from an earthenware casserole on the stove. She wore a neat white house-dress, gathered in below the breasts with a red silk band, and as she alternately stirred the casserole and shaped the rissoles with her pretty hands, the twisting and turning made her whole body quiver seductively.

The sight had so powerful an effect on me that for a while I stood rooted in admiration; and so did something else. At last I found my voice. 'Dear Fotis,' I said, 'how daintily, how charmingly you stir that casserole: I love watching you wriggle your hips. And what a wonderful cook you are! The man whom you would allow to poke his finger into your little casserole is the luckiest fellow alive. That sort of stew would tickle the most jaded palate.'

She retorted over her shoulder: 'Go away, you scoundrel; keep clear of my little cooking stove! If you come too near even when the fire is low, a spark may fly out and set you on fire; and when that happens nobody but myself will be capable of putting the flames out. A wonderful cook, am I? Yes, I certainly know how to tickle a man's . . . well, his palate, if you care to call it that, and how to keep things nicely on the boil . . .'

From The Golden Ass, *by* LUCIUS APULEIUS *c. 2nd cent. A.D.,*
translated by Robert Graves

opposite: The Assignation.

Once, Twice, Thrice

Once, twice, thrice, I Julia tried,
The scornful puss as oft denied,
And since I can no better thrive
I'll cringe to ne'er a bitch alive.
So hie away, disdainful sow!
Good claret is my mistress now.

English catch, 17th cent.

Upon the Nipples of Julia's Breast

Have ye beheld (with much delight)
A red rose peeping through a white?
Or else a cherry (double grac'd)
Within a lily? Centre plac'd?
Or ever mark'd the pretty beam
A strawberry shows, half drown'd in cream?
Or seen rich rubies blushing through
A pure smooth pearl, and orient too?
So like to this, nay all the rest,
Is each neat niplet of her breast.

ROBERT HERRICK, 1591–1674

These We Have Loved

Busts and bosoms have I known
Of various shapes and sizes
From grievous disappointments
To jubilant surprises.

ANON, 20th cent.

'... For though your garter met my
eye, my thoughts were far above it.'

opposite: 'Climbing drainpipes to
darkened windows....'

Be Quiet, Sir

Be quiet, Sir! begone, I say:
Lord bless us! how you romp and tear!
 There!
 I swear!
Now you've left my bosom bare!
I do not like such boisterous play,
So take that saucy hand away—
Why now you're ruder than before!
Nay, I'll be hanged if I comply—
 Fie!
 I'll cry....!
Oh!—I can't bear it!—I shall die!
I vow I'll never see you more!
(But are you sure you've shut the door?)

ANON, 18th cent.

The Epicure

Let us drink and be merry, dance, joke and rejoice,
With claret and sherry, with lute and with voice,
The changeable world to our joy is unjust.
All treasure uncertain—then down with your dust.
In frolics dispose your pounds, shillings and pence,
For we shall be nothing a hundred years hence.

We'll kiss and be free with Nan, Betty and Philly,
Have oysters and lobsters, and maids by the belly;
Fish-dinners will make a lass spring like a flea,
Dame Venus (Love's goddess) was born of the sea!
With her and with Bacchus we'll tickle the sense,
For we shall be past it a hundred years hence.

ANON, 18th cent.

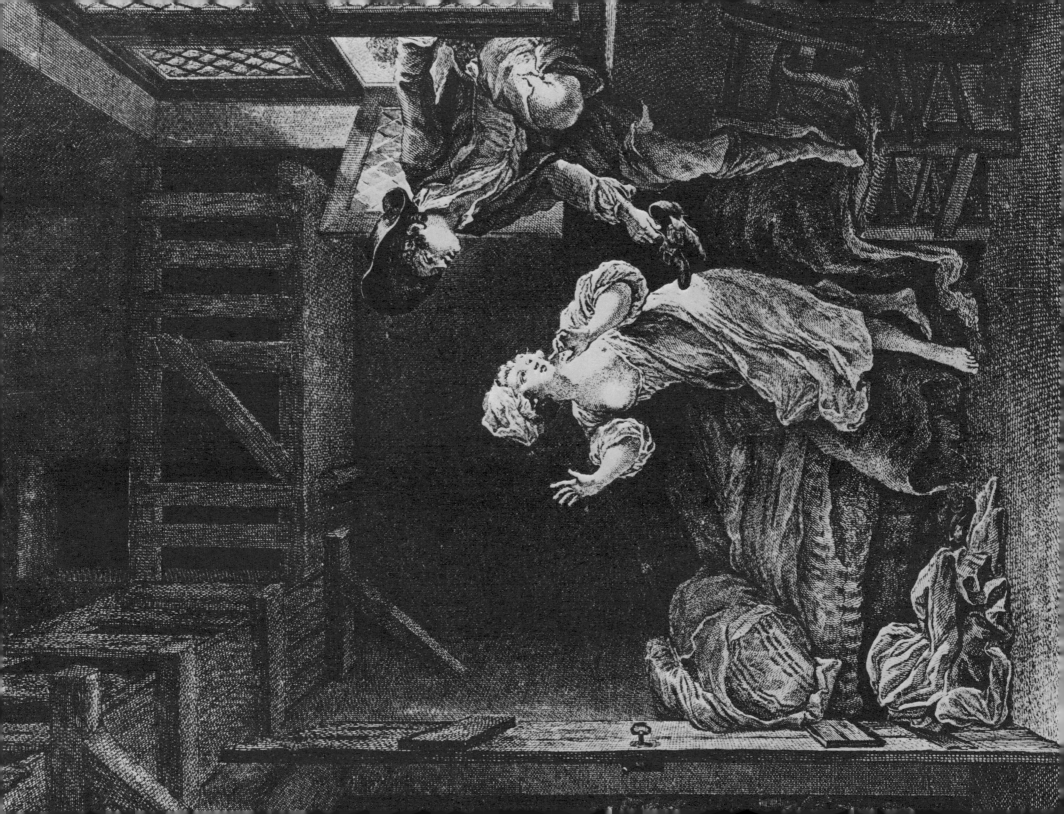

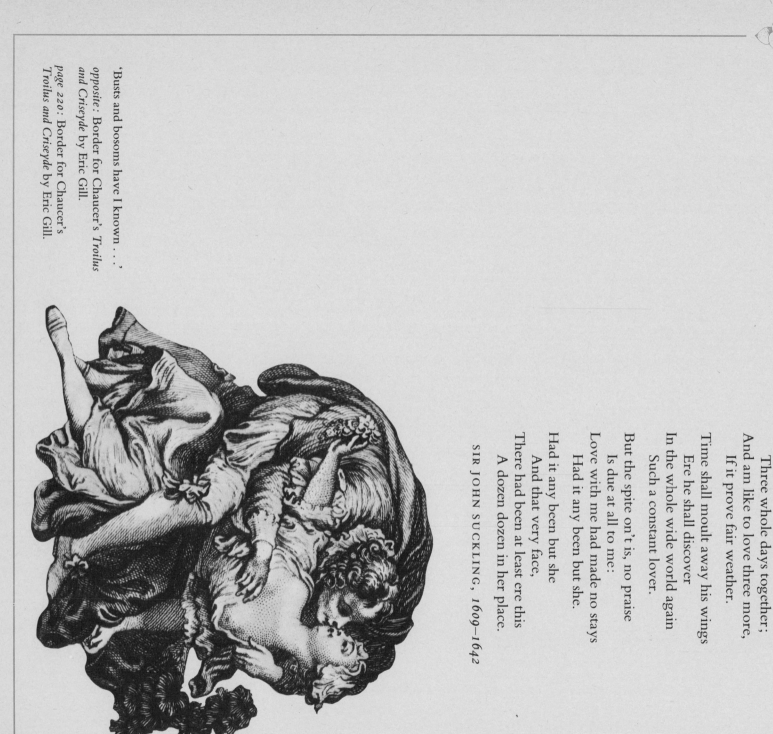

'Busts and bosoms have I known . . .'
opposite: Border for Chaucer's *Troilus and Criseyde* by Eric Gill.

page 220: Border for Chaucer's *Troilus and Criseyde* by Eric Gill.

Out Upon It, I Have Lov'd

Out upon it, I have lov'd
　　Three whole days together;
And am like to love three more,
　　If it prove fair weather.

Time shall moult away his wings
　　Ere he shall discover
In the whole wide world again
　　Such a constant lover.

But the spite on't is, no praise
　　Is due at all to me:
Love with me had made no stays
　　Had it any been but she.

Had it any been but she
　　And that very face,
There had been at least ere this
　　A dozen dozen in her place.

SIR JOHN SUCKLING, *1609–1642*

Young Corydon and Phillis

Young Corydon and Phillis
 Sate in a lovely grove;
Contriving crowns of lilies,
 Repeating tales of love:
And something else, but what I dare not name.

A thousand times he kissed her,
 Laying her on the green;
But as he farther pressed her,
 Her pretty leg was seen:
And something else, but what I dare not name.

Young Corydon grown bolder
 The minute would improve;
'This is the time', he told her,
 'To show you how I love –
And something else, but what I dare not name.'

The nymph seemed almost dying,
 Dissolved in amorous heat;
She kissed and told him sighing,
 'My dear, your love is great:
And something else, but what I dare not name.'

But Phillis did recover
 Much sooner than the swain;
She blushing asked her lover:
 'Shall we not kiss again?–
And something else, but what I dare not name?'

Thus love his revels keeping,
 Till nature at a stand
From talk they fell to sleeping,
 Holding each other's hand,
And something else, but what I dare not name.

SIR CHARLES SEDLEY, *1639–1701*

On Seeing a Lady's Garter

Why blush, dear girl, pray tell me why?
 You need not, I can prove it;
For though your garter met my eye,
 My thoughts were far above it.

ANON, *18th cent.*

Elegy to His Mistress

In summer's heat, and mid-time of the day,
To rest my limbs, upon a bed I lay;
One window shut, the other open stood,
Which gave such light as twinkles in a wood,
Like twilight glimpse at setting of the sun,
Or night being past, and yet not day begun;
Such light to shamefaced maidens must be shown
Where they may sport, and seem to be unknown.
Then came Corinna in her long loose gown,
Her white neck hid with tresses hanging down,
Resembling fair Semiramis going to bed,
Or Lais of a thousand wooers sped.
I snatched her gown — being thin, the harm was small —
Yet strived she to be covered therewithal,
And striving thus as one that would be cast,
Betrayed herself, and yielded at the last.
Stark naked as she stood before mine eye,
Not one wen in her body could I spy.
What arms and shoulders did I touch and see,
How apt her breasts were to be pressed by me,
How smooth a belly under her waist saw I,
How large a leg, and what a lusty thigh.
To leave the rest, all liked me passing well;
I clinged her naked body, down she fell:
Judge you the rest, being tired she bade me kiss;
Jove send me more such afternoons as this!

OVID, 43 B.C.–17 A.D., translated by Ben Jonson

A Lady Lately

A lady lately, that was fully sped
Of all the pleasures of the marriage-bed
Ask'd a physician, whether were more fit,
For Venus' sports, the morning or the night?
The good old man made answer, as 'twas meet,
The morn more wholesome, but the night more sweet.
Nay then, i' faith, quoth she, since we have leisure,
We'll to't each morn for health, each night for pleasure.

ANON, 18th cent.

Games

Introduction

The Love Games in this section have been specially designed, with the help of leading psychologists, to help you discover your real attitudes to love. Although they are relaxed and light-hearted and contain a good mixture of straight Fun, they are nonetheless designed to help you to understand yourself and your attitude to others, to help you assess what you want and need from love.

Falling in love is perhaps the most unpredictable happening in our lives. And yet many young people today are becoming interested in a more scientific search for a compatible partner, and are turning to the computer-dating system.

The games in this book are a kind of computer questionnaire with a difference – they inject a fun element into the whole process of self-analysis.

What Type of Lover am I?

The success or failure of a relationship may depend on how well you understand yourself and your expectations. Could you be trying to assume a false identity which really runs contrary to your true nature? Start off with Game 1, What Type of Lover am I?, and find out which of the twelve categories of lover you belong to or which is the nearest approximation to your own reactions and needs. Are you sensuous, diffident, romantic or what?

The Castle Game

'Love' can be a many faceted word with several rather unromantic under-currents lurking beneath the surface. Could it be that what really attracts you to your latest girl/boyfriend is the promise of financial security or a good sex life? If you feel like taking a cool look at your possible motives, try playing The Castle Game.

Consult the Oracle

Game 3 provides strictly light relief from the probings of the first two quizzes. Adapted from a delightful nineteenth-century game, Consult the Oracle may provide some surprising answers to questions such as 'Does he/she really love me?' or 'How many times will I fall in love?'

Identilove

Do you often day-dream about your ideal partner and conjure up rather hazy pictures of gloriously handsome young men or glamorous, model-girl women as the case may be? The Identilove game will help you design a more concrete picture of your ideal man/woman, and you don't need to be a budding Picasso to do so.

Love Maze

If you don't really like the face you created in Game 4, your girlfriend/boyfriend difficulties may stem from the fact that you're looking for the

wrong type. You found out what type of lover *you* are in the first game. The *Love Maze* will help you to discover your ideal partner, the kind of person with whom you should be really compatible, and will also help you to sort out your expectations from a relationship. Similar types don't necessarily make a good combination – you may find you need someone to act as a foil to your own personality rather than as a duplicate. Thread your way through the labyrinthine paths of the maze and find out!

Is it Love or Infatuation?

Take a look at your relationship in Game 6 and see if it really is love or just a pleasant, but passing infatuation. Are you trying to delude yourself? Are you so consciously searching for love that you build up every romance into the 'real thing'?

The Steeplechase

No long-term relationship is completely free of problems and upsets and Game 7, *The Steeplechase*, is designed to help you assess how you cope with the ups-and-downs of marriage – or how you are likely to cope if you are not yet married. Will your relationship survive the hurdles of the course? Will you get a soaking at the water jump? Play and find out!

Where's Your Venus? Where's Your Mars?

Lastly come two astrology based games. Both Mars and Venus have a powerful bearing on one's relationships. Venus strongly influencing the capacity for love and affection, and Mars a man or woman's sexual response. All you need to know is your date of birth – or that of your partner – and, with the help of the tables provided, you can work out the influence of the heavens on your love life.

So, 'The game's afoot: follow your spirit' and away you go.

DYNAMIC

You have great force of character and energy. People find you very attractive, partly because of your dynamic approach to life, and partly because you express feelings and desires other people may repress. In love you are passionate and possessive, and occasionally jealous and demanding. You probably exert a lot of physical energy in sport, or in your work or studies. You may, never get what you want unless you fight for it, and you may make enemies as well as friends. If, however, you don't launch into battle too fiercely, you will bring pleasure and stimulation to many of those around you.

REALISTIC

You go for the sensible, the practical, and are hardly ever bothered by irrational fears or self-doubt. You can dress extremely well, and quality is important to you. If you have a car, it will be a reliable make; it may be fast, but you drive carefully. In a relationship you have a lot to give, but are unlikely to choose someone for purely romantic reasons. You cope well with difficult situations and your inbuilt strength enables you to conquer afflictions which would daunt most people, although this same quality sometimes leads to intolerance. However, you have a capacity for great enjoyment and form friendships easily.

SENSUOUS

You live for love. You have a great capacity for enjoyment and live for the moment without needing to analyze too deeply the reasons for your actions. You also enjoy giving enjoyment. You probably own the most powerful car within (or just outside) your means. Domesticity is difficult for you. Your interests are too diffuse and it is hard to confine your affections to one person. You are not jealous, and cannot understand jealousy in others. There is a danger of becoming too fast to give you real satisfaction. However, with your charm you will never have any difficulty in attracting people.

INDEPENDENT

Tolerant and understanding, you are able to form mature relationships in which you neither ask for support, nor expect people to lean on you. As a lover you are confident and charming. You have your own brand of loyalty, but, if you feel that too many demands are being made on you, you are likely to slide gently away. Your clothes will have a definite individual touch. You can see other people's points of view, even if you do not agree with them. You tend to feel that you don't need other people, and consequently you may find yourself alone quite often, in spite of your good qualities.

OPTIMISTIC

You are naturally cheerful and free from depressing hangups. You are enthusiastic, ambitious and likely to succeed, because you put a lot into everything you do. Although you suffer from periodic black moods, you are probably amusing and popular. You enjoy material possessions, but can be careless; generous with them. You tend to see only the good points in people — and in yourself! In a long-term relationship you may be rather insensitive, which could lead to poor communication. Often you use your super-activity to avoid involvement, but you should ultimately make a devoted partner.

PROTECTIVE

People are attracted by your inner strength and great sense of justice. You will be admired for the way you cope with life and relationships. Love is very real to you, and you have the gift of making people feel loved and secure. You appreciate beauty, and your clothes and possessions are chosen with care. You need to be in control of people, possibly because you feel you can only keep up your own strength by maintaining order around you. Remember that it can be wearing always to be the 'strong' partner; other people can be competent and might like to feel you needed them.

Answer Yes or No

Section A

DO YOU:
1 Remain cheerful, despite missing a train?
2 Like giving and receiving fism?
3 Choose dependable friends?
4 Cope well with emotional scenes?
5 Remember meals you had years ago?

6 Think modern love are unrealistic?
7 Drive a hard bargain
8 Ever gamble?
9 Sympathize with
10 Believe in life insu

More Yes's to the odd bers— move to left **D.**
More Yes's to the eve bers— move to right **F**

Section D

Answer Yes or
1 Would you con camping holiday wi partner?
2 Do you put ambi fore enjoyment?
3 Can you have relationships?
4 Can you converse
5 Do you try to furt reputation as a lover
6 Is sex important to
7 Could you tolerat in your standard of l
8 Do you plan yo life?
9 Do dull-minded irritate you?
10 Do you often r physical violence?
11 Is your seduction nique to sweep pe their feet rather than a approach?
12 Do you find lor or traffic jams exc frustrating?

More Yes's to questi move to **Optimistic**
More Yes's to quest move to **Sensuous**
More Yes's to ques 12 move to **Dynam**

Section C

Answer Yes or No

DO YOU:
1 Immediately assume your lover is tired of you, if he/she fails to ring?
2 Often feel tired?
3 Find your lover can easily affect your moods?
4 Worry about relationships?
5 Prefer interesting conversation to 'nonsense talk' with your lover?
6 Find emotional arguments irritating?
7 See through people easily?
8 Control your feelings?
9 Let yourself be easily influenced?
10 Feel that your relationships are determined by the other person?
11 Control your temper easily?
12 Usually think compliments from the opposite sex are genuine?

More Yes's to questions 1–4 move to **Diffident**
More Yes's to questions 5–8 move to **Intellectual**
More Yes's to questions 9– 12 move to **Tranquil**

You are capable of deeply satisfying relationships with people. You need love and affection and others recognize this and find you easy to love. Your dependence on others may stem from the fact that you do not feel yourself to be an individual in your own right. Although you seek guidance from your partner you will sometimes find yourself illogically objecting to their interference. This can lead to angry scenes and resentment. However, once you learn to cope with your ambivalent feelings towards your lover, you should be able to derive great pleasure and fulfilment from your relationships.

DEPENDENT

You tend to idealize and seek perfection, to create fantasies around yourself when life does not come up to your expectations. You can probably get away with unusual or fantastic clothes because you have confidence in your image. In relationships you are not interested in imperfections; in fact you sometimes make yourself believe that there are no faults on either side. You have a tendency to overdramatize your affairs, and may have a somewhat rosy, idealistic vision of domestic bliss! However, you attract many friends who find your view of life both stimulating and amusing.

ROMANTIC

You are kind and gentle, and people like and respect you because of your sincerity and lack of affectation. Although others have a high opinion of you, you do not always have a high opinion of yourself! In your choice of clothes you may be indecisive. When you are feeling happy you know you look marvellous, but, if your mood is low, you tend to be easily discouraged about your appearance. You can be passionate in your love, once you are sure that it is returned. You are an emotional person, and when you get depressed, hang on until you swing the other way, for, in the right situation, with the right people, you have the capacity for great fulfilment in life.

DIFFIDENT

Logical and thoughtful, you can cope with many aspects of life which bewilder other people. You have a sense of purpose in life and are happiest in a situation you feel that you can understand. You do not attach much importance to material things unless they have a real bearing on your chosen way of life. In a relationship you should prove mentally stimulating, but may perhaps have an excessive faith in your ability to talk things out. Because you fear the irrational, you tend to repress your feelings and emotions. Do not fight against them too much or you may miss out on some important parts of life.

INTELLECTUAL

In a mad world you are a breath of sanity. While others dash round in circles which often prove futile, you are content to wait for the right moment to act, rather than rushing in impetuously. People find you relaxing company because they know that you observe situations calmly. You tend to wait for the other person to come to you rather than making direct efforts at friendships, but once sure of being loved you can be passionate and firm. Underlying your apparent detachment could be the fear of being rejected. However, you attract people easily, so you have no real cause for worry.

TRANQUIL

You act on intuition rather than working out a life-style in advance. You are happiest in situations where you can play it by ear, and have faith in your inner perceptions. As a result you do not feel the need to explain your actions to others. None the less, in love you probably attach a lot of importance to communication, tolerance and understanding. You may dislike relationships involving too much routine. Because you react quickly to new ideas, you may find it hard to finish what you begin. However, intuition will be the ruling factor in your life, so stick to it!

INTUITIVE

When moving into a new house, do you immediately
...e contact with your neighbours?
...alk easily to people in shops, buses etc?
...orry about the future?
...void taking things too seriously?

...nly Yes go to square A: mainly No go to square B.

Section B
Answer Yes or No

..YOU:
..hink love is ephemeral?
..ecome bored without a ..r?
..void seeing friends for .. of intruding?
..believe implicitly most ..gs people tell you?
..nalyze your love-life?
..t in easily with other

people's arrangements?
7 Read both heavy and light escapist books on holiday?
8 Often get into difficult situations?
9 Ask people favours?
10 Enjoy calculated risks?

More Yes's to the odd numbers—move to left **C**
More Yes's to the even numbers—move to right **E**

Section E
Answer Yes or No

..you easily hurt?
..you confide in friends?
..you listen to advice?
..you look mainly for ..th and understanding ..e?
..e you concerned about ..essing people?
..y sometimes in-
..y attracted to people?
..you try to predict what ..happen at a party?
..you try to attract the ..glamorous person at a ..?
..you always know some-
..you have hurt some-
..o you know instantly ..will fall in love?
..o you sometimes in-
..ively dislike people?
..re you sensitive to the ..sphere of a social ..ring?

Yes's to questions 1–4 to Dependent
Yes's to questions 5–8 to Romantic
Yes's to questions 9–..ve to Intuitive

Section F
Answer Yes or No

1 Are you intolerant of nonsense in others?
2 Would you stop yourself falling in love with someone who was not free?
3 Do people ask you for advice?
4 Do you find it hard to understand other people's difficulties?
5 Are you open-minded about new ideas?
6 Do you give people the benefit of the doubt?
7 Can you let the other person have the last word?
8 Can you take criticism?
9 Are your standards of integrity particularly high?
10 Are you patient?
11 Do people often cry on your shoulder?
12 Do you think it is only fair to let people get to know you before you launch into an affair with them?

More Yes's to questions 1–4 move to **Realistic**
More Yes's to questions 5–8 move to **Independent**
More Yes's to questions 9–12 move to **Protective**

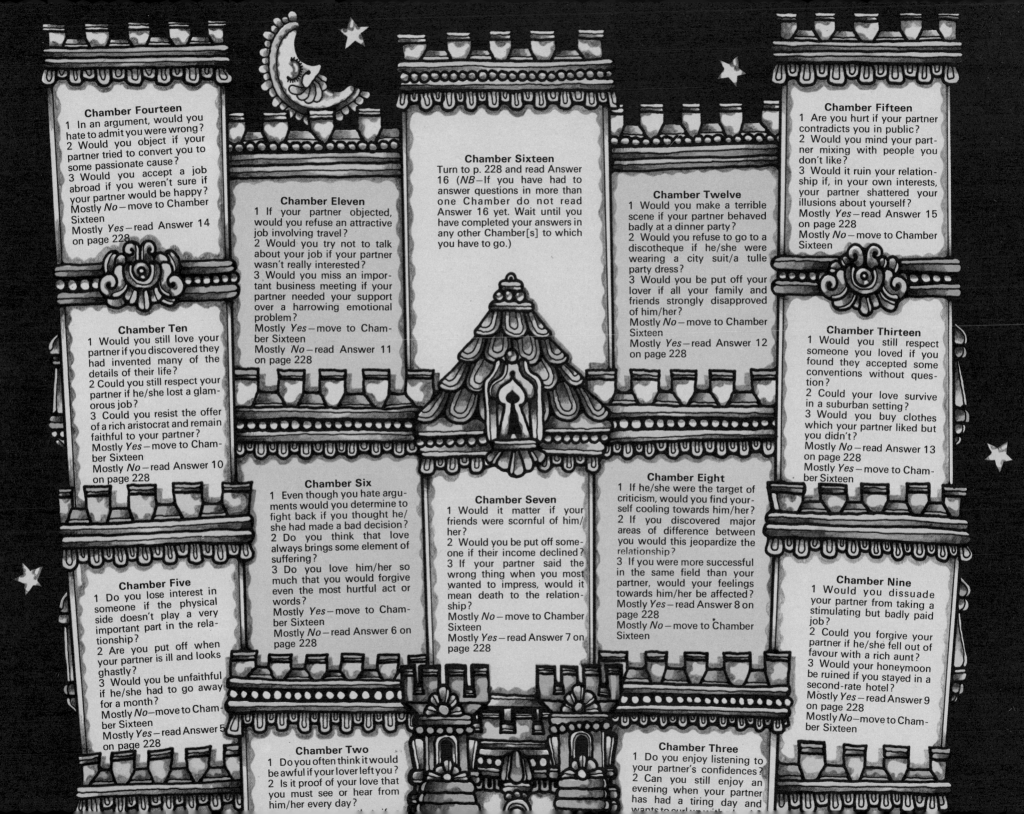

Chamber Fourteen
1 In an argument, would you hate to admit you were wrong?
2 Would you object if your partner tried to convert you to some passionate cause?
3 Would you accept a job abroad if you weren't sure if your partner would be happy?
Mostly *No* — move to Chamber Sixteen
Mostly *Yes* — read Answer 14 on page 228

Chamber Eleven
1 If your partner objected, would you refuse an attractive job involving travel?
2 Would you try not to talk about your job if your partner wasn't really interested?
3 Would you miss an important business meeting if your partner needed your support over a harrowing emotional problem?
Mostly *Yes* — move to Chamber Sixteen
Mostly *No* — read Answer 11 on page 228

Chamber Sixteen
Turn to p. 228 and read Answer 16 (*NB* — If you have had to answer questions in more than one Chamber do not read Answer 16 yet. Wait until you have completed your answers in any other Chamber[s] to which you have to go.)

Chamber Twelve
1 Would you make a terrible scene if your partner behaved badly at a dinner party?
2 Would you refuse to go to a discotheque if he/she were wearing a city suit/a tulle party dress?
3 Would you be put off your lover if all your family and friends strongly disapproved of him/her?
Mostly *No* — move to Chamber Sixteen
Mostly *Yes* — read Answer 12 on page 228

Chamber Fifteen
1 Are you hurt if your partner contradicts you in public?
2 Would you mind your partner mixing with people you don't like?
3 Would it ruin your relationship if, in your own interests, your partner shattered your illusions about yourself?
Mostly *Yes* — read Answer 15 on page 228
Mostly *No* — move to Chamber Sixteen

Chamber Ten
1 Would you still love your partner if you discovered they had invented many of the details of their life?
2 Could you still respect your partner if he/she lost a glamorous job?
3 Could you resist the offer of a rich aristocrat and remain faithful to your partner?
Mostly *Yes* — move to Chamber Sixteen
Mostly *No* — read Answer 10 on page 228

Chamber Thirteen
1 Would you still respect someone you loved if you found they accepted some conventions without question?
2 Could your love survive in a suburban setting?
3 Would you buy clothes which your partner liked but you didn't?
Mostly *No* — read Answer 13 on page 228
Mostly *Yes* — move to Chamber Sixteen

Chamber Six
1 Even though you hate arguments would you determine to fight back if you thought he/she had made a bad decision?
2 Do you think that love always brings some element of suffering?
3 Do you love him/her so much that you would forgive even the most hurtful act or words?
Mostly *Yes* — move to Chamber Sixteen
Mostly *No* — read Answer 6 on page 228

Chamber Seven
1 Would it matter if your friends were scornful of him/her?
2 Would you be put off someone if their income declined?
3 If your partner said the wrong thing when you most wanted to impress, would it mean death to the relationship?
Mostly *No* — move to Chamber Sixteen
Mostly *Yes* — read Answer 7 on page 228

Chamber Eight
1 If he/she were the target of criticism, would you find yourself cooling towards him/her?
2 If you discovered major areas of difference between you would this jeopardize the relationship?
3 If you were more successful in the same field than your partner, would your feelings towards him/her be affected?
Mostly *Yes* — read Answer 8 on page 228
Mostly *No* — move to Chamber Sixteen

Chamber Five
1 Do you lose interest in someone if the physical side doesn't play a very important part in the relationship?
2 Are you put off when your partner is ill and looks ghastly?
3 Would you be unfaithful if he/she had to go away for a month?
Mostly *No* — move to Chamber Sixteen
Mostly *Yes* — read Answer 5 on page 228

Chamber Nine
1 Would you dissuade your partner from taking a stimulating but badly paid job?
2 Could you forgive your partner if he/she fell out of favour with a rich aunt?
3 Would your honeymoon be ruined if you stayed in a second-rate hotel?
Mostly *Yes* — read Answer 9 on page 228
Mostly *No* — move to Chamber Sixteen

Chamber Two
1 Do you often think it would be awful if your lover left you?
2 Is it proof of your love that you must see or hear from him/her every day?

Chamber Three
1 Do you enjoy listening to your partner's confidences?
2 Can you still enjoy an evening when your partner has had a tiring day and wants to curl up with a

constructive advice if your partner has a problem?
Mostly *Yes*, move to Chamber Sixteen
Mostly *No*, read Answer 1 on page 228

are full of work details, and few endearments, do you find that your feelings cool off a little?
Mostly *Yes*—read Answer 4 on page 228
Mostly *No*—move to Chamber Sixteen

WEST WING

If you answer mainly *Yes* to the questions below, move to the appropriate Chamber(s).

Section 1
1 Do you think a relationship should provide security?
2 Do you easily accept other people's judgments?
3 Do you like other people to make decisions for you?
Mainly *Yes*, go to Chamber One

Section 2
1 Would you forego a holiday rather than go alone?
2 Would you enjoy community life?
3 Would you hate to live alone?
Mainly *Yes* go to Chamber Two

Section 3
1 Do you confide in people?
2 Are you a poor listener?
3 Do you often have long telephone conversations?
Mainly *Yes*, go to Chamber Three

Section 4
1 Do you fall in love easily?
2 Do you analyze your love-life?
3 Do you know intuitively if you will fall in love with someone?
Mainly *Yes*, go to Chamber Four

Section 5
1 Do you attach a lot of importance to physical attraction?
2 Before a date, do you plan tactics?

3 Do you make sure *all* your clothes are clean before a date?
Mainly *Yes*, go to Chamber Five

Section 6
1 Can you forgive someone who frequently stands you up?
2 Could you put up with a moody lover?
3 If your lover is less involved than you, do you still plunge in wholeheartedly?
Mainly *Yes*, go to Chamber Six

Section 7
1 Do you admire sophistication?
2 Do your friends' opinions of your date matter?
3 Would you mind if your companion developed a rash in public?
Mainly *Yes*, go to Chamber Seven

Section 8
1 Do you think there is a woman behind every successful man?
2 Would your partner's success give you personal satisfaction?
3 Are you attracted to people similar to yourself?
Mainly *Yes*, go to Chamber Eight

Now try the questions in the Chamber to which your answers have directed you.
(*Important* If your answers have led you to two or more Chambers, answer the questions in each one before moving to Chamber Sixteen or turning to the Answers.)

EAST WING

If you answer mainly *Yes* to the questions below, move to the appropriate Chamber(s).

Section 9
1 Would you go out again with someone who took you to a cheap restaurant?
2 Would you have guilt feelings if you won a fortune?
3 Do you think poverty is a major cause of marital unhappiness?
Mainly *Yes*, go to Chamber Nine

Section 10
1 'The whole world loves a lover'. Do you agree?
2 Would you rather give a separate party for certain friends?
3 Have you thought of having your family tree drawn up?
Mainly *Yes*, go to Chamber Ten

Section 11
1 Would you accept help from your partner's relations, if it put you under an obligation?
2 Would you like to become involved with a colleague more successful than yourself?
3 Does the boss attract you more than the office Adonis?
Mainly *Yes*, go to Chamber Eleven

Section 12
1 Would you be embarrassed to introduce an outlandishly dressed friend to your family?
2 Do you tend to take up your friends' hobbies?

3 Would you be put off by a lover lacking in social graces?
Mainly *Yes*, go to Chamber Twelve

Section 13
1 Do you sometimes say things just to shock people?
2 Do your friends often disapprove of your lovers?
3 Do you avoid 'popular' entertainment on principle?
Mainly *Yes*, go to Chamber Thirteen

Section 14
1 Can you be satisfied with someone who is not your intellectual equal?
2 Do you react badly to criticism?
3 Do you easily tolerate indecision in your partner?
Mainly *Yes*, go to Chamber Fourteen

Section 15
1 Are you put off people if you do not share their views?
2 Do you shun relationships with flamboyant, extrovert people?
3 Do you find opposites attract?
Mainly *Yes*, go to Chamber Fifteen

Now try the questions in the Chamber to which your answers have directed you.
(*Important* If your answers have led you to two or more Chambers, answer the questions in each one before moving to Chamber Sixteen or turning to the Answers.)

START

Assemble at the Main Gate to the Castle and answer the following questions:

1 When you are introduced to someone, which goes through your mind—
(a) What do they think of me?
(b) What do I think of them?

2 Which job would you choose—
(a) An emotionally rewarding job working with people on your wavelength?
(b) A job which gives you status and recognizes your talents and abilities?

3 Going unattached to a party, do you aim—
(a) To make a favourable impression on just one person?
(b) To make a favourable impression on everyone?

4 When you see a beautiful stranger, are you more curious to know—
(a) What kind of person are they, how do they think and feel?

(b) What do they do, who are they, where do they come from?

5 When you meet a new group of people, do you—
(a) Tend to let your instincts decide how you feel about them?
(b) Consciously sum them up in your mind?

6 When you first fall in love with someone, do you—
(a) Only want to see them and tend to forget about your other friends?
(b) Feel you proudly want him/her to meet all your friends and bring him/her into your circle?

7 If you fell for someone and

then realized their opinions and way of life were totally opposed to yours, would you—
(a) Be disappointed, but feel you could not help continuing to love them all the same?
(b) Be put off entirely, deciding that what you thought

was love was merely a passing infatuation?

Mainly *Yes* to (a) questions— go to **East Wing of the Castle** and answer Sections 1–8
Mainly *Yes* to (b) questions— go to **West Wing of the Castle** and answer Sections 9–15

THE CASTLE GAME

The Castle Game: Answers

Answer 1

You need a *parent figure*—what you are really looking for in a relationship, is someone to mother/father you, to give you the degree of tolerance and protection and indulgence that only a child should really expect.

Answer 2

You want *relief of loneliness*—loneliness is a great problem, and people can be driven to commit themselves very unwisely rather than face any more time alone.

Answer 3

You just want a *listener*—this really has been known to influence the course of true love! To pour your troubles into a sympathetic ear is comforting. You feel you need to be understood and appreciated.

Answer 4

This is a difficult area in which to see clearly, but *emotionalism* seems to be more the question than love. You are 'in love with love'! This can mean either being so fascinated by one's own reactions when in a state of love, that the loved object becomes relatively unimportant, or that all you really want is someone to love *you*.

Answer 5

Sex pure and simple is what you want! Obviously it is fundamental to you, but make sure that 'I love you!' means a little more than 'I want to make love to you!', or that 'I want to live with you for ever!' doesn't only mean 'I want us to make love all day and every day!' A little unrealistic for a long-term policy.

Answer 6

You're confusing love with *martyrdom*—he or she makes you suffer so dreadfully that you must be in love! Because the loved one is either beastly to you all the time, or keeps you at arm's length, your

anguish becomes an integral (possibly the most pleasant!) part of the relationship.

Answer 7

Your girlfriend/boyfriend is chosen for *status symbol* value—something to dazzle people with! Friends will burn with jealousy when you sweep off with that dark, handsome man in his super sports car. Conversely, the man with the glamorous blonde in tow must surely impress business colleagues and less fortunate friends!

Answer 8

An *inner foil* is what you want—someone who will enhance or underline the role you see yourself in at the moment, somebody who is an extension, a magnified version of what you aspire to be.

Answer 9

The answer's simple—what you want is *money*! It *is* easier to relax with none of those niggling little quarrels about overspending, or missing the last bus home, but for you the road to happiness is paved with gold—so beware of the Midas touch! Or at least admit it!

Answer 10

Your *social status* is a problem for you—and you may find yourself choosing someone simply because they will open doors to wider, more exciting, social circles. Any combination goes as long as it's advantageous—e.g. from slum to stately home, from conventional moneyed circles to trendy intellectual clique!

Answer 11

As you must have realized by now, your *career's* the thing! You're climbing up the ladder of success—and he/she will get you there quicker. It is easy to invest such people with a completely illusory glamour without realizing it.

Answer 12

Conformity means more to you than love. You may be choosing the same type of person your friends have chosen; or even someone who will be 'acceptable' in your home environment —worse, getting a boyfriend or girlfriend simply because your friends all have one, or because your parents have pushed you into it.

Answer 13

Non-conformity means more to you than love—at its most exaggerated it means deliberately choosing someone who will cause embarrassment to your family or friends. Motivated by petty revenge, or the desire to prove yourself a superior being—or, of course, just grown-up and independent—it can be worked at all levels.

Answer 14:

Be careful—it's *power* you want! You may be a bit of a tyrant, searching, as you seem to be, for someone weaker than yourself! Try an equal, for a change. You might find it quite a challenge.

Answer 15

You're looking for an *outer foil*, someone who will provide the necessary contrast to allow you to shine in your chosen role! If you want to be the life and soul of the party, you obviously don't want competition!

Answer 16

Love is what you want and give. Like everyone else you may want power, or relief from loneliness, or someone to look after you or set you off interestingly as well; but love for your partner will always come first. Forced to choose between your other motives and love itself, love will always win out. Congratulations! Provided you don't fall victim to any of the above schemes, you should have a very rich and satisfying life.

Consult the Oracle

Play this Victorian game, adapted from Gypsy Rickwood's Fortune Telling Book, and see what the oracle can tell you. All you need is a pack of cards. First shuffle them well and place them face-down on the table in the form of a horseshoe. Then choose one of the six questions below, concentrate hard and draw out one of the cards; the number and suit on the card you have drawn corresponds to the number of the answer to the question which has been asked. You may well be surprised at some of the answers!

(a) Does care for me ?
(b) Why am I beloved ? (Lady)
(c) Why am I beloved ? (Gentleman)
(d) How many times shall I fall in love ?
(e) Am I blinded by love ?
(f) What will first strike me about the person I am to marry ?

DOES CARE FOR ME ?

Diamonds

1 Eternally dreaming of you in absence.
2 No.
3 Not yet.
4 Too selfish to care much.
5 Regards it as a jest.
6 Madly devoted.
7 Less than last year.
8 With silent adoration.
9 Too fickle by nature.
10 Try to forget.
Kn As a friend.
Qn Declare yourself and you will discover.
Kg With increasing warmth.

Hearts

1 With varying intensity of feeling.
2 Sometimes hates the thought of you.
3 Is trying to forget.
4 Yes, do not misunderstand the long silence.
5 Sorrowfully and without any hope.
6 Not one bit.
7 Better in absence.
8 Only when in need of pecuniary assistance.
9 As a safety valve.
10 Against all better judgments.
Kn With great loyalty, seeing how trying you are.
Qn When feeling homesick.
Kg Adores you always.

Clubs

1 Do you expect it ? Better not.
2 Is temperamentally shallow, and cannot care.
3 Will care when it is too late.
4 Nothing can alter such affection.
5 Has entirely forgotten you already.
6 Is deliberately unfaithful.
7 Finds distraction elsewhere.
8 Cannot be relied upon for long.
9 You mistake kindness for something warmer.
10 Too unimaginative to care.
Kn Is playing you false.
Qn Never has and never will.
Kg In spite of everything, yes.

Spades

1 Does not feel any too sure.
2 You are one of many.
3 Yes, very dearly.
4 Has departed in a temper.
5 Too jealous and easily upset to care.
6 You are the only pebble on the beach.
7 With increasing intensity.
8 No, it is all pretence.
9 Even though pledged elsewhere.
10 Ever since you first met.
Kn With a passing fancy.
Qn Have not the years proved it so ?
Kg Yes, and is very much annoyed that it is so.

WHY AM I BELOVED ? (Lady)

Diamonds

1 He does not really mean it.
2 For your material advantages.
3 For your charm.
4 That happy laugh.
5 Your good sense appeals to him.
6 Placidity, verging upon dullness, pleases him.
7 You always agree with him.
8 You are his Aphrodite.
9 Because he wished for somebody just like you.
10 Because you were so good to him.
Kn You cheered his loneliness.
Qn You encouraged his hopes.
Kg For your endless tactfulness.

Hearts

1 He approves of your views on life.

2 Alas, he loves a certain lady even better.
3 For your conversational powers.
4 Because he is very miserable just now.
5 He thinks it adds lustre to his reputation.
6 Vanity on his part.
7 He depends upon you.
8 For your beauty.
9 For purely selfish reasons.
10 He is sentimental by nature.
Kn Because you are an heiress.
Qn He likes clinging ivy.
Kg He thinks you are wonderful.

Clubs

1 Because you are good and trusting.
2 Not for your beauty.
3 He thinks you very practical.
4 He wants a good housekeeper.
5 He is tired of change.
6 He feels you to be his mental equal.
7 Because you are young and kittenish.
8 He wants to take you from another.
9 For the sake of variety.
10 He wants a good comrade.
Kn You have stood by him through so much.
Qn A mad and passing fancy for you only and no more.
Kg Out of contrariness.

Spades

1 From long association.
2 Your spirited repartee pleases him.
3 You are the tragic centre of his life.
4 You remind him of his first wife.
5 Because you caught him on the rebound.
6 No one can explain it at all.
7 You fascinate all, why not him?
8 He likes to be in the fashion.
9 For your fortitude.
10 You bring romance into his life.
Kn The circumstances under which you met account for it.
Qn He sees in you a darner of socks.
Kg Youth calls to youth.

WHY AM I BELOVED?
(Gentleman)

Diamonds

1 Pity's akin to love.
2 You are not beloved, you are respected.
3 Because you are a coming man.
4 It is your hearty manner.
5 She has great faith in your judgments.
6 She prefers quantity to quality.
7 Because everyone else dislikes you.
8 Because she adores success.
9 Weakness appeals to her.
10 She isn't sure that she does.
Kn Because you always make a point of avoiding her.
Qn There is no one else in her life at the moment.
Kg Long habit accounts for it.

Hearts

1 She likes your grand manner.
2 You are her last chance.
3 She has angled for you for a long time.
4 She hopes to make something of you.
5 She mistakes your stupidity for strong silence.
6 You are such a contrast to your predecessor.
7 Your masterful ways impress her.
8 You have the gift of compliment.
9 Her demands are not exacting.
10 She thinks you a celebrity.
Kn She feels that you rely on her.
Qn For your debonaire manner.
Kg Only by way of variety.

Clubs

1 There are times when she detests you.
2 She is maternally affectionate.
3 Because she is never sure of you.
4 You have many tastes and interests in common.
5 Because her people oppose it.
6 'Because you are you', as no doubt she has said.
7 Your youth appeals to her maturity.
8 Because she can trample upon you.
9 She only wants to take you from a friend.
10 She is a man-eater; beware of her, she loves everyone in turn.
Kn She is a slave to your will and adores you.
Qn You know how to manage her.
Kg She thinks you deeply wronged.

Spades

1 For that high-handed way you have.
2 She admires your sulky charm and moodiness.
3 Because you take her out so much.
4 She only pretends it.
5 She could listen to you for ever without being bored.
6 Because weakness appeals to her.
7 She wishes to have a comfortable home.
8 She is too shallow to have a real reason.
9 She looks upon you as her superior.
10 She worships your heroicness.
Kn Your wisdom — of course.
Qn Because you are so generous.
Kg For your great goodness.

HOW MANY TIMES SHALL I FALL IN LOVE?

Diamonds

1 Once and for ever.
2 Every time you go to a new place.
3 Often. With heartbreaking consequences.
4 Once in early and once in very late life.
5 You begin in the schoolroom.
6 Never at all.
7 Once, when it is too late.
8 Once against your better judgment.
9 You are fickle and cold-hearted and do not love anyone but yourself.
10 Your fidelity is the admiration of all.
Kn A lonely life awaits you.
Qn Often, but in vain.
Kg You have a true and loyal heart.

Hearts

1 You are always finding a new star.
2 The last is always the best.
3 Your Irish blood makes you faithful.
4 You are an anchorite.
5 You flit from flower to flower.
6 You will, once too often.
7 Often, but soon over.
8 When it least suits your plans.
9 You will break all records.
10 When you go East.
Kn You boast and will be punished.
Qn Take care; you number is up.
Kg If you go South.

Clubs

1 You cannot resist dark eyes.
2 Oh! Those endearing young charms.
3 With one after another.
4 You enjoy doing so.
5 In Normandy.
6 Very unwisely.
7 Disastrously.
8 Wait a year or so.
9 It will come and go like a dream.
10 You will walk slowly into it.
Kn You are doing so now.
Qn Alas, you cannot forget the past.
Kg Frequently.

Spades

1 You always love unsuitably.
2 You love an illusion.
3 You have put all that aside for good.
4 No one can keep count.
5 You are too fastidious.
6 For a brief spell.
7 A midsummer madness.
8 Once, and never recover.
9 Once, a long time ago.
10 You are too shallow.
Kn On summer seas.
Qn Twice with the same person.
Kg You love a memory.

AM I BLINDED BY LOVE?

Diamonds

1 You are. Seek not to see.
2 No, you see everything too clearly.
3 You prefer it so — wisely.
4 No, you are too intelligent.
5 You are perfectly correct in your judgments.
6 Yes, you are behaving foolishly.
7 It is not Love which blinds you.
8 Yes, but it does not matter.
9 No.
10 Fate will loose the bandage.
Kn You close your eyes deliberately.
Qn Nothing can blind you.
Kg It is important for you to forget.

Hearts

1 Better so.
2 Wilfully.
3 You desire not to see.
4 Not you!
5 It makes for peace that you are.
6 No, you always suspect everyone.
7 You close your eyes at times.
8 You might alter your judgments were you not.
9 Blinded by selfishness.
10 Indeed you are not.
Kn Through great consideration.
Qn Ever so little.
Kg You are thinking of someone else.

Clubs

1 You will not remain so.
2 Expect a shock.
3 There is nothing to fear.
4 You are very foolish in this respect.
5 All who love well do not love wisely.
6 Remain contentedly short-sighted.
7 You have eyes like gimlets.
8 There is nothing to see except beauty.
9 Your mind is set upon a different object.
10 No, only dazzled.
Kn Do not exaggerate; you see well enough.
Qn You wear rose-coloured spectacles.
Kg You never will be.

Spades

1 Kindness makes you so.
2 Remain so or your vanity will suffer.
3 Not at all.
4 Open your eyes and face facts.
5 To the blind all things are sudden.
6 Greatly to your own advantage.
7 Leave it at that.
8 All is well.
9 No, you do not appreciate what you have.
10 In a special manner.
Kn Occasionally.
Qn You were, but, alas, you are so no longer.
Kg You know all too well that nothing is hidden, nor need it be.

WHAT WILL FIRST STRIKE ME ABOUT THE PERSON I AM TO MARRY?

Diamonds

1 Heartiness.
2 Mournfulness.
3 A fine patriotism.
4 Love of games.
5 The magic of a smile.
6 Eyes of most unholy blue.
7 Piano fingers.
8 A good profile.
9 A certain defiance.
10 Loud taste in clothes.
Kn A high colour.
Qn Red-gold hair.
Kg A determination to do all the talking.

Hearts

1 Down-cast eyes.
2 A very smart appearance.
3 You will be anything but well impressed.
4 Tremendous self-assurance.
5 An aristocratic calm.
6 Eyes of a different colour.
7 Dimples.
8 Raven hair.
9 A very cold, rather aloof and formal manner.
10 Something bird-like.
Kn That thrilling personality.
Qn A silvery voice.
Kg A slim and graceful poise.

Clubs

1 Your first impression is hostile.
2 After a time you will grow used to a squint.
3 A gushing manner.
4 You will be frankly bored.
5 Undeniable beauty.
6 Strong silence.
7 Sympathy.
8 Happiness of temperament.
9 Buoyancy.
10 Friendliness.
Kn A steady stare.
Qn A determination to become introduced to you.
Kg A charm of weakness.

Spades

1 That southern charm you know so well.
2 Shyness amounting to gaucherie.
3 Pushfulness.
4 A stormy silence.
5 A sort of worldly wisdom.
6 Eagerness.
7 Out-spokenness.
8 An effect of wealth.
9 Good manners.
10 Something wrong somewhere.
Kn Youth and elegance.
Qn Depression.
Kg That all-conquering smile.

IDENTILOVE

Many of us have fairly definite ideas of what we would like in a girlfriend or boyfriend but when it gets down to what they actually *look* like, the picture goes a bit blurry at the edges! So here's a way to design your own 'perfect partner' – even if you don't consider yourself as a budding Michelangelo.

Answer the questions in Part 1 of the quiz, and write down the key letter you choose for each answer. Then look at Part 2 and find the various characteristics signified by the letters. Draw or trace them on to the basic face shown in Part 3. Finally, read the instructions in Part 4, and you can interpret the motives behind your choice!

1 With a completely new girlfriend/boyfriend, would you prefer that they . . .
A Came up and introduced themselves to you in a natural and friendly way?
B Were obviously interested in you from the word 'go'?
C Were someone you knew already?
D Were introduced to you by a close friend?

2 First conversations can be awkward but to your relief you find that he or she . . .
E Has a lot of interesting things to say.
F Is so fascinating and amusing that you don't need to worry about your own conversation.
G Has a lot of interests in common with you.
H Wants to go to a pop concert, so there's no need to talk much.

3 You tell a friend about your new date, and emphasize that . . .
I He/she is tremendously sophisticated.
J He/she is absolutely mad about you.
K You suit each other ideally.
L He's not HER type at all!/she's not HIS type at all!

4 Imagine that your new boyfriend or girlfriend has borrowed the family car. You have a minor accident, damaging a door. Arriving back, you face his or her father who is FURIOUS. Your date . . .
M Keeps cool and takes all the blame.
N Generally defends you and manages to placate father with charm.
O Tactfully keeps out of the way, letting you sort it out.

5 You enjoy going out with this particular date because. . .
P He arranges everything beautifully and seems to know intuitively just what you want to do/She always knows where she wants to go to, and where the most interesting things are going on.
Q He always gets in touch BETWEEN dates/she is always pleased when you phone her.
R He/she fits in with your suggestions.
S He likes to go out on regular days of the week, so you always know where you are.

You should now have five key letters. Match these with the features below (in the appropriate column), and draw or trace them on to the basic face in Part 3.

PART THREE

GIRLS

A Well cared-for hair, not too exaggerated in style. **B** Long, romantic hair. **C** Soft, fluffy, feminine style. **D** Casual, slightly fly-away style. **E** Eyes—dark-looking and steady. Laughter lines. **F** Eyes—large, long-lashed, and alluring. **G** Eyes—light-looking, straightforward but far-away look. **H** Eyes—round, light-coloured, curly lashes. **I** Eyebrows—well shaped, evenly curved. **J** Eyebrows—firmly arched. **K** Eyebrows—fine and almost straight. **L** Eyebrows—delicate, and higher at inner corners than outer, faintly questioning. **M** Lips—gently curving and smiling. **N** Lips—sensuous, full and soft. **O** Lips—firm, straight, not very full. **P** Nose—straight, medium-sized, regular. **Q** Nose—well-shaped, curvy, slightly uptilted. **R** Nose—small, very uptilted. **S** Nose—long and a little irregular. **Optional extra:** A liberal sprinkling of freckles.

BOYS

A Young style, hair brushed forward and sideways. **B** Long, trendy hair. **C** Slightly casual, untidy style. **D** Neat, rather traditional hair style. **E** Eyes—dark with lines around them. **F** Eyes—heavily lidded, sensuous. **G** Eyes—ordinary, light and straightforward. **H** Eyes—with heavy, masculine glasses. **I** Eyebrows—thick, evenly curved. **J** Eyebrows—very arched. **K** Eyebrows—fine and rather straight. **L** Eyebrows—fine, higher at the inner corners, faintly questioning. **M** Lips—straight and firm. Not full. **N** Lips—full and sensuous (above) *or* wide and smiling (below). **O** Lips—delicate and somewhat sensitive. **P** Nose—well shaped and slim. **Q** Nose—good-sized and masculine. **R** Nose—uptilted, boyish. **S** Nose—longish, with indentation on upper lip. **Optional extra:** A well-shaped, thick moustache.

PART FOUR ANSWERS & EXPLANATIONS

INTRODUCTION

There it is—the picture of your ideal girl or boyfriend! Do you feel like keeping it in mind, so that you'll recognize him or her, when you meet? If you don't really like the face, your difficulties may stem from the fact that you're looking for the wrong type! Ask yourself what's wrong with the face, and then see our analysis in the appropriate group. Is it too old or unattractive? (*Group 1*); lacking in character? (*Group 2*); weak or immature? (*Group 3*); or is it basically okay but with one or two bad points? (*Group 4*).

GROUP ONE

Too Old, Unattractive or Rather Boring

You're not very confident, and consequently you go for the type of person with firm ideas and opinions. After a while you probably find them too overbearing and this may lead to quarrels which make you feel even less secure! Forget about the 'ideal' person for a while. Try to get to know *yourself* a little better, and you'll find it easier to discover the type who definitely would suit you.

GROUP TWO

Nothing Special, Characterless

You just aren't fussy enough! You like almost everybody—especially if they want to go out with you. All you really want is as many dates as possible each week. And, lucky you, you'll probably get them. But you'd better forget your dream of a real 'romance'—that isn't what you really want at present. Don't worry, it will come. For the moment you'd better stick with the less exciting but safer type whose face you have chosen.

GROUP THREE

Too Immature or Weak

You possibly pretend to have a fantastically romantic and exciting life, but underneath you are rather timid. Although you feel you must keep up with your friends, you really find that dating scares you. Try not to be so frightened of the real world. Take up new interests; try to make as many new friends as possible. You'll find most of them are as shy of you as you are of them! As your confidence grows, you'll attract more interesting people, and be able to choose properly!

GROUP FOUR

More or Less Okay

Well, nothing's ever quite perfect, and it's probably asking for disappointment to lay hard and fast rules about what you want in the way of romance! Some of the best relationships are between people who would never have chosen each other in theory!

Don't take this quiz too seriously and above all don't start looking in earnest for the person you've drawn! Remember, though that you shouldn't expect to find complete perfection in one person. Nobody's perfect—not even you!

SENSUOUS

1 Do you like the challenge of opposition?
2 Would you depend on your partner for moral/emotional support?
3 Can you stand criticism?

A
1 Do you admire strength of character?
2 Would complete freedom in a relationship drive you too far?
3 Would someone who lives in a dream-world annoy you?

Mostly Yes, answer questions A. Mostly No, answer questions B.

Mostly Yes, go to Bay 6. Mostly No, bypass B and go on to Bay 1. Mostly No, bypass B and go on to Bay 6.

B
1 Must your partner have a similar life-style to yours?
2 Would someone without your zest for life bore you?
3 Do you want to be put on a pedestal?

Mostly Yes, go to Bay 6. Mostly No, go to Bay 1.

ROMANTIC

1 Do you fall for glamorous people?
2 Do you enjoy uncertainty in a relationship?
3 Must life always be a whirl of pleasure?

Mostly Yes, answer questions A. Mostly No, answer questions B.

A
1 Is strong attraction more important than stability?
2 Do you despise self-pity in others?
3 Are you bored by constancy?

Mostly Yes, go to Bay 3. Mostly No, bypass B and go to Bay 4.

B
1 Do you tend to be too unrealistic?
2 Would infidelity upset you terribly?
3 Do you ever think of qualities you'd want in a long-term partner?

Mostly Yes, go to Bay 4. Mostly No, go to Bay 6.

TRANQUIL

1 Do you need to be pushed into action?
2 Do you like a strong decisive approach?
3 Do you find idealistic people immature?

Mostly Yes, answer questions A. Mostly No, answer questions B.

A
1 Do you want someone to look up to?
2 Can you cope with arguments?
3 Can you stand physical violence?

Mostly Yes, go to Bay 3. Mostly No, bypass B and go to Bay 5.

B
1 Do you want to share your lover's dreams?
2 Would you secretly like a Hollywood-style romance?
3 Are 'sweet nothings' essential to love?

Mostly Yes, go to Bay 4. Mostly No, go to Bay 3.

DYNAMIC

1 Is being loved an ego-trip?
2 Would you mind if your partner were more successful than you?
3 Is being admired by your partner one of the most important aspects of love?

Mostly Yes, answer questions A. Mostly No, answer questions B.

A
3 Do you want total devotion?

Mostly Yes, go to Bay 5. Mostly No, bypass B and go on to Bay 7.

B
1 Should couples be free as individuals?
2 Do you hate the clinging type?
3 Are you bored by people who won't answer back?

Mostly Yes, go to Bay 5. Mostly No, go to Bay 3.

OPTIMISTIC

1 Are you upset by moodiness or apathy in others?
2 Do you find 'fanciful thinking' boring?
3 Do forceful people attract you?

Mostly Yes, answer questions A. Mostly No, answer questions B.

A
1 Do you dislike too many demands being made on you?
2 Do you find very deep relationships too restricting?
3 Can you let the person you love have complete freedom?

Mostly Yes, go to Bay 5. Mostly No, bypass B and go on to Bay 7.

B
1 Do you think most people are attracted by opposites?
2 Do you find people with different opinions from your own stimulating?
3 Do you often fall in love with quiet people?

Mostly Yes, go to Bay 5. Mostly No, go to Bay 5.

1 Would you lose respect for an indecisive person?
2 Could you be happy with one less emotional than you?
3 Do you want a full social...

A
1 Do you value independence in a partner?
2 Is a sense of humour...
3 Does good-heartedness...

1 Do you enjoy difficult relationships?
2 Could you cope with a thrift?
3 Are a sense of fun and prowess of primary importance in your partner?

Mostly Yes, answer questions... Mostly No, answer questions...

A
1 Would you like an ultra-... missive partner?

If you... meet y... lik... among... find... and an... questio...

THE H...

DEPENDENT

1 Are you easily upset by unflattering remarks?
2 Do you want one steady love?
3 Do you want to be organized by someone?
Mostly *Yes*, answer questions A. Mostly *No*, answer questions B.

A
1 Is affection ultimately more important than passion?
2 Do you need someone sympathetic to whom you can confide your worries and problems?
3 Would honesty be an essential virtue in someone you loved?
Mostly *Yes*, go to Bay 2. Mostly *No*, bypass B and go on to Bay 8.

B
1 Do you find slightly 'mad' people exciting?
2 Do you believe quarrelling clears the air?
3 Do you want to be understood emotionally?
Mostly *Yes*, go to Bay 8. Mostly *No*, go to Bay 2.

REALISTIC

1 Are you patient with others?
2 Do you like to be responsible for someone's emotional welfare?
3 Would you be upset if you weren't included in your partner's plans?
Mostly *Yes*, answer questions A. Mostly *No*, answer questions B.

A
1 Do you enjoy quiet evenings?
2 Can you always keep cheerful?
3 Do you want to be indispensable to your lover?
Mostly *Yes*, go to Bay 12. Mostly *No*, bypass B and go on to Bay 11.

B
1 Should couples 'live and let live'?
2 Do you find depression catching?
3 Do you want a partner with guts?
Mostly *Yes*, move to Bay 11. Mostly *No*, go to Bay 12.

DIFFIDENT

1 When depressed, do you want to be told to snap out of it?
2 Do unpractical people annoy you?
3 Do you dislike being lectured?
Mostly *Yes*, answer questions A. Mostly *No*, answer questions B.

A
1 Do placid, easy-going people attract you?
2 Do you want to be treated firmly?
3 Do you like strong characters?
Mostly *Yes*, go to Bay 12. Mostly *No*, bypass B and go on to Bay 10.

B
1 Is communication the first requisite for love?
2 Do you like getting very 'involved'?
3 Do you think intellectual ability is all-important?
Mostly *Yes*, go to Bay 10. Mostly *No*, go to Bay 12.

INDEPENDENT

1 Would you be happy with a 'dreamer'?
2 Do other people's activities interest you?
3 Can you tolerate vagueness in others?
Mostly *Yes*, answer questions A. Mostly *No*, answer questions B.

A
1 Would you be put off by someone whose conversation was boring?
2 Do you dislike the mundane?
3 Does intelligence matter more than looks?
Mostly *Yes*, go to Bay 9. Mostly *No*, bypass B and go on to Bay 11.

B
1 Would you be put off by a forgetful person?
2 Do you value sociability more than intellect?
3 Do you want someone dependable?
Mostly *Yes*, go to Bay 11. Mostly *No*, go to Bay 9.

INTELLECTUAL

1 Do you prefer independent people?
2 Would you find too many emotional demands irksome?
3 Would an over-sensitive partner annoy you?
Mostly *Yes*, answer questions A. Mostly *No*, answer questions B.

A
1 Do irrational feelings in others irritate you?
2 Are you embarrassed when adults cry?
3 Would you find a dynamic person fun?
Mostly *Yes*, go to Bay 9. Mostly *No*, bypass B and go on to Bay 10.

B
1 Do you enjoy heart-to-heart talks?
2 Should your partner be a listener rather than a talker?
3 Can you cope with emotional scenes?
Mostly *Yes*, go to Bay 10. Mostly *No*, go to Bay 9.

...you tolerate weak people?
...d you enjoy playing the
...al protector figure?
Mostly *No*, move to Bay 1.

...you always have your
...ay?
...like being the boss?
...ou a gentle lover?
...*Yes*, go to Bay 2.
...*No*, go to Bay 1.

...MAZE

...for any faults?
...*Yes*, go to Bay 7. *Mostly*
...ass B and go on to Bay 8.

...our partner always under...
...ou?
...u need a close emotional

The Love Maze: Answers

Bay 1 Protective and Sensuous

Both partners would derive great pleasure from this relationship, giving each other mutual help, and satisfying each other's wishes. If the protective partner realizes and can fulfil the sensuous lover's need for physical stimulation, then it should be a lasting relationship. This concerns not only sex, but also the need for emotional warmth and material comforts. In being made to feel wanted and needed, the protective person can keep doubts about his/her own identity at bay.

The only slight danger in this relationship is that the sensuous partner might find protection too suffocating, and go off pleasure-seeking. The protective person has to make sure that the sensuous partner doesn't entirely lose himself/herself in sensation.

Protective – Turn to Bay 2 for your second-best partner. Then turn to Conclusion 8.

Sensuous – Turn to Bay 6 for your second-best partner. Then turn to Conclusion 7.

Bay 2 Protective and Dependent

It is in the protective person's nature to want to look after someone, and it is in the dependent person's nature to want to be looked after, so in many ways this is an ideal relationship. The dependent person seeks security and a sense of well-being, even the sense of identity, which the protective partner is able to give. The protective partner has a very clear-cut role as a kind of emotional provider, and being one of the strong caring for the weak will gratify his/her emotional needs.

The danger of this relationship is that the dependent person, although wanting support, may sometimes resent dominance and too much interference from the protective partner, and equally the protective partner may tire of protecting. In this case, the less rigidly the roles are played the better.

Protective – Turn to Bay 1 for your second-best partner. Then turn to Conclusion 8.

Dependent – Turn to Bay 8 for your second-best partner. Then turn to Conclusion 1.

Bay 3 Tranquil and Dynamic

This combination of an introverted person (Tranquil) and an extroverted person (Dynamic) is extremely good socially. The couple complement each other, each being attracted by qualities in the other which they lack in themselves. The calmness of the tranquil lover makes a good foil to the adventuring spirit of the dynamic one. The dynamic partner expresses the tranquil

partner's feelings, and fights the world for him/her. In return, the tranquil partner brings an atmosphere of peace and serenity and enables the dynamic partner to have a comfortable respite from the competitive pace of his/her life. The tranquil person accepts aggression without hostility and the dynamic person enjoys being the leader.

Possible dangers are that in time the dynamic partner may doubt the value of his/her own aggression as being something which is not displayed in the other person, and that each partner may lose interest in the other because they are so different from each other. However, this is basically a good relationship, and will do both partners good on a short-term basis.

Tranquil – Turn to Bay 4 for your second-best partner. Then turn to Conclusion 2.

Dynamic – Turn to Bay 5 for your second-best partner. Then turn to Conclusion 11.

Bay 4 Tranquil and Romantic

This is a good match and one where both partners should find themselves on the same wavelength. Both are dreamers and tend to find imaginative solutions to their problems. They get on well together, but if the romantic partner is a woman she may find herself wishing that her tranquil lover were more of a hero figure. However, there are compensations for this, for the tranquil partner is easily contented, and will enjoy sharing the fantasy world of the romantic person. In their own minds, they will create a perfect relationship and they are likely to be sentimental and nostalgic and very loving as a couple. It is likely to be a long-lasting relationship which may very successfully lead to marriage.

A possible danger is that their mental image of their relationship as perfect may fade. If it does, both will have a tendency to think that the grass will be greener somewhere else, or with someone else, and if they do split up, this will be the most likely cause.

Tranquil – Turn to Bay 3 for your second-best partner. Then turn to Conclusion 2.

Romantic – Turn to Bay 6 for your second-best partner. Then turn to Conclusion 6.

Bay 5 Dynamic and Optimistic

Each partner here is attracted by the lively qualities the other possesses, and with which he/she can identify. They are both extroverts, and they understand each other, have the same capacity for enjoyment and sociability and the same

attitude to the outside world. They will get on well with the same kind of people, and have the same enthusiasms for things. Life for this couple will be fun and vital and very lively, and they can also help each other in many ways: the optimist will cheer the dynamic person when there are setbacks, and will also refuse to take hostility seriously when it occurs; and because the optimistic partner tends to take life at face value, the dynamic partner can help him/her to become more aware of people's motives.

A possible danger is that one or both partners may become dissatisfied with the lack of communication on emotional matters, but on the whole, this should be a good combination of personalities for a long-term relationship.

Dynamic – Turn to Bay 3 for your second-best partner. Then turn to Conclusion 11.

Optimistic – Turn to Bay 7 for your second-best partner. Then turn to Conclusion 10.

Bay 6 Sensuous and Romantic

An excellent combination. Both partners have rich inner worlds, and what goes on in their minds is real to them, so they act out their fantasies together. The sensuous lover is likely to understand the romantic more than the other way round, because the romantic partner is far more involved in his/her own fantasy world, which the sensuous partner may resent. They like love, believe in it, live for it, and radiate it to people around them. In fact, they may satisfy each other so much that they may begin to live entirely in their own world, manipulating the outside world to fit in with their fantasies. Consequently, this combination has a better chance of success as a love affair than a marriage, because the realities of earning a living, paying bills, etc., may interfere too much with the perfect world the two lovers create around themselves.

Sensuous – Turn to Bay 1 for your second-best partner. Then turn to Conclusion 7.

Romantic – Turn to Bay 4 for your second-best partner. Then turn to Conclusion 6.

Bay 7 Intuitive and Optimistic

This is a good combination for a long-term relationship or marriage. Both partners are fairly independent; neither relies on the other too much, yet they have a lot to give each other. Both like taking chances. It's in the intuitive person's nature to take risks, and the optimistic person will take chances and be adventurous without thinking of it as

a risk at all, so they will have an exciting life together. The intuitive partner may be inclined to cut himself/herself off from reality, and the optimistic partner will be a lever on reality. The intuitive partner will help the optimistic one to understand other people's feelings, and give him/her more insight into situations. But the optimistic partner will sometimes find the intuitive person difficult to understand, and the intuitive might sometimes find the optimist lacking in sensitivity.

As a couple they will have to make an effort to understand each other's point of view or they may eventually end up at cross-purposes.

Intuitive—Turn to Bay 8 for your second-best partner. Then turn to Conclusion 5.
Optimistic—Turn to Bay 5 for your second-best partner. Then turn to Conclusion 10.

Bay 8 Intuitive and Dependent

This is a useful combination for a love affair or marriage. The intuitive person has empathy and will be able to sense the needs of the dependent person, though the help given will be emotional rather than practical. It should be a very close relationship if the dependent person is willing to contribute to it. The intuitive person will be able to mediate between the dependent partner and the outside world. Intuitive people are good at adapting to new situations and will carry the dependent person along with them. The intuitive partner, especially in a marriage, will need the dependent person as an anchor and to provide stability for a life-style.

Possible dangers? The intuitive partner might find the dependent person's problems hampering after a while, and the dependent partner may be made to feel insecure by the apparent inconsistency of the intuitive.
Intuitive—Turn to Bay 7 for your second-best partner. Then turn to Conclusion 5.
Dependent—Turn to Bay 2 for your second-best partner. Then turn to Conclusion 1.

Bay 9
Independent and Intellectual

Both partners here mutually agree to 'do their own thing', and there is a lot of freedom in the relationship. The intellectual gives the independent person the stimulation of knowledge and new ideas, while the independent partner helps the intellectual over difficulties in the relationship when the problems are emotional ones. The independent partner, not being over-emotional or over-sensitive, can cope with the intellectual's rational approach to life.

Both partners can pursue their own lives within the relationship, or in marriage. The intellectual has a tendency to bottle up feelings, trying to cope with life by formulating complex theories. To the independent lover the intellectual may sometimes seem intolerant and efforts must be made to understand each other's point of view if this is to be a lasting and satisfying relationship.
Independent—Turn to Bay 11 for your second-best partner. Then turn to Conclusion 9.
Intellectual—Turn to Bay 10 for your second-best partner. Then turn to Conclusion 4.

Bay 10 Intellectual and Diffident

Both the intellectual and the diffident lover find facing life difficult and can be a great help to each other, especially in a short-term relationship. The intellectual can help by rationalizing the diffident lover's view of life, while the diffident lover will give more emotional understanding of life to the intellectual. The more extrovert the intellectual partner is, the greater chance of success for this relationship. It should be a very close relationship, where both partners try to understand each other, and where each feels concerned for the other's welfare. It will also be good for the ego of both partners. In the long term, however, the main danger would be that of lack of communication if one or both partners withdrew into themselves, and it is a socially limiting combination in the long view, as neither partner can be used as a springboard to the outside world.
Intellectual—Turn to Bay 9 for your second-best partner. Then turn to Conclusion 4.
Diffident—Turn to Bay 12 for your second-best partner. Then turn to Conclusion 3.

Bay 11 Realistic and Independent

A very good combination—each should find it easy to live with the other, and the outlook for a long-term relationship is good. Both partners have very separate identities and yet they are not isolated from each other. Both enjoy the present, rather than looking back into the past, and with a realist in the partnership they should be able to plan successfully for the future. They like the same things and have the same aims, and are both intolerant of nostalgia and sentiment. Democratic people, they have an outward direction to their lives and are unlikely to find themselves involved in hair-brained schemes. Each is involved and interested in the other's life, and neither will wish to dominate or take over from the other.

They are both capable of lasting friendships, but the danger might be that as they are both so self-reliant, they may find that they do not need each other much.
Realistic—Turn to Bay 12 for your second-best partner. Then turn to Conclusion 12.
Independent—Turn to Bay 9 for your second-best partner. Then turn to Conclusion 9.

Bay 12 Diffident and Realistic

This is a good combination, with one partner complementing the other. Different in personality and outlook, they yet have a lot to give each other. The realist may be of considerable practical help to the diffident lover, who is inclined to exaggerate problems and dwell on the worst aspect of things. The diffident lover is a help to the realist in their emotional life, bringing understanding and emotional depth to the relationship; he/she is inclined to form very strong affections and this will be both enjoyable and highly flattering to the realist.

In a long-term relationship there is the possibility of lack of communication unless both partners make an effort—impatience on the part of the realist, and feelings of isolation on the part of the diffident lover can put up barriers. If this difficulty can be overcome, long-term prospects should be good.
Diffident—Turn to Bay 10 for your second-best partner. Then turn to Conclusion 3.
Realistic—Turn to Bay 11 for your second-best partner. Then turn to Conclusion 12.

The Love Maze: Conclusions

Conclusion 1 – Dependent

Dependent with *Dependent*: This is not a good combination. Although it might be a close relationship it would become claustrophobic. You are both looking for care and protection, and are unable to fulfil this role for each other. Rather than trying to cling to each other for support, you should find strong partners to suit your needs.

With *Tranquil*: You may be attracted to a tranquil person across a crowded room, but the problem is, who would make the first move? If you leave it to them, you'll still be waiting to start the beautiful relationship when it's time to draw your old-age pension.

With *Diffident*: Not the most cheerful couple in the world, but you should understand each other and have a quiet, cosy relationship. This may easily lead to marriage, but try to resist. You would be happier with someone with a more positive outlook on life.

With *Intellectual*: You would get on well with the intellectual initially, but in the long-term he/she could well cut you out of their way of thinking, and you would have difficulty in under-standing their rational approach to life.

With *Romantic*: Madly attracted to each other, and you'll have a beautiful starry trip together. The problem is once the moonshine dies down, you might find him/her a tiny bit too shallow for your depth of feeling.

With *Sensuous*: You'll have a great time with him/her, but then so will everyone else... If you want a faithful lover, run away quick!

With *Independent*: Rather a one-sided relationship. Your need for love and companionship is stronger than theirs and this could lead to insecurity on your part in a long-term relationship.

With *Optimistic*: A good match. The optimist is fun and easy to live with. He/she won't always understand your sensitivity, but nonetheless will be a great person to have around, and you could do worse.

With *Dynamic*: He/she will sweep you off your feet all right – but watch out where you land. Dynamic isn't the one to suit your needs, not liking to take responsibility for other people; but it could be a fun relationship if not taken too seriously.

With *Realistic*: Not bad at all. The realist's outlook will be quite good for you, and although your personalities are very different you could try blending. It won't be a very deep relationship, but it will be workable.

Conclusion 2 – Tranquil

Tranquil with *Tranquil*: Too much tranquility may change to apathy. You would understand each other well and probably be free from conflicts and hostility, but, both wanting to be led, you may be in danger of getting into a rut.

With *Dependent*: Not for you, sorry. There might be an attraction between two people who are similar in many ways and both looking for someone strong, but it would be a bit like the blind leading the blind.

With *Diffident*: You will probably have a mutual understanding with a diffident partner, and a sensitive relation-ship may develop. However, you would find greater fulfilment with someone who was more out-going and could give you a more action-packed life.

With *Intellectual*: Not ideal. The intellectual would be of no help in your quest for a fun social life, nor would he/she satisfy your emotional needs. Interesting for a while, but not ideal in the long run.

With *Intuitive*: A good combination for friendship or marriage. The intuitive person will lead you into all sorts of interesting situations and get on to your emotional wave-length.

With *Sensuous*: Wonderful for a while, great fun and a great ego-trip for you, but beware of a lasting relationship. The sensuous person needs taming, and you are not really equipped for the task.

With *Protective*: The protective person has your best interests at heart, and you could have an easy, pleasant life, having your problems solved for you. A strong partner like this would give you security – perhaps at the expense of your own personal ambitions!

With *Independent*: A bad deal as far as you are concerned. In marriage you would not be given a sense of belonging, as the independent person can't help going his/her own way, leaving you behind. Even in a short-term relationship you might find a lack of emotional content.

With *Optimistic*: Although the optimistic person isn't emotional, he/she likes to be involved with people, and for this reason you would get on well, and be carried into the swim of whatever was happening around you.

With *Realistic*: Another rewarding relationship between opposites. He/she will take over all practical problems and most of the day-to-day decisions – it will be up to you to make sure that love and understanding are maintained.

Conclusion 3 – Diffident

Diffident with *Diffident*: This would be a close relationship, in which you would sympathize with each other and understand each other's problems. But, although you will communicate well, your moods are so similar that rather than helping each other you may sink each other deeper into gloom.

With *Dependent*: The kind of relation-ship you might get involved in and live to regret. Both of you tend to stick to what is available rather than breaking new ground, and if this relationship led to marriage it would be very limiting.

With *Tranquil*: A little freer as a relation-ship, but this one, too, would become heavy after a while. You would be understood by your partner, but a tranquil lover isn't really in a position to do too much for you.

With *Intuitive*: Good for a brief love affair or friendship, as the intuitive person can understand you and give sympathy, and you will enjoy the unpredictability of life in the company of an intuitive partner. However, in the long-term you would probably feel irritated by his/her grasshopper mind and lack of stability.

With *Romantic*: Disaster. You would have no time for each other, and probably would never come together in life the first place. The romantic's view of life is immature and unreal to you, and you would find yourself without any real point of contact with him/her.

With *Sensuous*: No again. You are miles apart, and would find a sensuous partner superficial, lacking emotional understanding and unsympathetic to your needs.

With *Protective*: A very good combina-tion. A protective person would give you a sense of belonging which would be satisfying and very comforting to you. You could get very involved in this relationship, which could be put successfully on a permanent basis.

With *Independent*: You need a close relationship, and an independent partner wouldn't ever get close enough for a long-term prospect; but it would be interesting and could work quite well as a short-term relationship.

With *Optimistic*: Attraction of opposites maybe, but for anything more than a brief acquaintance this relationship would probably come unstuck, due to the difficulty there would be in seeing each other's point of view, and in understanding each other's needs.

With *Dynamic*: A dynamic person would be good for you, enabling you to

live a more highly-charged life than would otherwise be possible. You would have to forgo a certain amount of communication, but other things would make up for this.

Conclusion 4 – Intellectual

Intellectual with *Intellectual*: You have the same rational approach to life and you stimulate each other mentally, bringing about an interesting and close relationship. However, there is a slight danger of removing yourselves from reality, and emotional problems may be difficult to cope with.

With *Dependent*. The approach to life is too different in this combination, and you would find the dependent's emotional traumas too much to cope with.

With *Tranquil*. Not ideal, but an improvement on the last relationship. The routine would become dreary after a while, with no room for personality expansion.

With *Intuitive*. An interesting combination, although the approach to life is very different. You would each give each other things to think about, although there is a danger of lack of understanding in the long term.

With *Romantic*. Good for a while, a nice break and good for your ego, but if you're thinking in terms of ever-after your outlooks and aims would clash, as Mr/Miss Romantic has never heard of logic or rationality.

With *Sensuous*. Totally opposed. You would find Mr/Miss Sensuous annoying and shallow, and he/she would find you unbearable, too.

With *Protective*. No. Protection is something you can do without and would find mentally restricting. All right if you want a nurse/mother/benefactor, but not as a soul mate.

With *Optimistic*. Pleasant but not a very rewarding relationship as far as you are concerned. The optimist simplifies life, while you complicate it, and if the differences are exaggerated, lack of communication and misunderstanding will follow.

With *Dynamic*. Very good match – you have all the ideas and theories and your dynamic partner puts them into action. A very useful and stimulating combination.

With *Realistic*. Both being rational people, this would be a good combination. Well worth a try for a short or long-term relationship.

Conclusion 5 – Intuitive

Intuitive with *Intuitive*: A very exciting romance; you are on the same wavelength and can stimulate each other's already vivid imaginations. However, there is a danger of living in a world of your own, and losing sight of all conventional standards.

With *Tranquil*. You could help a passive person become less passive, and their sensitivity, in turn, would give an extra dimension to your life. Good for a long-term relationship if you have enough patience.

With *Diffident*. You would find a diffident person irksome after a while, although in the initial stages you would probably get on well, and understand and sympathize with their feelings and views.

With *Intellectual*. A good relationship, stimulating new ideas in both partners. However, in the long-term you might find that ideas differ too much, a rational approach to life being quite foreign to you.

With *Romantic*. A beautiful relationship for both of you, where you could get carried away into marriage. This would be fine if you could keep a grip on reality, but both being flighty characters you could go off the deep-end together instead.

With *Sensuous*. Very good for a love affair, but not for a deeper relationship. The Sensualist's simple view of life would probably lack interest for you after a while.

With *Protective*. A nice combination for a long-term relationship. The protective person would give you a secure base from which to launch your 'crazy' ways – provided you could have a certain amount of freedom.

With *Independent*. You would get on well with Mr/Miss Independent, who would be a steadying influence on you but wouldn't hamper your movements.

With *Dynamic*. Mr/Miss Dynamic is always on the go, and although you might find him/her exciting company, the pace might become too much after a while.

With *Realistic*. Not for you; total lack of understanding on both sides – and you'd end up wondering whether you and Mr/Miss Realistic belong to the same species.

Conclusion 6 – Romantic

Romantic with *Romantic*: A good relationship at the beginning, making each other's fantasies come true, being able to communicate on a magical level, but problems will come later. Your romantic ideals cannot last for ever, and when they fade you will both find it hard to face the reality of broken dreams.

With *Dependent*. You like to idealize people, and Mr/Miss Dependent wouldn't fit into your ideal. Sorry.

With *Diffident*. As with a dependent person, you would find that Mr/Miss didn't come up to your expectations as a romantic hero/heroine.

With *Intellectual*. The idea of an intellectual might appeal to you, being someone you could put on a pedestal – but in the long term you would realize you had little in common, for your views are totally different.

With *Intuitive*. You would have a beautiful relationship with Mr/Miss Intuitive – it could successfully lead to marriage if you both toned yourselves down a bit and came to grips with reality a bit more.

With *Protective*. You would enjoy this relationship for a while and then become impatient with it, so perhaps it's better not to start it in the first place – Mr/Miss Protective might be inclined to cramp your style.

With *Independent*. He/she just wouldn't live up to your image of an ideal partner and could cause you to lose faith in your fantasies.

With *Optimistic*. Quite a good prospect for marriage. Mr/Miss Optimistic is willing to go for a romantic trip and his/her cheerfulness and practical good sense would be a help to you when times were hard.

With *Dynamic*. Mr/Miss Dynamic probably appeals to you, being someone you can admire. Fine for a while, but thinking further ahead you would find him/her lacking in imagination.

With *Realistic*. Keep well away – you don't want all your illusions shattered, do you?

Conclusion 7 – Sensuous

Sensuous with *Sensuous*: You understand each other's needs and can give each other the love and enjoyment you both want. It sounds an ideal combination, but for a long-term relationship this may not be a stable match. You may find the search for pleasure gets out of hand because neither of you is good at control or order.

With *Dependent*. You would be flattered by the admiration and loving ways of a dependent person, but would probably lose interest after a while. Not for keeps.

With *Tranquil*. A good relaxing relationship if you're thinking of settling down to married bliss — Mr/Miss Tranquil would make a nice, cosy husband/wife for you.

With *Diffident*. You could give Mr/Miss Diffident a very happy time, and you'd enjoy their company for a while, but in the long run the relationship would become heavy-going and you'd look for ways out.

With *Intellectual*. Not right for you. You probably wouldn't strike up an acquaintance with Mr/Miss Intellectual in the first place, but if you did you'd realize your views on life were so different you could be living on separate planets.

With *Intuitive*. Very good for a love affair but not so good for marriage. You'd find their thinking too way-out and quickly tire of someone who lived on another plane.

With *Independent*. If you want someone who will cater for your needs and give you a life of comfort and pleasure you'd best forget Mr/Miss Independent — he/she is too self-reliant and independent for a close relationship of this kind.

With *Optimistic*. A good, easy-going relationship which would work well as a marriage. Mr/Miss Optimistic is fun to be with and would enjoy sharing your beautiful world.

With *Dynamic*. Not for you. You'd find a clash of interests right from the beginning, and Mr/Miss Dynamic is not the person to settle into your life-style — he/she would be off where the action is.

With *Realistic*. No. You'd find Mr/Miss Realist far too spartan for your tastes and he/she wouldn't understand your aims, or sympathize with them.

Conclusions 8 – Protective

Protective with *Protective*: You both feel the need to control and protect a weaker partner, and there is no scope for this in your relationship. You do not cater for each other's emotional needs enough.

With *Tranquil*. A person who would appreciate your protective instincts. His/her gentleness and calm would be an added bonus in your life, too.

With *Diffident*. You would be very good for a diffident person, giving them security — this would be a close relationship on an emotional level, provided you could cope.

With *Intellectual*. Mr/Miss Intellectual would resent your wish to control their

lives, and you would find the relationship unrewarding, because what you offer isn't sought this time.

With *Intuitive*. Not for you. You would find the intuitive person's refusal to see sense annoying, and there would probably be little common ground for communication.

With *Romantic*. You might feel protective towards a romantic person and want to 'save' them. But basically the romantic doesn't want to be saved, so it would be better to concentrate your efforts elsewhere.

With *Independent*. This could be a good alliance between equals. You are both strong people who understand each other's wish for self-assertion, but from the long-term point of view a lack of emotional ties might lead to a sense of isolation on your part.

With *Optimistic*. Although this combination would lead to a trauma-free existence, the optimist is unable to reciprocate in the close relationship you are looking for.

Conclusion 9 – Independent

Independent with *Independent*: Fine for a modern marriage between two individuals who want to express themselves and achieve their personal life-style. There is a risk that you may both become so independent that after a while you may not need each other any more, and have nothing to give each other.

With *Dependent*. Not for you. You would find Mr/Miss Dependent's emotional demands hampering and irritating and wish you hadn't tied yourself to such a restricting relationship.

With *Tranquil*. No again, for the same reasons but to a lesser degree. You are too self-reliant to understand dependence in any form.

With *Diffident*. Another fruitless relationship — your views on life are so different that understanding and

communication would be doomed from the start.

With *Intuitive*. A good relationship; although you may find Mr/Miss Intuitive difficult to understand sometimes, this would not affect the basic feeling between you.

With *Romantic*. You would not sympathize with the romantic view of life, finding it immature and lacking any kind of sense or interest. Better leave Mr/Miss Romantic to go his/her own way.

With *Sensuous*. You would find the hedonist's view of life easier to understand and to cope with. If you're a pleasure-loving person Mr/Miss Sensuous would appeal to you and make life extremely pleasant for you.

With *Protective*. You would get on well with Mr/Miss Protective and find plenty in common, but you may find difficulties will crop up if this develops into a long-term relationship, for he/she might wish to take control of you.

With *Optimistic*. A very good combination. Mr/Miss Optimist would be easy to live with, not making too many demands on you, and his/her vitality and sense of adventure would add to the relationship.

With *Dynamic*. There would be conflict in this relationship due to the dynamic person's wish to assert their will over you, but if you can compromise and be led sometimes, this will be an exciting and rewarding combination.

Conclusion 10 – Optimistic

Optimistic with *Optimistic*: A good relationship, free from too much tension or hostility. You have the same enthusiasm for life, the same sociability, and you will probably have a lot of fun together and build up a workable life-style. The only slight problem is that the relationship may not be emotionally very deep.

With *Dependent*. You would have a beneficial effect on the dependent person, and your unfailing good spirits would enable you to cope with their emotional difficulties. It may be rewarding for you for a while, but in the end you would probably tire of the responsibility.

With *Tranquil*. A very good combination. Mr/Miss Tranquil would be happy to share their lives with you, and it would be a very enjoyable and problem-free relationship.

With *Diffident*. Not for you. Although you get on well with people in general,

you would quickly tire of someone you felt was always moaning about life. This is a case where opposites don't attract.

With *Intellectual*. Not on the same wavelength, especially if the intellectual is introverted; you would find him/her dull and unco-operative after a time.

With *Romantic*. You will probably be attracted to Mr/Miss Romantic, who is willing to join in the fun and likes an exciting social life. A good combination if you can be tolerant of his/her flighty ways.

With *Sensuous*. A good combination. You will be able to adjust pleasantly to the sensualist's demand for pleasure and ease. Beautiful for a short relationship and could expand into marriage too.

With *Protective*. You would get on with Mr/Miss Protective on a superficial level, but for a deeper relationship you would find his/her concern for your welfare unnecessary and claustrophobic.

With *Realistic*. You get on well with realistic people and although you would both be happy in this relationship, perhaps emotional contact would suffer, both of you having a practical approach to life. You might find a less unemotional partner more rewarding.

Conclusion 11 – Dynamic

Dynamic with *Dynamic*: A fantastic safari or adventure team, but if you're thinking of a domestic life people will take care. Two dynamic people will stimulate each other to achieving great things, but there is a danger that hostilities will arise when you start competing with each other.

With *Dependent*. You would have little patience for a dependent person, and once you felt they had 'clung on to' you you would lose any sympathy you might have had for them.

With *Diffident*. Not for you – you would be unable to understand why you couldn't make Mr/Miss Diffident happy, and the unrewarding

relationship would leave you with a sense of failure.

With *Intellectual*. Although Mr/Miss Intellectual has different aims in life, you find his/her company stimulating, bringing new ideas which you can translate into action. A very good combination if you can be tolerant of the intellectual's seeming lack of 'go'.

With *Intuitive*. Good for a short relationship, as Mr/Miss Intuitive will also bring you new ideas and another approach to life, but in a deeper relationship you might find yourself unable to understand the intuitive's inconsistency and lack of purpose.

With *Romantic*. A good ego-trip – you will be flattered by the romantic's view of you. And then you will probably realize that you and Mr/Miss Romantic have very little common ground, and his/her 'up in the clouds' approach might become very annoying.

With *Sensuous*. A good ego-trip, again, and a good short-term relationship – in the long run you may find conflicting interests would prevent a deep relationship.

With *Protective*. Mr/Miss Protective would bring stability into your life, and help you during bad patches – there might be some conflict due to his/her wish to dominate, but if you can agree to be equals this would be a good relationship.

With *Independent*. The same as above, but to a lesser degree – there would be more freedom in this relationship, and a good chance of working out conflicts because of Mr/Miss Independent's tolerance and self-confidence.

With *Realistic*. Another good combination. Mr/Miss Realist can take part in your plans for the future, and be a great practical help, provided interests don't clash. Compromise on both sides would help to make the relationship a success.

Conclusion 12 – Realistic

Realistic with *Realistic*: A fine combination for a secure marriage with common interests, and you will probably be a

successful couple in the eyes of society, planning and achieving the goals you set for yourselves. You may, however, find that practical things take up most of your energy, and as a result emotional contact may be lacking.

With *Dependent*. You enjoy being a strong person with strong opinions, and Mr/Miss Dependent would admire you for this – a good relationship if you are able to cope with the occasional emotional scene.

With *Tranquil*. Mr/Miss Tranquil will fall in easily with your wishes, and you should be able to respond to his/her emotional warmth. Certainly a good combination.

With *Intellectual*. Although you may not regard yourself as an intellectual, you have a lot in common, especially in your rational approach to life, so you have a great deal to offer each other.

With *Intuitive*. This one won't work. Total non-understanding between people whose views are completely opposed. You would find it impossible to sympathize with lack of logic and inconsistency.

With *Romantic*. Even more of a disaster. A total lack of appeal on both sides.

With *Sensuous*. May be fun for a short time, but you would not admire the sensualist's continual demand for pleasure and ease, finding their needs a weakness rather than an attractive quality.

With *Protective*. An alliance between equals, rather like a business partnership, but perhaps lacking the emotional content necessary to make the relationship work as a marriage.

With *Optimistic*. A good relationship – Mr/Miss Optimistic could help you build up a good future and would enjoy the present. Emotional understanding may not always occur, but this would be made up for in other ways.

With *Dynamic*. This is a case of two headstrong people together, but if you are both willing to compromise it could be a good relationship.

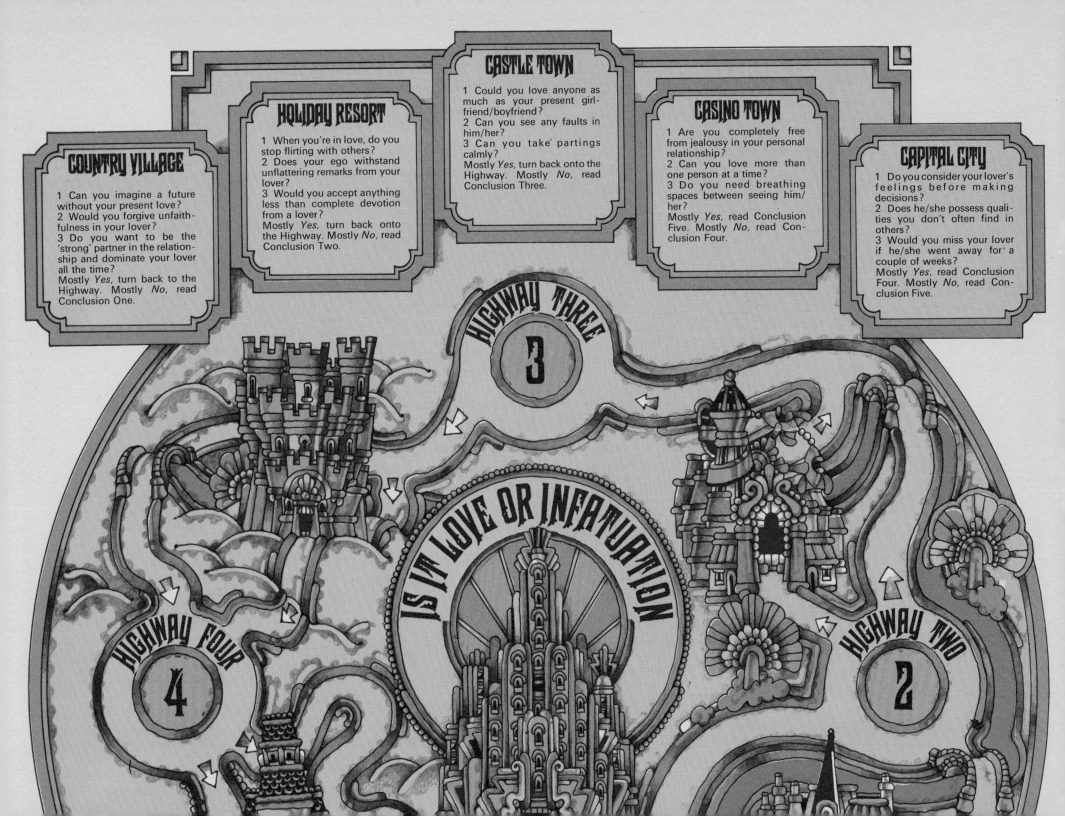

COUNTRY VILLAGE

1 Can you imagine a future without your present love?
2 Would you forgive unfaithfulness in your lover?
3 Do you want to be the 'strong' partner in the relationship and dominate your lover all the time?
Mostly *Yes*, turn back to the Highway. Mostly *No*, read Conclusion One.

HOLIDAY RESORT

1 When you're in love, do you stop flirting with others?
2 Does your ego withstand unflattering remarks from your lover?
3 Would you accept anything less than complete devotion from a lover?
Mostly *Yes*, turn back onto the Highway. Mostly *No*, read Conclusion Two.

CASTLE TOWN

1 Could you love anyone as much as your present girlfriend/boyfriend?
2 Can you see any faults in him/her?
3 Can you take partings calmly?
Mostly *Yes*, turn back onto the Highway. Mostly *No*, read Conclusion Three.

CASINO TOWN

1 Are you completely free from jealousy in your personal relationship?
2 Can you love more than one person at a time?
3 Do you need breathing spaces between seeing him/her?
Mostly *Yes*, read Conclusion Five. Mostly *No*, read Conclusion Four.

CAPITAL CITY

1 Do you consider your lover's feelings before making decisions?
2 Does he/she possess qualities you don't often find in others?
3 Would you miss your lover if he/she went away for a couple of weeks?
Mostly *Yes*, read Conclusion Four. Mostly *No*, read Conclusion Five.

HIGHWAY THREE
3

HIGHWAY FOUR
4

HIGHWAY TWO
2

IS IT LOVE OR INFATUATION

HIGHWAY ONE

START HERE

1 Do you find it hard to believe that he/she loves you?
2 Do you always wish you could be alone together?
3 Do you worry constantly about being jilted?
Mostly *Yes*, turn down Lane One to Country Village. Mostly *No*, carry on along the Highway.

HIGHWAY TWO

1 Do you find the first meeting the most exciting?
2 Can you say 'I love you' even if you don't mean it?
3 Do you make your lover jealous to test his/her love? Mostly *Yes*, turn down Lane Two to the Holiday Resort. Mostly *No*, carry on along the Highway.

HIGHWAY ONE
1

Is your present relationship love, or is it infatuation? Follow your route along the Highway to find out.

GO

HIGHWAY THREE

1 Do you think of your lover incessantly?
2 Do you believe fate brought you together?
3 Would you give up anything and do anything for him/her?
Mostly *Yes*, turn down Lane Three to Medieval Castle Town. Mostly *No*, carry on along the Highway.

HIGHWAY FOUR

1 Has your lover made you uninterested in other members of the opposite sex?
2 Does the relationship give you a feeling of constant well-being?
3 Can you forgive his/her faults?
Mostly *Yes*, take Lane Four to the Capital City. Mostly *No*, take Lane Five to the Casino Town.

CONCLUSION 1

Your relationship seems to be an infatuation rather than true love. As a result of an early dependence on your parents, you are seeking security and protection, and because you may lack self-assurance, you feel a need to attach yourself to a strong figure. This need dominates your love. Fear of separation is probably an important factor in the relationship. You want your partner to be both lover and parent, and he/she may soon feel trapped. Try to take into account your partner's needs and see how much you can return his/her love.

Enjoy the infatuation for the time being, but bear in mind that real love should be based on mutual affection and not on a desperate need.

CONCLUSION 2

You are infatuated. Like other forms of infatuation, this form of loving has an illusory quality about it — in your case the illusion is required to support your doubts about yourself. You take to extremes the natural wish to prove yourself desirable to yourself and to other people. You demand extreme love and admiration from your partner to compensate for your lack of ability to form deep emotional relationships. As soon as your lover starts seeing you as an ordinary person with ordinary faults you may well flit away to find someone else, thereby avoiding criticism.

A really deep love will be possible if you stop idealizing yourself, jump off the pedestal and start being human.

CONCLUSION 3

This is an infatuation based on sexual fantasy. We all go through such a stage during adolescence, in order to try ourselves out and to prepare ourselves for adult love.

You may find it difficult to cope with strong sexual feelings, and consequently tend to turn them into fantasy rather than acting them out. Some people in this category may have difficulty in separating themselves from their idealized parents, and they may substitute a partner who seems strange and frightening. This subconscious fear causes them to idealize their lover and think of him/her as almost superhuman. It may subside on better acquaintance, and with more experience of relationships with the opposite sex in general.

CONCLUSION 4

You seem to have passed through all the stages of infatuation and found the real thing. You have few fantasy illusions about your relationship with your lover, for fantasy is unnecessary if you are satisfied with the real thing. You have confidence in yourself as a lover and you can accept criticism. The responsibility of being in love may sometimes make you feel anxious, but you recognize and accept that anxiety is as much a part of a relationship as loving is, and manage to cope with setbacks without too much upset.

You can enjoy a loving relationship as a natural and integrated part of your life, and you should be very happy with the partner you have chosen.

CONCLUSION 5

You are not infatuated and you are not in love either. If you were thinking of a specific person while answering the quiz questions you don't seem to find the relationship very rewarding. Maybe the affair has taken on the aspect of a duty or a routine you could do without. Or maybe you have a nice pleasant relationship that floats along without much depth of feeling — for you don't appear to be exactly swept off your feet!

Alternatively, perhaps you are experimenting with several different relationships and enjoying the chase for the time being.

When you do meet someone special in your life, try this game again and see if you arrive at a different conclusion!

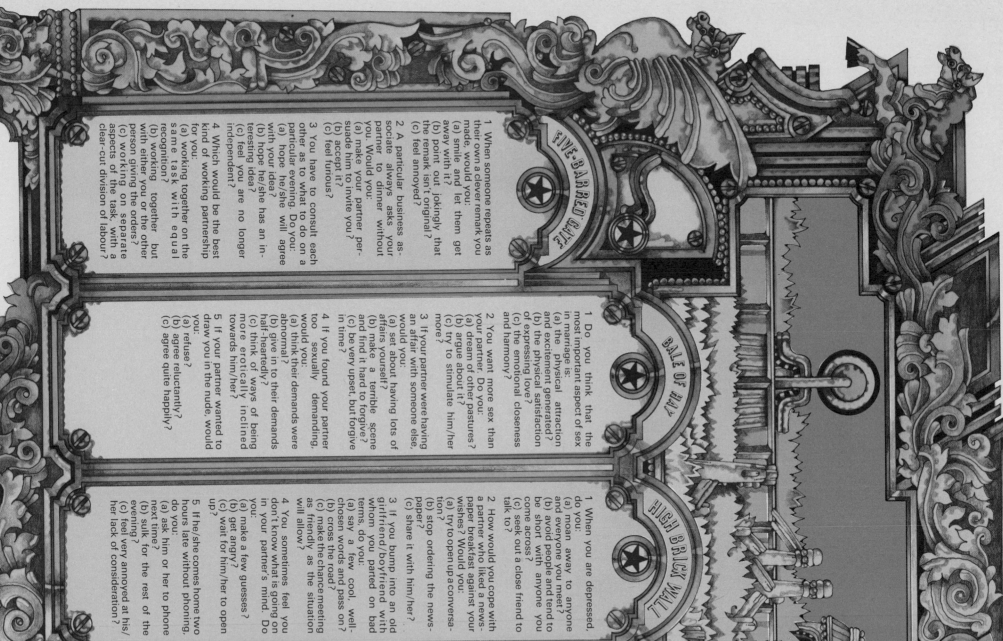

FIVE-BARRED GATE

1 When someone repeats as their own a clever remark you made, would you:
(a) smile and let them get away with it?
(b) point out jokingly that the remark isn't original?
(c) feel annoyed?

2 A particular business associate always asks your partner to dinner without you. Would you:
(a) make your partner persuade him to invite you?
(b) accept it?
(c) feel furious?

3 You have to consult each other as to what to do on a particular evening. Do you:
(a) hope he/she will agree with your idea?
(b) hope he/she has an interesting idea?
(c) feel you are no longer independent?

4 Which would be the best kind of working partnership for you:
(a) working together with equal recognition?
(b) working together but with either you or the other person giving the orders?
(c) working on separate aspects of the task, with a clear-cut division of labour?

BALE OF HAY

1 Do you think that the most important aspect of sex in marriage is:
(a) the physical attraction and excitement generated?
(b) the physical satisfaction of expressing love?
(c) the emotional closeness and harmony?

2 You want more sex than your partner. Do you:
(a) dream of other pastures?
(b) argue about it?
(c) try to stimulate him/her more?

3 If your partner were having an affair with someone else, would you:
(a) set about having lots of affairs yourself?
(b) make a terrible scene and find it hard to forgive?
(c) be very upset, but forgive in time?

4 If you found your partner too sexually demanding, would you:
(a) think their demands were abnormal?
(b) give in to their demands half-heartedly?
(c) think of ways of being more erotically inclined towards him/her?

5 If your partner wanted to draw you in the nude, would you:
(a) refuse?
(b) agree reluctantly?
(c) agree quite happily?

HIGH BRICK WALL

1 When you are depressed, do you:
(a) moan away to anyone and everyone you meet?
(b) avoid people and tend to be short with anyone you come across?
(c) seek out a close friend to talk to?

2 How would you cope with a partner who liked a newspaper breakfast against your wishes? Would you:
(a) try to open up a conversation?
(b) stop ordering the newspaper?
(c) share it with him/her?

3 If you bump into an old girlfriend/boyfriend with whom you parted on bad terms, do you:
(a) say a few cool, well-chosen words and pass on?
(b) cross the road?
(c) make the chance meeting as friendly as the situation will allow?

4 You sometimes feel you don't know what is going on in your partner's mind. Do you:
(a) make a few guesses?
(b) get angry?
(c) wait for him/her to open up?

5 If he/she comes home two hours late without phoning, do you:
(a) ask him or her to phone next time?
(b) sulk for the rest of the evening?
(c) feel very annoyed at his/her lack of consideration?

First Hurdle

1 Invited to dine in rich c... do you:
(a) never feel safe in ... house again?
(b) make believe you a... them?
(c) tend not to notice the... after the initial impact?

2 When there's an ac... the street, do you:
(a) walk by quickly?
(b) see if you can help?
(c) simply feel envious?

Second Hurdle

1 Do you meet your bo... girlfriend's parents for... time with:
(a) positive dread?
(b) curiosity?
(c) mixed feelings?

2 Your partner finds you... difficult. Do you:
(a) agree to keep them as... from your partner as yo...

Third Hurdle

1 You have a burglary... do to, do you:
(a) never feel safe in y... house again?
(b) see it as just one... unfortunate things?
(c) feel terribly upset ab... your possessions?

2 When you have a b... to do, do you:
(a) try not to think abo... it out of your mind for a... you possibly can?
(b) determine to get it... quickly?

This game will help... your capacity to... the hurdles of mar...

STEE... TR...

1 Do you see children as:
(a) potential adults?
(b) little pests?
(c) little angels?

2 If your baby sucked his thumb, would you:
(a) not mind about it?
(b) look up Dr Spock?
(c) try to make him stop it?

3 Do you look back on your own childhood with:
(a) mixed memories?
(b) very happy memories only?
(c) unhappy or hardly any memories at all?

4 Do you think children should:
(a) mould into the adult life around them?
(b) express themselves fully as children?
(c) be made to conform to adult standards?

5 You see a newborn baby, and the thought of having a child goes through your head. Is your first reaction:
(a) how would I look after it?
(b) how would I afford it?
(c) how could I/my wife go through with giving birth?

WATER JUMP

1 If your partner had a hobby you found boring (cars, chess, amateur operatics, etc.) would you:
(a) be tolerant because he/she is so involved in it?
(b) make a genuine attempt to be interested?
(c) dismiss the offending hobby and love him/her despite it?

2 If your partner had to move with his/her job to another part of the country, would you:
(a) try to persuade him/her not to go?
(b) go without complaint?
(c) make a terrible scene and ask your partner to change his/her job?

3 Your lover is working late or studying for an examination. Is your first reaction:
(a) to resent it a bit?
(b) to resign yourself to the situation?
(c) to suspect he/she has found someone else?

4 Your partner's job keeps him/her away when you want him/her at home. Do you:
(a) try to persuade him/her to give up working overtime?
(b) hope a present sacrifice will be a future gain?
(c) tell him/her to give up the job?

OPEN DITCH

1 Which is nearest to your reaction on seeing very old people? Do you:
(a) find them repulsive?
(b) feel sad?
(c) find them boring?

2 If your partner grew very fat, would you:
(a) find another lover?
(b) accept it?
(c) get him/her to diet?

3 What do you consider the main compensation for old age?
(a) happy memories of the past?
(b) wisdom and experience?
(c) the extra time and leisure?

4 Do you think that the main advantage of youth is:
(a) being fun and beautiful as only the young can be?
(b) having the health and energy to make use of every moment?
(c) the thought of having the whole of life in front of you?

5 If your partner had an exciting idea for the future, like going to live abroad, would you:
(a) never take the risk?
(b) agree immediately?
(c) have to discuss it for a while?

6 Which statement most closely reflects your reaction to the prospect of being forty?
(a) Forty sounds horrible, I can't imagine it.
(b) I hope to live up to the saying 'Life begins at forty'.
(c) Not so bad if I'm happy and successful by then.

HASE

...can't afford a television till
...year. Would you:
...persuade your partner to give
...king or drinking?
...start saving a deposit?
...to raise a bank loan?

...en a close friend is in
...al, do you:
...el guilty that you don't visit
...rly enough?
...regularly to visit and enjoy
...ng them up?
...regularly from a sense of

...them get through to each
...n their own time?
...ange a meeting and get
...alking?

...ou moved to a new house,
...you:
...eep out of the way of the
...bours?
...et talking to them imme-
...?
...ait until you were approach-
...them?

...think about it halfheartedly
...hand?

...gine a fire broke out in your
...n. Would you:
...n for the neighbours?
...ll the fire brigade, then run?
...to deal with it yourself?

...paring to go away on holi-
...o you:
...ays seem to have a last-
...e panic?
...et everything ready well in
...ce?
...ganize without too much

...e, Five-Barred Gate and
...each hurdle. Conclusions
...ages 246–7.

Steeplechase: Conclusions

You have scored the hurdles separately, now read the Conclusion for each of them. The hurdles you scrape through, or fail altogether, will indicate some areas in your marriage at which you might be able to work a little harder.

Five-Barred Gate: Conclusion

The questions we asked here were to test your ability to adapt yourself to running in double harness! Learning to do so is an important aspect of a successful marriage.

Mostly (a)
You are able to adapt to your partner without feeling threatened, and you will enjoy your image as a couple. Giving and receiving comes naturally to you, and on that basis you should make a very successful partnership in marriage.

Mostly (b)
You have just scraped over this hurdle. Perhaps you have never had to bother with selfish feelings before? It usually takes a long time to settle into a relationship and being wildly in love is a crash course which won't cover every angle. Maybe you can give up some of your independence and let your partner take over occasionally; a partnership can sometimes allow you a good deal more freedom than the solitary state.

Mostly (c)
Sorry, you've failed this hurdle. You seem to be so wrapped up in your own self-image that you find it difficult to share your identity with your partner. You are apt to become resentful if your partner doesn't back up your somewhat romantic view of yourself. A more realistic approach is necessary, so that you can accept criticism sometimes, and realize that everyone has an ugly as well as a beautiful side to their nature. You will have to be prepared to compromise a little more so that you can share your life happily with someone else.

Bale of Hay: Conclusion

This hurdle was to test whether you would be mature enough to cope with the sexual side of marriage. Sex and the expression of love are two of the most important ingredients in a happy marriage.

Mostly (a)
You did not get over this hurdle. You want a perfect sex life with your partner,

but you seem to expect this perfection with very little effort on your part. Like all other aspects of marriage, physical happiness comes from mutually understanding each other's wishes and desires. Your present romantic notions about sexual love will probably not be sustained after a few years of marriage. You will then have to take a more realistic look at yourself and your partner.

Mostly (b)
You have just scraped over this hurdle. You may have difficulties at present which could be easily overcome. Affection and the demonstration of it can mean so many things. Who hasn't pulled away from a kiss when feeling angry with the other person? Difficulties often stem from uncertainty about one's emotional and sexual abilities. Look at yourself closely and don't give in to your tendency to underestimate yourself.

Mostly (c)
You have made a clean jump over this hurdle. You have the ability to enjoy sex as an integral part of marriage, and because you see sex and affection as one and the same thing you are likely to adjust well to your partner. As a couple you are close enough to deal with any sexual problems that may arise without losing faith in each other.

High Brick Wall: Conclusion

The Brick Wall tests how easily you can express emotion and communicate with your partner.

Mostly (a)
You have just scraped over this hurdle. Sometimes communication between people breaks down because one feels that what they want to say is unacceptable to their partner. What is *not* being said then becomes the most important factor; which is bound to create tension sooner or later. It would be better if you tried to express your feelings without being afraid of your partner's reaction. But as you did scrape over this hurdle, your communication problems shouldn't be difficult to solve.

Mostly (b)
You didn't get over this hurdle. It is easy to communicate when things are going well, but during difficult times in the relationship you tend to cut yourself off emotionally from your partner. The

less you express, the more difficult it is to communicate, and the more easily tension and conflict arise. In a love-situation anger must be expressed too, if you are ever going to come to terms with each other.

Mostly (c)
You are sufficiently aware of your own feelings and those of your partner to be able to communicate adequately. Being well adjusted to each other's personalities you can face discord without loss of communication. You have the ability to express emotion easily, and this isn't an area you need worry too much about.

Treble Hurdle: Conclusion

The questions in the Treble Hurdle were to assess how you would be likely to cope with the domestic and practical problems which can crop up in marriage. Coping with difficult relatives, or poverty, or illness, for instance, can sometimes put a great strain on the marriage.

Mostly (a)
You failed to get over this hurdle. You tend to cut yourself off from unpleasant thoughts, with a feeling of 'it can never happen to me'. This means that in the face of difficulties you may well choose to escape mentally instead of facing up to your problems. You tend to be dependent on other people, and your inability to cope with routine and practical tasks may stem from a dependent wish to be looked after in a parent/child relationship, instead of taking your proper place as a partner in the marriage.

Mostly (b)
You don't have to bother with domestic problems, for you seem to be able to cope. If you were to hit the breadline you could still enjoy life, because you can get satisfaction from your personal relationships, regardless of material factors. You can accept the fact that good and bad things in life come together.

Mostly (c)
You scraped over this hurdle. Strangely enough, it often seems easier for you to accommodate the big dramas in your life than to deal with the minor setbacks, but you seem to be able to cope with *some* of the domestic problems, and probably you find that you can manage until several minor disasters

occur at the same time; then you begin to feel fragmented; and your relationship may suffer in the process. Patience and a little faith in yourself will help. Try to plan your life so that everything doesn't happen at once. This might give you more confidence in your ability to cope.

Open Ditch: Conclusion

The questions at the Open Ditch test how you would be likely to adjust to middle and old age, and how your attitude to age might affect your relationship with your partner.

Mostly (a)

You scraped over this hurdle. You have conflicting feelings about the passage of time. Losing weight if you are too fat, or having a face-lift for your wrinkles is one way of coping with the problem. But really it's best to accept one's age. Middle-aged fauns are a bit of a paradox. There are interesting qualities which help one rise above the aging process and these could be cultivated. Interest and excitement in new ventures and acquaintances, for instance, and flexibility in one's outlook and opinions.

Mostly (b)

You passed well over this hurdle. You have a high enough opinion of yourself as a person not to feel denigrated by becoming old. Because you live life to the full, enjoying the advantages of each age, you are not likely to become a lonely old recluse.

Mostly (c)

You failed this hurdle. Wanting to be young and beautiful for ever seems a nice ideal, but it is an impossible one, and failure to face up to it will make you an unhappy person; and this in turn will make your partner unhappy. You cannot be an eternal adolescent and take on all the responsibilities of a home and children successfully. Life has a beginning, a middle and an end. Each is new and exciting, and each has its own problems and satisfactions.

Water Jump: Conclusion

This was to test how you would cope with your partner's involvement in his/her work and interests. If you failed this hurdle you should be wary of marrying a man who has to take frequent trips away from home/a woman who is very involved in her career.

Mostly (a)

You just scraped over this hurdle. You are probably in two minds about your partner's involvement with his/her work. Perhaps you feel deep down that you shouldn't be reacting in the way you do, and tell yourself that it is silly to be jealous of a mere job. Or perhaps you understand that your partner's job really does mean he/she has to be away from you a lot, and that this is in no way a scheme to avoid you. Remember that a happy but busy partner is often more pleasant to live with than a discontented person with too much time to spare.

Mostly (b)

You passed well over this hurdle. You are able to allow your partner sufficient freedom from the relationship to become involved in work and express his/her individuality. Presumably this means you can trust your partner not to let work ruin your relationship.

Mostly (c)

You failed to get over this hurdle. You tend to be so dependent on your partner that you wish to deny him/her an identity of his or her own. Togetherness is very nice, but not at the expense of your partner's personal ambitions and ideals. You should try to allow your partner more self-expression within the relationship, for your present attitude is bound to lead to conflict.

Double Hurdle: Conclusion

This hurdle was to test the likelihood of your being able to cope well with children, and the resulting problems of adjustment in the relationship with your partner.

Mostly (a)

It sounds as though you have a realistic approach to the strains that children put on a relationship, especially in the areas of responsibility and sharing. Sometimes children expect their parents to take control of their feelings of fear and anger, and it looks as though you will be able to do this.

Mostly (b)

Everyone finds children a problem and the role of parent isn't an easy one, but the art is not to make the problem bigger than it is. As you did in fact scrape over this hurdle there's no reason why you shouldn't be a confident parent. Children often become difficult when their parents are going through a difficult time (uncertainty over a job, resentment in the partnership), but when the cause is removed it becomes easy to enjoy them again.

Mostly (c)

You failed this hurdle. At times the childishness in children becomes intolerable for you. Apart from the real and practical problems here, maybe you have difficulty in accepting your own remnants of childhood, such as the need to be looked after and the enjoyment of being passive in some situations. If you aren't already a parent, you may doubt your ability to deal with children; but nearly everyone else has doubts and once you become a parent you will probably instinctively adjust to parenthood.

Where's your Venus?

Everyone knows whether, in astrology, they are 'Aries', or 'Taurus', or whatever, because on the day they were born the sun was 'in' that particular sign of the Zodiac. What they do not know until it is calculated for them is what signs the other planets were in. For instance, the Moon might have been in Pisces and Jupiter in Leo. When an astrologer casts a birth chart (or 'horoscope', as it was traditionally known) he works from the individual's birth date, the time and place of birth, and from that starting-point calculates (amongst various other things) the exact position of each planet.

Here, we consider Mars and Venus, both of which have a powerful bearing astrological table opposite. First find your year of birth on the top line of the table and then your month of birth at the lefthand side of the chart (1= January, 2=February, etc.). The table shows in which sign of the Zodiac Venus was on the first of each month, and also any date during that month on which it moved to another sign. For instance, if you look at the table, you will see that in January 1947 Venus was in Capricorn on the first of the month, and moved into Aquarius on 26 January.

In order to find out where your own or your partner's Venus is, turn to the astrological table opposite. First find your year of birth on the top line of the table and then your month of birth at the lefthand side of the chart (1= January, 2=February, etc.). The table shows in which sign of the Zodiac Venus was on the first of each month, and also any date during that month on which it moved to another sign. For instance, if you look at the table, you will see that in January 1947 Venus was in Capricorn on the first of the month, and moved into Aquarius on 26 January.

Venus Through the Signs

♈ Venus in Aries
A warm and affectionate man or woman; probably very emotional, but with fiery, positive emotion. Best summed up as ardent and true—but watch out for selfishness, especially if the Sun sign is Aries when, although there will be kindness, there may also be self-seeking tendencies.

♉ Venus in Taurus
Here is someone who will lavish affection on a partner, and contribute much to the development of a relationship. Possessiveness is bound to be present, and the loved one will almost inevitably be thought of as 'mine', in much the same way as any other treasured possession.

♊ Venus in Gemini
Those who have Venus in this sign will enjoy their relationships, and perhaps take them rather lightly. There is a strong possibility that they will have 'more than one string to their bow', and they can find themselves in love with two people at the same time.

♋ Venus in Cancer
This placing contributes much tenderness, and a strong tendency to look after the loved one. A certain claustrophobic feeling may be in evidence, because the person is so cherishing or sentimental. They may also dwell in the past too much. A high emotional level is very likely.

♌ Venus in Leo
Love, affection and loyalty will be expressed in a grand and probably expensive way, especially if the Sun sign is Leo or Libra. There may be a tendency to dominate or rule the partner, and dramatic scenes are possible!

♍ Venus in Virgo
This tends to contribute over-critical, clinical or chaste tendencies, inhibiting a full, satisfactory expression of love; so conflict can occur, especially if the Sun sign is loving, romantic Libra. The need for a 'perfect' partner may be a root cause of difficulty in relationships.

♎ Venus in Libra
This placing indicates a whole-hearted romantic who is not a fully integrated person until he or she is enjoying a permanent relationship. If the Sun sign is Virgo, this will warm the matter-of-fact, practical Virgoan heart. Powerfully romantic and affectionate feelings are inevitable.

♏ Venus in Scorpio
Considerable intensity, emotion and intuition will be very evident in the expression of affection and feelings. Jealousy and possessiveness may mar the relationship, and a very 'black-and-white' attitude to love is very likely. These tendencies are modified if the Sun sign is Libra or Sagittarius.

♐ Venus in Sagittarius
This is definitely a lively position for Venus, and the overall attitude to love and relationships may not be too serious. More than one relationship is likely, and there is also an idealistic facet, which is very positive. Great warmth, affection and enthusiasm will be fully expressed, however.

♑ Venus in Capricorn
Venus's influence in this sign is chilly; but once the barriers are broken one finds an extremely loyal, faithful, and dependable person. There will be few words of affection, but what is said is meant—especially if the Sun sign is Capricorn, rather than Sagittarius.

♒ Venus in Aquarius
This placing nearly always contributes a sort of filmstar glamour; if the Sun sign is Capricorn it may be a little difficult to come really close to that person—physically or emotionally, but especially emotionally. There is often a marked tendency towards platonic friendships rather than romantic relationships.

♓ Venus in Pisces
A kind, loving, willing slave who cannot do enough for one! Life could become blissfully romantic in an unorganized way. There should be very little difficulty in getting on with a 'Venus in Pisces', though emotions could well run rather high at times.

Where's your Mars?

You may have noticed when looking at the position of Venus that it falls in either the same sign as your Sun, or in the next sign, or in the sign after that. This is because Venus's orbit is inside that of the Earth, and as seen from here it always appears close to the Sun — as a bright morning star or a beautiful evening one.

Your Mars can be 'in' any of the twelve signs of the Zodiac; so while your Sun sign may be Gemini, Mars need not be in that sign — it could be in Libra or any of the other signs. Mars is at its strongest in Aries, the sign it rules, and in Scorpio, the sign whose rulership it shares with Pluto.

Now turn to the table opposite and

find out where your Mars (and your partner's!) were on your birthdates. The procedure is exactly the same as it was for finding your Venus, except that it will show you in which sign Mars was on the first day of any month, and the day or days in that month when it moved to another sign.

Mars Through the Signs

♈ Mars in Aries
Mars in Aries will contribute highly-sexed and passionate tendencies. The person will be demanding, but never-theless straightforward and good company. There will be no lack of enthusiasm, warmth and energy, and a general feeling that life is to be enjoyed to the full.

♉ Mars in Taurus
An extremely passionate and highly-sexed man or woman. Feelings are usually slow to be roused, but once aroused, sexual desire is strong. Jealousy and possessiveness can often creep into relationships. People with Mars in Taurus are extremely sensual and sexually demanding, and will often have expensive tastes.

♊ Mars in Gemini
Here is someone who may not want to become too deeply or emotionally involved with any one partner. A strong sexual desire is unusual, but there is great liking for innovation, variety and change in the style of love-making; many lovers are likely, with relationships kept at a superficial level.

♋ Mars in Cancer
Highly-sexed, but nevertheless rough-ness and boisterousness will be intensely disliked, so a gentle and sensitive approach is most advisable. Very strong feelings, emotions and intuitions are always present, and there is a tendency to cling to a relationship. In Cancer, Mars often increases fertility.

♌ Mars in Leo
Those with Mars in Leo will appreciate comfort and luxurious, aesthetically pleasing surroundings for their sexual activities, and the result could be a highly sophisticated romp. There should undoubtedly be plenty of lively re-sponse to advances, but a slight hint of condescension may make one feel like an ever-grateful subject!

♍ Mars in Virgo
Virgo is purity personified, but Mars is all energy and sex: a contradiction in terms. Desire is certainly present, but the expression of it in a straightforward way may not be at all easy. Psychological difficulties as a result of conflict can cause repression, and deviation is possible.

♎ Mars in Libra
A languid attitude towards sex is very likely, and excuses may be made to put off the over-ardent lover. Once aroused, sensuousness will be evident; but, even so, sex has to be idealistic, colourful and beautiful — 'out of this world' rather than noticeably earthy!

♏ Mars in Scorpio
Mars in Scorpio, more than in any other sign, will make the individual extremely highly sexed. Unfortunately, jealousy and resentfulness can frequently blight relationships. Possibly the best way to combat this is to cultivate demanding interests, so that the excess of energy and emotion is positively and creatively directed.

♐ Mars in Sagittarius
A lively, unserious attitude to sex is likely. The man or woman with Mars in Sagittarius will enjoy relationships, but will make and break them easily, for freedom is highly prized. Those with Mars in Sagittarius will be passionate, but the grass will always seem greener on the other side!

♑ Mars in Capricorn
If those with Mars in Capricorn, caught up in the essential business of getting on in the world, can find the time to indulge in sexual relationships, they will be seething with passion at one moment, and an iceberg the next; but they will admire and identify with faithfulness and constancy.

♒ Mars in Aquarius
Having an affair with someone with Mars in Aquarius will be an interesting experience; but togetherness, in the physical sense, may seem almost a necessary evil to them! They accept the fact that desires must be satisfied, but are somehow 'above it all'. Passion is not really their scene.

♓ Mars in Pisces
Passion must always be combined with a colourful romanticism for those with Mars in Pisces. The emotional level is extremely high, but plain and simple earthy pleasures may not be enough to satisfy some highly individual escapist tendencies. An uncomplicated 'strong' partner will have a beneficial steadying influence.

Acknowledgments

Editorial Director: Christopher Dorling
Art Director: Peter Kindersley
Editors: Michael Leitch, Daphne Wood
Designers: Wendy Bann, Nicholas Maddren, David Pocknell

Photographers
Michael Busselle: 114–144, 178, 181–192
John Hedgecoe: 2–8, 14–15, 33–36, 46–47, 50–51, 54–56, 62–63, 66–67, 78–79, 82, 86–87, 90–91, 94–95

Artists
Roger Coleman: 146–147, 150–151, 154–155, 158–159
Andrew Farmer: 229
David Roe: Decorative motifs and games
Justin Todd: 195, 198–199, 202–203, 206–207

Sources of Illustrations
The authors and publishers are particularly grateful to the following museums, galleries and photographic collections for permission to reproduce the illustrations in this book:

10–11 Uffizi Gallery, Florence/Scala
18–19 Prado, Madrid/Hamlyn Group Library
21 British Museum, London/C. M. Dixon
22 Trustees of the National Gallery, London
23 Musée Nationale d'Art Moderne, Paris
24 Mary Evans Picture Library
25 Chrishall Church, Essex/Michael Holford
26 Philip Goldman Collection, London/Geremy Butler
27 Victoria and Albert Museum, London
30 Museum of Fine Arts, Boston
31 National Gallery, London
38–39 City Art Galleries, Manchester
42–43 Palazzo Schifanoia, Ferrara/Scala
45 Lady Lever Art Gallery, Port Sunlight
49 Guildhall Art Gallery, London
58 Mansell Collection
59 Trustees of the Wallace Collection
60, 61 Mary Evans Picture Library
65 Mansell Collection
68, 69 Mary Evans Picture Library
70 Stefan Buzas
71 Victoria and Albert Museum, London
74–75 Mansell Collection
76 Mary Evans Picture Library
77 Victoria and Albert Museum, London
78–79 Mary Evans Picture Library
83 Tate Gallery, London
85 National Gallery of South Australia, Adelaide
88 Victoria and Albert Museum, London/Geremy Butler
92, 93 Mary Evans Picture Library
96, 98–100 Mansell Collection
101, 103 Editions Graphiques Gallery, London
105 Mansell Collection
106 Mary Evans Picture Library
107 Mansell Collection
108 Mary Evans Picture Library
109, 111 Mansell Collection
149 Palazzo Schifanoia, Ferrara/Scala
152 Österreichische Galerie, Vienna/Galerie Welz, Salzburg
153 Mary Evans Picture Library
157 Trustees of the Wallace Collection, London
162, 163 Mary Evans Picture Library
165 Editions Graphiques Gallery, London
166 Bibliothèque Nationale, Paris/Snark International
168 Conway Picture Library
171 Victoria and Albert Museum, London
172 Private Collection/Hamlyn Group Library
175 Mary Evans Picture Library
178 left Field Talfourd/Radio Times Hulton Picture Library
178 right Field Talfourd/Mary Evans Picture Library
190–191, 192 top left, bottom left, bottom right Conway Picture Library/Associated Press
192 top right Conway Picture Library
194 Mansell Collection
201 Tate Gallery, London
205 Radio Times Hulton Picture Library
208, 211, 212 Mary Evans Picture Library
213 Victoria and Albert Museum, London
215 Mary Evans Picture Library
216, 217 Mansell Collection
218 Mary Evans Picture Library
219, 220 Victoria and Albert Museum
248, 250 Mary Evans Picture Library

Publishers and Agents
The authors gratefully acknowledge the kind permission given by the following publishers and agents to reproduce copyright material.

From Rex Warner's translation of Xenophon's *The Persian Expedition* published by Penguin Books, London.

From *Love* by Walter de la Mare by permission of the Literary Trustees of Walter de la Mare and the Society of Authors as their representatives.

'Flowers for Heliodora' and 'The Mosquito' by Meleagros translated by Dudley Fitts from *Poems from the Greek Anthology*. Copyright 1938, © 1956 by New Directions Publishing Corporation. Reprinted by permission of New Directions Publishing Corporation, New York and Faber and Faber Ltd., London.

From Constance Garnett's translation of *Anna Karenina* by Leo Tolstoy published by William Heinemann Ltd., London, and Dodd, Mead & Company, New York.

'Not to Sleep' and 'The Metaphor' by Robert Graves from *Collected Poems 1965*. Reprinted by permission of Robert Graves.

'The Two' by Hugo von Hofmannsthal translated by Derek Parker. Original German text published by Insel Verlag, Frankfurt/Main.

From *The History of Mr Polly* by H. G. Wells. Reprinted by permission of the Estate of H. G. Wells.

'The Morning is Full' and 'Girl Lithe and Tawny' from *Twenty Love Poems and a Song of Despair* by Pablo Neruda, translated by W. S. Merwin. Published by Grossman Publishers, New York, and Jonathan Cape Ltd., London.

'Blow, wind, to where my loved one is' by Ramayana from *Poems from the Sanscrit* translated by John Brough published by Penguin Books Ltd., London. Copyright © John Brough, 1968.

From *Marriage and Morals* by Bertrand Russell published by George Allen & Unwin Ltd., London and Liveright, Publishers, New York. Copyright R. 1957 Bertrand Russell.

From 'To Earthward' from *The Poetry of Robert Frost* edited by Edward Connery Lathem. Copyright 1923, © 1969 by Holt, Rinehart and Winston

Inc. Copyright 1951 by Robert Frost. Reprinted by permission of Holt, Rinehart and Winston, Inc., New York and Jonathan Cape Ltd., London.

'In praise of Cocoa' by Stanley Sharpless published by the New Statesman, London.

'viva sweet love' by e. e. cummings published by permission of McGibbon & Kee Ltd., London, and Alfred Rice, New York.

'Recuerdo' by Edna St. Vincent Millay from *Collected Poems* published by Harper and Row, New York. Copyright 1922, 1950 by Edna St. Vincent Millay.

From 'The Look' from *Collected Poems* by Sara Teasdale, published by the Macmillan Company, New York. Copyright 1915 by the Macmillan Company, renewed 1943 by Mamie T. Wheless.

From 'In the Midnight Hour' from *Tonight at Noon* by Adrian Henri published by Andre Deutsch Ltd., London, and David Mackay Co. Inc., New York. Copyright © 1969 by Adrian Henri.

'Bid adieu' from *Chamber Music* from *Collected Poems* by James Joyce. Copyright 1918 by B. W. Huebsch Inc., renewed 1946 by Nora Joyce. Reprinted by permission of Viking Press Inc., New York and the Executors of the James Joyce Estate.

'Warm are the Still and Lucky Miles' and 'Lullaby' from *Collected Shorter Poems 1927–1957* by W. H. Auden published by Faber and Faber Ltd., London and Random House, Inc., New York.

'Jig' and from 'Live you by Love Confined' by C. Day Lewis from *Collected Poems 1954*. Copyright by C. Day Lewis. Reprinted by permission of Jonathan Cape Ltd. and Hogarth Press, London and the Harold Matson Company Inc., New York.

'And Your Dress is White' translated by Jack Bevan from Salvatore Quasimodo's *Selected Poems* published by Penguin Books Ltd., London, and Henry Regnery, Chicago.

From *Day of These Days* (*The Bloom of Candles*) by Laurie Lee.

'Song of the Pink Bird' from *Little Johnny's Confession* by Brian Patten published by George Allen & Unwin Ltd., London and Hill and Wang, New York. © Brian Patten, 1967.

From 'Sex Versus Loveliness' from *Phoenix II: More Uncollected Writings of D. H. Lawrence* edited by Warren Roberts and Harry T. Moore. All rights reserved. Reprinted by permission of The Viking Press Inc., New York, Laurence Pollinger Ltd., London, and the Estate of the late Mrs Frieda Lawrence.

'Carpe Noctem' from *The Cicadas* by Aldous Huxley published by Chatto and Windus, London and Harper & Row, New York. Copyright, 1929, 1931 by Aldous Huxley. Reprinted by permission of Harper & Row, Publishers, Inc.

'Serenata' from *Selected Poems* by Federico Garcia Lorca translated by Derek Parker. All Rights Reserved. Reprinted by permission of New Directions Publishing Corporation, New York.

From Alan Russell's translation of *Madame Bovary* by Gustave Flaubert, published by Penguin Books, London.

From *Love and Marriage* by Ellen Key published by G. P. Putnam's Sons, New York.

From 'Glory of Life' by Llewellyn Powys Inc., by permission of Malcolm Elwin, Literary Executor to the Llewellyn Powys Estate.

'Daybreak' by Stephen Spender from *Collected Poems 1928–1953* published by Faber and Faber Ltd., London, and Random House, Inc., New York. From 'The Postures of Love' by Alex Comfort (1946) from *The Signal to Engage* published by Routledge & Kegan Paul Ltd., London.

From *This Side of Paradise* by F. Scott Fitzgerald published by Charles Scribner's Sons, New York, and The Bodley Head, London. From The Bodley Head Scott Fitzgerald Vol. 3.

'Unfortunate Coincidence' from *The Portable Dorothy Parker* by Dorothy Parker. Copyright 1926, 1954 by Dorothy Parker. Published by the Viking Press Inc., New York.

From 'Music I heard with you' from *Collected Poems* by Conrad Aiken (Copyright 1953 by Conrad Aiken) published by Oxford University Press, New York.

From 'After Long Silence' from *Collected Poems* by William Butler Yeats, copyright 1933 by the Macmillan Company, New York, renewed 1961 by Bertha Georgie Yeats. By permission of M. B. Yeats and the Macmillan Companies of Canada and London.

From *The Golden Ass* by Apuleius translated by Robert Graves. Reprinted by permission of Robert Graves.

A condensation of a passage from 'The Girl Who Caught a Nightingale' from Giovanni Boccaccio's *Decameron*, translated by Richard Aldington. © Catherine Guillaume.

Every effort has been made to trace the owners of any copyright material that may exist. Should any material have been included without the permission of the owner of such copyright, acknowledgment will gladly be made in any future edition if attention is called to it.

General Acknowledgments

The following Games were devised by Jane Deverson and Dr Roger Hobdell: What Type of Lover Am I?; The Love Maze; Is It Love or Infatuation?; The Steeplechase. The authors would also particularly like to thank Mr Arvas of Editions Graphiques Gallery, London, Mr and Mrs L. F. Lethbridge, and Dr Charles Rycroft for their help in compiling this book.

Literary and Art Index

This index lists poems (under both their titles and the first lines of the poem or extract quoted) and their authors; the source and author of prose extracts; and artists and their paintings, drawings or photographs. Figures in italics refer to pictures.